iittala.com

IITTALA
1881

The Kettelhut Chair

Finn Juhl | 1951

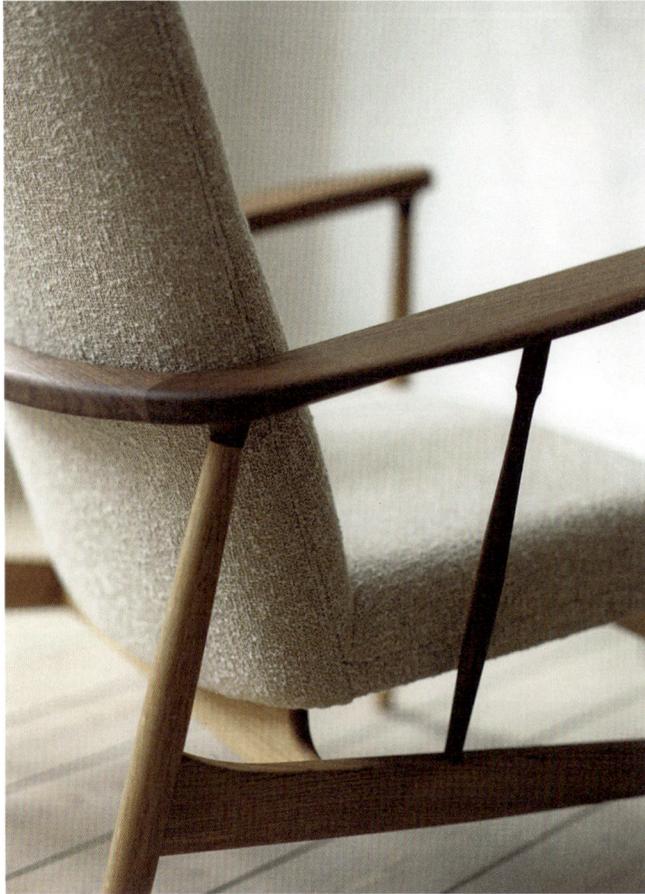

H
FJ

finnjuhl.com

The Kettelhut Chair, designed by Finn Juhl in 1951, stands out with its broad, embracing armrests. The distinctive and comfortable chair is known in the vintage market as SW 86, named after its original Danish manufacturer, Søren Willadsen Møbelfabrik. However, driven by international aspirations, Finn Juhl sent the drawing of the chair to the American furniture manufacturer Baker Furniture.

Baker Furniture launched and relaunched several of Finn Juhl's designs in the early 1950s, but for unknown reasons, this particular chair never made it into their collection.

For the global relaunch, the chair has been renamed 'Kettelhut' after Mary Ellen Kettelhut, the former Vice President of Marketing at Baker Furniture. In 2021, she reached out to House of Finn Juhl as she owns the original watercolor of the chair. The characteristic design immediately sparked interest.

Today, the Kettelhut Chair is available in a combination of oak and walnut, with upholstery options in leather or textile.

HOUSE OF FINN JUHL

The Kettelhut Chair is shown with the textile Zero in the color 0001 from Sacho / Kvadrat.

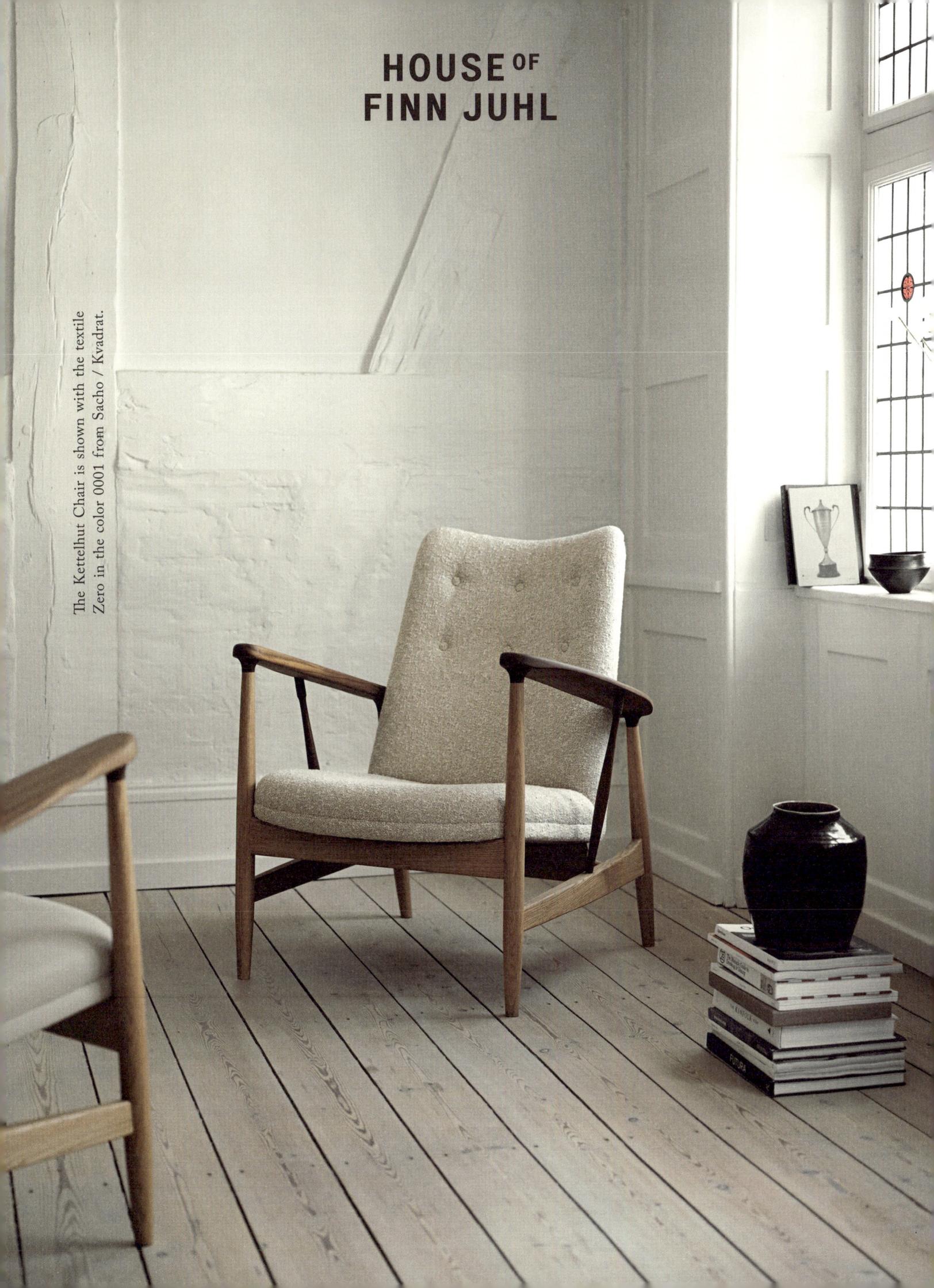

Bubble

Handcrafted Vessels in Resin

Exlore the collection at
tf.design

KINFOLK

JOURNEYS

A New Way to Explore

Venture beyond the horizon with *Kinfolk Journeys*, a new volume full of inspiring and sustainable ways to travel slower and see the world anew. Whether taking a subterranean tour of Tashkent, joining a local mailman on his delivery route through rural New Zealand, or sailing the high seas en route to Antarctica, the 18 all-new stories within will transform the way you travel from A to B, no matter the distance. Take a journey with *Kinfolk*.

KINFOLK

MAGAZINE
—

EDITOR IN CHIEF	John Burns
CONTENT EDITOR	George Upton
ART DIRECTOR	Christian Møller Andersen
DESIGN DIRECTOR	Alex Hunting
COPY EDITOR	Rachel Holzman

STUDIO
—

PUBLISHING DIRECTOR	Edward Mannering
DESIGNER & ART DIRECTOR	Staffan Sundström
DIGITAL MANAGER	Cecilie Jegsen
ENGAGEMENT EDITOR	Rachel Ellison
STUDIO MANAGER	Vilma Rosenblad

—

CROSSWORD	Mark Halpin
PUBLICATION DESIGN	Alex Hunting Studio
COVER PHOTOGRAPHS	Luke Lovell
	Mar + Vin

WORDS
—

Fedora Abu
Precious Adesina
Lynn Ahn
Ann Babe
Fiona Bae
Katie Calautti
Ed Cumming
Benjamin Dane
Jareh Das
Gabriele Dellisanti
Marah Eakin
Tom Faber
Elle Hunt
Robert Ito
Rosalind Jana
Tara Joshi
Monika Kim
Jessica J. Lee
Francis Martin
Emma Moore
Ali Morris
Emily Nathan
Okechukwu Nzelu
Raphael Rashid
Apoorva Sripathi
George Upton
Alice Vincent

**STYLING, SET DESIGN,
HAIR & MAKEUP**
—

Troye Antonio
Serena Congiu
Tine Daring
David de Quevedo
Piu Gontijo
Tana Grossberg
Sarah Hardy
James Lear
Maika Mano
Yosephine Melfi
Davide Perfetti
Ghost (Jessica) Pudelek
Sandy Suffield

**ARTWORK &
PHOTOGRAPHY**
—

Ollie Adegboye
Oghalé Alex
Nuits Balnéaires
Sergiy Barchuk
Lee Beel
Jonas Bjerre-Poulsen
Inigo Bujedo Aguirre
Park Chan Woo
Valerie Chiang
Yaroslav Danylchenko
Allen Danze
Bea De Giacomo
Charlie Engman
Hollie Fernando
Charly Gosp
Dudi Hasson
Cecilie Jegsen
Stephen Kent Johnson
Yongkwan Kim
Hong Kiwoong
Kourtney Kyung Smith
Alixe Lay
Jae An Lee
Luke Lovell
Mar + Vin
Christina Nwabugo
Linda Nylind
Zhenya & Tanya Posternak
Spessi
Texture On Texture
Aaron Tilley
Sarah van Rij
Bekah Wriedt
Jenny Zarins

PUBLISHER
—

Chul-Joon Park

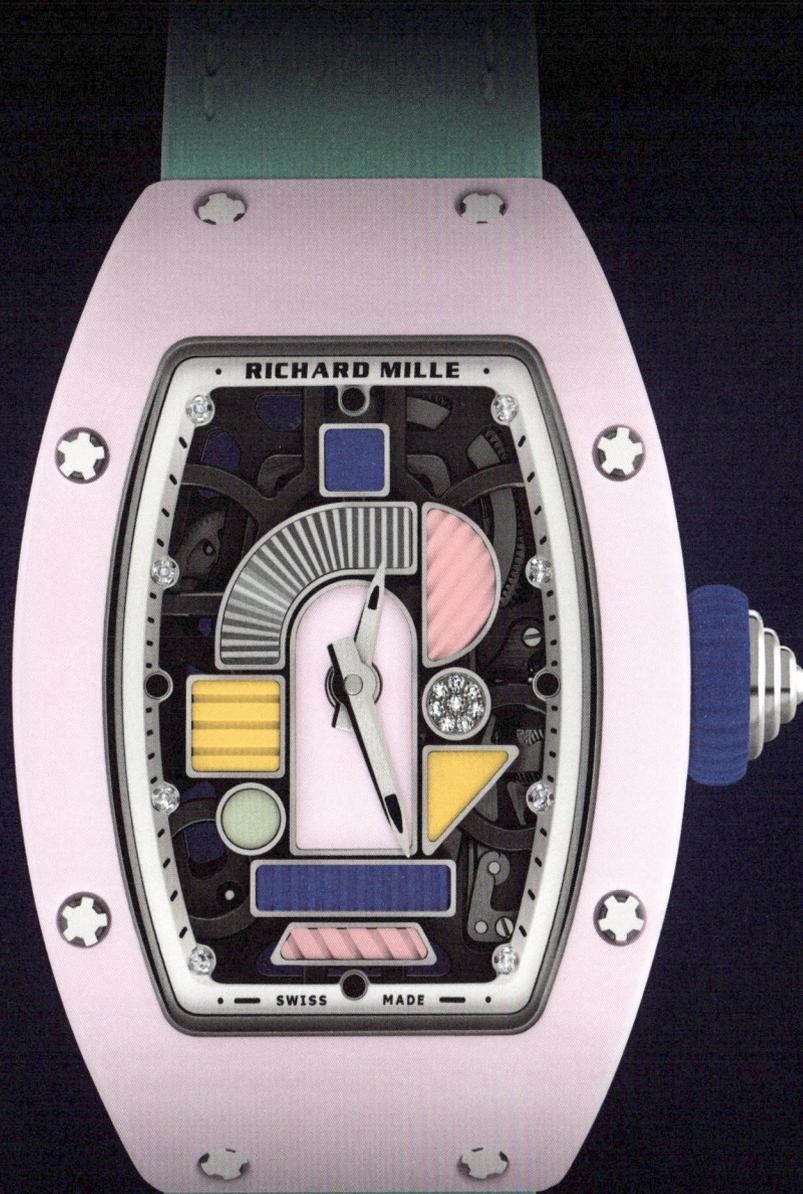

RICHARD MILLE

RM 07-01 COLOURED CERAMIC

In-house skeletonised automatic winding calibre
50-hour power reserve (±10%)
Baseplate and bridges in grade 5 titanium
Variable-geometry rotor
Dial with coloured ceramics, white gold guilloché
and diamond-set decors
Case in blush pink TZP ceramic and white gold

A Racing Machine
On The Wrist

WELCOME
Seoul Special

So much has been written about the rise (and rise) of Korean culture in recent years that the headlines are almost rote by this point: BTS has become the world's biggest boy band; *Squid Game* was the most-watched show ever on Netflix; Bong Joon Ho's thriller *Parasite* was the first film not in the English language to win the Academy Award for best picture; and gochujang, the fermented Korean chili paste, suddenly seems to taste great in everything—even cookies.

But what of Korean culture beyond this familiar ticker tape? *Kinfolk* has published a Korean edition of the magazine for the last 10 years, run a community space in the heart of Seoul for the last five, and, more recently, has hosted a slate of pop-ups in some of the city's most enthralling neighborhoods. For Issue Fifty-Three, our team has drawn on this deep-rooted connection to slip out of the K-culture mainstream and reveal the slower side of Seoul that we've come to know and love. Starting on page 114, you'll find a guide to the best that the Korean capital has to offer: our favorite neighborhoods, coffee shops and bakeries, natural wine bars, restaurants, local fashion brands, museums and galleries, plus surprising information you won't find elsewhere—like the best place for late-night fried chicken.

Elsewhere in the issue, we visit climates more tropical. In West Africa, we tour a handcrafted, bohemian home in Lagos that has been lovingly preserved in homage to the groundbreaking architect who built it. Farther down the coast, in Abidjan, we meet Rym Beydoun—founder of the underground fashion label Super Yaya. And our fashion editorial, shot in São Paulo by photographers Mar + Vin, captures siblings Mahany and Danyllo Pery striking poses that nod to the work of Malian artist Malick Sidibé.

We also meet Mustafa, the singer, songwriter and poet who, since the age of 12, has been laser-focused on using his talent to address the challenges facing his community; Tara Joshi catches up with him ahead of the release of his second album. We also speak to experimental harpist Mary Lattimore, Britain's favorite cook, Nigel Slater, and menswear designer Evan Kinori. Plus, our writers ask why our homes are slowly turning into hotels, why some couples look alike and where the pope sources his socks.

WORDS
JOHN BURNS

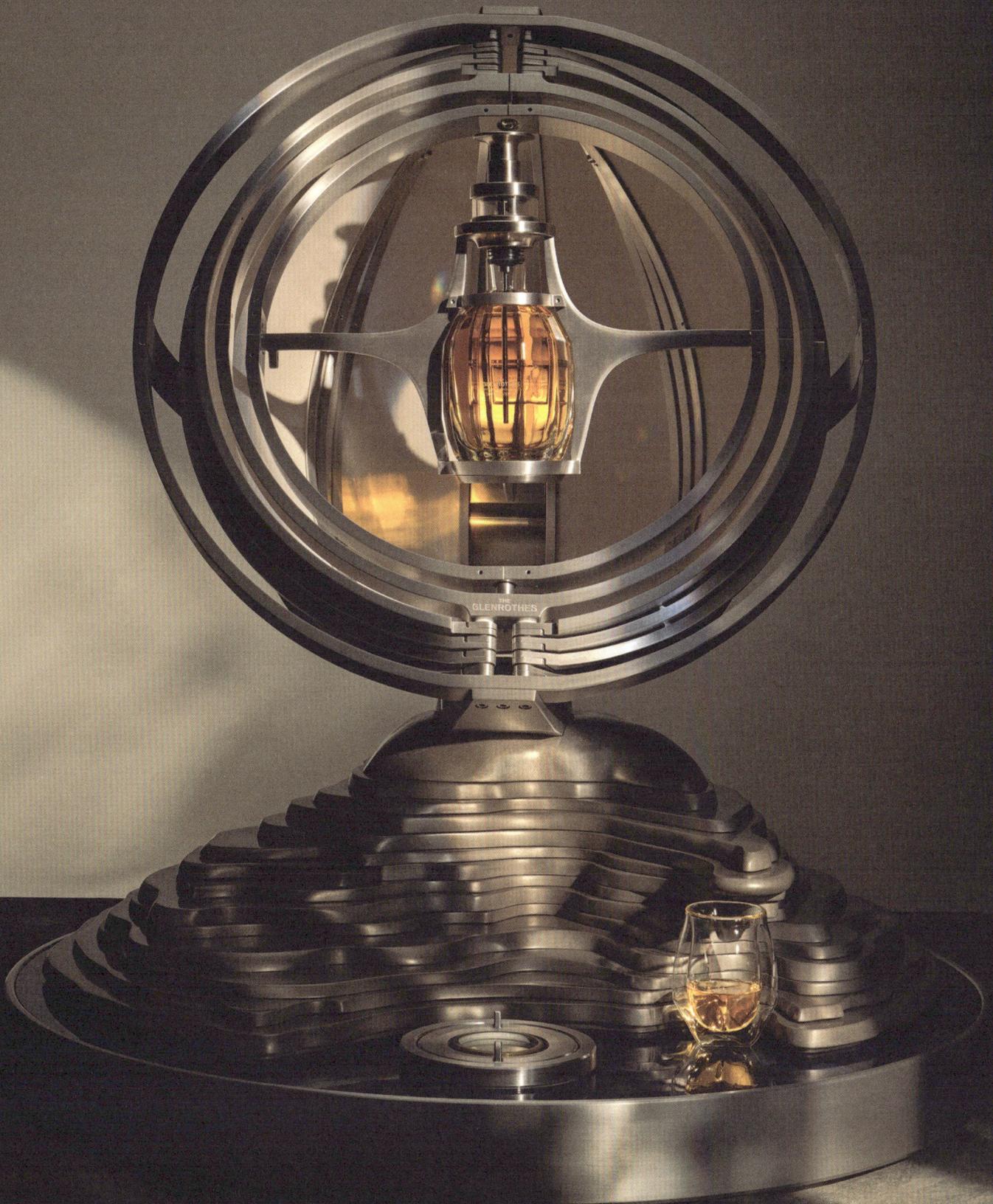

Whisky Makers of Exception

THE
GLENROTHES
ESTD 1879

THEGLENROTHES.COM

Please enjoy and share The Glenrothes responsibly.

STARTERS
On fate, favors and fermentation.

FEATURES
From Abidjan, São Paulo and Lagos.

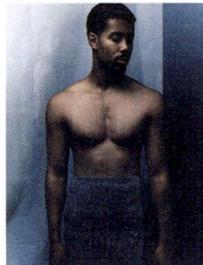

"Self-care requires an exchange, it's about giving." (Mustafa – P. 61)

marset

Taking care of light

114 — 160

SEOUL
A guide to the Korean capital.

161 — 176

DIRECTORY
Trend forecasting and de-influencing.

CHAOS BREEDS CREATIVITY,
OUR PISTON SPORT AL SHAPES IT.

Kaweco
GERMANY, SINCE 1883.

Starters.◆

20

WALK? DON'T WALK?
How to explore a city.

WORDS
FRANCIS MARTIN
PHOTO
SARAH VAN RIJ

Longtime readers of travel writing might sometimes find themselves incredulous at the number of adventures that befall the author during their journey. Of course, uneventful days will rarely make it to print, but those writers have also likely unearthed the essential secret to exploring a city: The more doors you push open, the more likely you are to discover something interesting.

Sometimes, the door-pushing can be literal. You could, for example, happen to be wandering around the cemetery island of San Michele in Venice and hear the incongruous sound of cheery voices. Pushing open the door of what used to be a monastery reveals Laguna nel Bicchiere—a historical vineyard, where, with the help of Google Translate, you can soon be sampling the previous year's vintage with the lagoon's winemakers.[1]

Cities can often be places of unexpected contrasts. For a traveler exploring any new place, a good approach is to embrace some contradictions of your own. You're somewhere unfamiliar? Do things you'd do at home. Struggling to orient yourself? Deliberately get lost. Don't know anyone? Act as if you do.

Books can be a guide, but don't just stick to guidebooks. Try to read a novel set in the city. It probably won't tell you *where* to eat, but it might give you a sense of *how* the city's people eat. It could also suggest a starting point for your interpretation of the city: a historical event on which to focus, or a character through whose eyes you can see the streets.

When it comes to meeting people, you have nothing to lose, and—to employ another motivational cliché—a little goes a long way. In a city full of strangers, a brief interaction can give you the start of a sense of belonging. Get a haircut, take a yoga class or go to a bar to watch a soccer game. The worst that could happen is that you've done something you already enjoy doing; the best is that you make a new friend who can help reveal an otherwise hidden face of the city.

Most barriers to meeting people and to keeping the conversation going can be overcome with judicious use of your phone. Translation apps are no substitute for proficiency but can bridge the gap between phrasebook platitudes and the kind of specific or slang vocabulary you need in a proper conversation. For connecting with local residents, Couchsurfing used to be the go-to. A paywall was introduced a few years ago, leading to an exodus of users, but it remains a useful tool for travelers. A free alternative, if your situation in life allows, might be found in the form of dating apps.

A temporary phone service provider or an eSIM will ensure you have internet access and, together with a well-charged battery, give you the security to get lost, leaving you free to follow your nose. A tightly packed itinerary might mean you can tick off the maximum number of must-sees but it will also make it much harder to stumble upon the kind of adventures that reveal a new dimension of the city. It's why, more than anything else, it's important to travel with an open mind and give yourself the time and space to encounter the unexpected.

(1) Laguna nel Bicchiere is a nonprofit group that recovers and preserves Venice's ancient vineyards. Since 2008, the organization has managed a vineyard in the former Camaldolese convent on the island of San Michele, where it grows Dorona—a native white grape—and produces natural wines using traditional winemaking techniques.

Amisha Padnani spends her days thinking about death. As an editor on the Obituaries desk of *The New York Times*, she works with a team to cover the noteworthy deaths of the day. In 2018, she launched the *Times'* Overlooked series to tell the stories of remarkable people who were not recognized in their lifetimes—women and people of color who, long passed over by papers of record, might have otherwise been lost to history.[1]

ELLE HUNT: How did you come to join the Obituaries desk?

AMISHA PADNANI: I started on the desk in early 2017. Initially, my role was to think about the digital side: How could we be faster with breaking news, or gain new readers? Now I'm more of a traditional story editor, responding to that day's deaths. We have some 2,000 obituaries already in our system that we have to stay on top of so that we're ready whenever they're needed.

EH: How do you select who to feature?

AP: If the person made news in their lifetime, chances are their death is news as well. We look through the *Times'* archives and talk to colleagues to help us determine a person's importance. But we also look for figures who didn't seek out the spotlight, and quirky or interesting tales, like the woman who popularized the sock puppet. I'm always pushing to diversify our coverage: There are so many more people who made a mark on the world than the ones we learn about in textbooks.

EH: Is this what inspired you to start the Overlooked series?

AP: We used to get emails from readers asking why we didn't feature more women and people of color, and the explanation given was that in past generations they hadn't been invited to the table. We launched the project in March 2018, on International Women's Day. That morning, I received hundreds of emails from people saying that they'd felt seen. As a young woman of color, I knew just what they meant.

EH: How do you put together the "definitive record" of someone's life?

AP: It can be hard: In the case of the Overlooked series, the people are long gone and there may not be much data. You're really a detective, and you don't want to get anything wrong. For advance obituaries, we can sometimes talk to the subject. I remember, years ago, overhearing one of our writers interviewing the inventor of the poodle skirt: "What scissors did you use to cut the fabric?" When the woman realized it was for her obituary, she was thrilled, but we don't always get that response.

(1) Padnani is also the author of *Overlooked*, a companion book to the column sharing 66 extraordinary obituaries, ranging from the notable (poet Sylvia Plath and mathematician Alan Turing) to the obscure (Terri Rogers, a transgender ventriloquist and magician).

ODD JOBS
Amisha Padnani, obituarist.

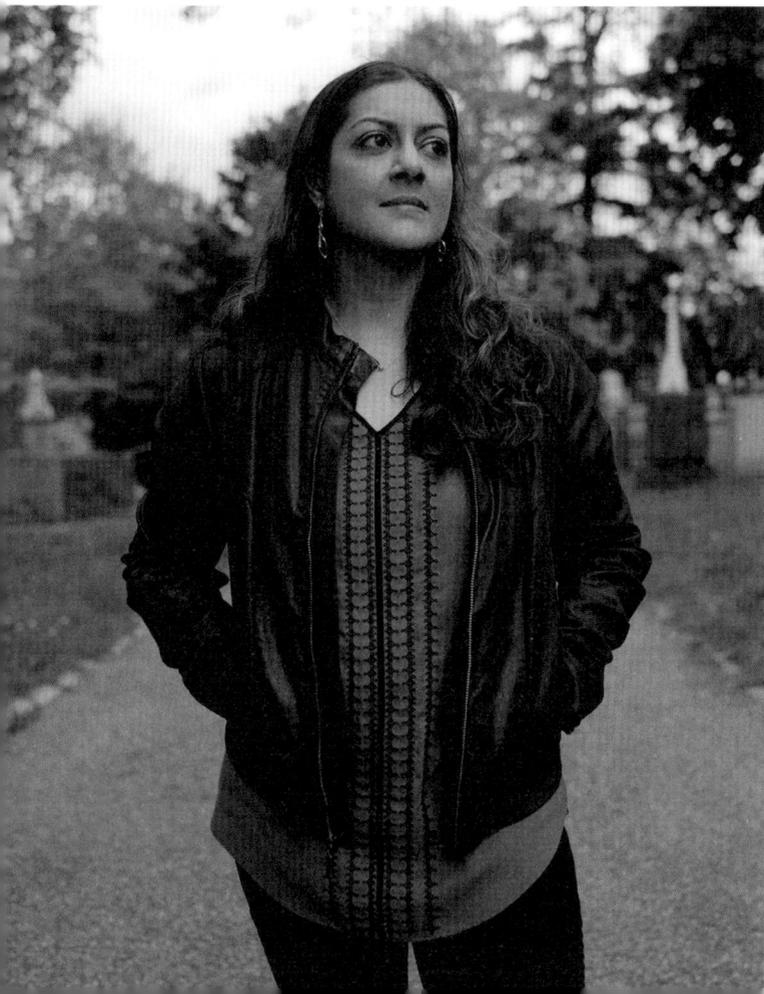

WORDS
ELLE HUNT
PHOTO
VALERIE CHIANG

Fermentation is the soul of Korean cuisine. Born from the need to preserve food, its origins are intertwined with the advent of agricultural society and go far beyond kimchi, the spicy fermented cabbage that is known widely outside Korea. For this dish, the nuruk, a traditional fermentation starter, transforms the beets to emulate the texture of beef sashimi.

SERVES 3

For the sashimi:
2 pounds beets
3½ ounces salt
½ pound nuruk

For the marinade:
Mix equal parts sherry vinegar, lemon juice and sugar

For serving:
Green apples
Edible flowers
Chervil
Dill
Sorrel
Basil oil

Slice the beets into three or four large pieces to ensure they ferment uniformly and soak up the rich, savory flavors developed during the fermentation process. Rub with the salt, sprinkle the nuruk over the beets and place in a jar. (Traditionally, Koreans prefer earthenware jars, as they are porous and air enhances fermentation, but glass jars can also be used.) Cover with a cotton cloth and leave to ferment in a cool, dark space—ideally a basement or a wine fridge that is around 60°F. The salt will draw water from the beets—remove this with a spoon every few days if you prefer a firmer, chewier texture.

After one to three months, when the fermentation is complete, remove the beets from the jar and rinse under running water. This will ensure they retain the deep, umami flavor developed during fermentation. Slice the beets as thinly as possible and prepare the marinade by combining the vinegar, lemon juice and sugar in equal proportions. Place the sliced beets in the marinade: If you're short on time, a 10-minute soak in the marinade is sufficient, but feel free to leave it in the refrigerator overnight to pickle.

Plate the beets with slices of apple, edible flowers and herbs and drizzle with basil oil. The basil oil and sherry vinegar will enhance the flavors while ensuring they remain delicate and refreshing.

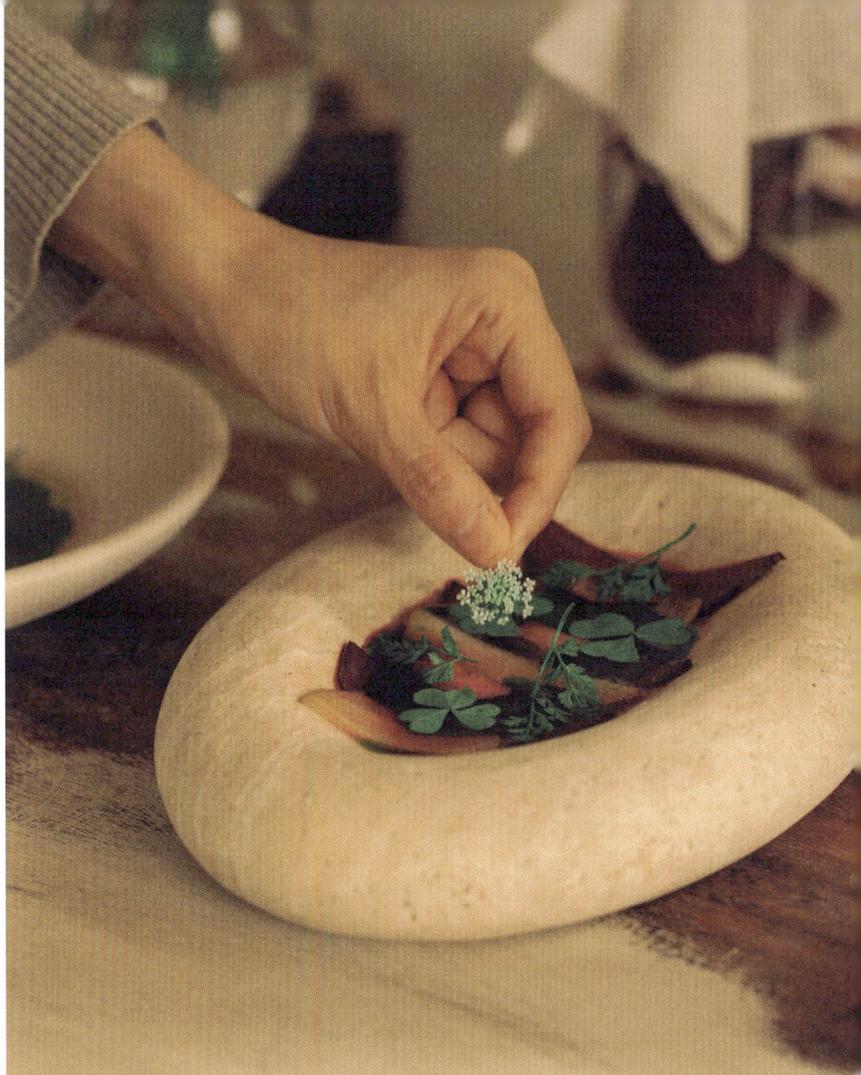

WORDS
LYNN AHN
PHOTO
HONG KIWOONG

BEET SASHIMI
A recipe from Seoul restaurant Millennial Dining.

JONATHAN NUNN

WORDS
APOORVA SRIPATHI
PHOTOS
ALIXE LAY

A date with the British food critic.

When Jonathan Nunn started Vittles in March 2020, he intended it to just be a fun side project. Four years later, the food and culture newsletter has over 60,000 subscribers who receive email dispatches three times a week on everything from gastrodiplomacy to the hyper-regional traditions of Britain and Ireland.

In championing small restaurants, underrepresented food cultures and emerging writers through Vittles (the newsletter has around 120 different contributors each year), Nunn is changing the way people think about food both in London, where he lives, and beyond, shaking up an industry that had grown stale over the years. In 2022, *London Feeds Itself*, a collection of essays edited by Nunn exploring the city's food culture through public and marginal spaces, was published in print to critical acclaim.

APOORVA SRIPATHI: You started out working with tea. What brought you to writing?

JONATHAN NUNN: I worked at Postcard Teas for 10 years as a bartender, copywriter, retail manager, sourcer and a liaison with restaurants for their tea menus. I was very much into food and restaurants but I only started writing about it in 2018, when Eater London saw on Twitter that I had gone to Kingsbury in northwest London for mangoes and asked if I'd ever considered writing about food. I realize now that I'd really been writing about food for a long time before that. The least interesting thing you can write about tea is a list of tasting notes—what

you're actually writing about is place; how different climates and elevations affect the taste of different teas, the people who make the tea. It's a real confluence of agriculture and culture, which is also what restaurants are about.

AS: How did you come to launch Vittles?

JN: I started Vittles in March 2020. I was working on a big project with the writer Angela Hui on Chinatown for Eater London when lockdown hit, and I realized that the whole thesis of the project was going to be changed by the pandemic. There were a lot of people in the food world who were out of work and I thought it would be fun to do a community newsletter that wasn't just based on restaurants, but could have recipes and guides to shops and other forms of food writing. And it was always a part of Vittles from the start that we wanted to pay people as well as we could.

AS: What do you want to achieve with Vittles?

JN: A lot of people wanted to try food writing for the first time but hadn't had the opportunity to do so. It had taken someone else pushing me for me to start writing about food for the first time, and I thought there's got to be plenty of other people in a similar position. It turned out from week one that we were inundated with pitches. For the first six months, we were publishing one piece a day. I don't think anything in my life has felt as easy and productive as that period. That set the template of what Vittles is in terms of the diversity of writers and themes.

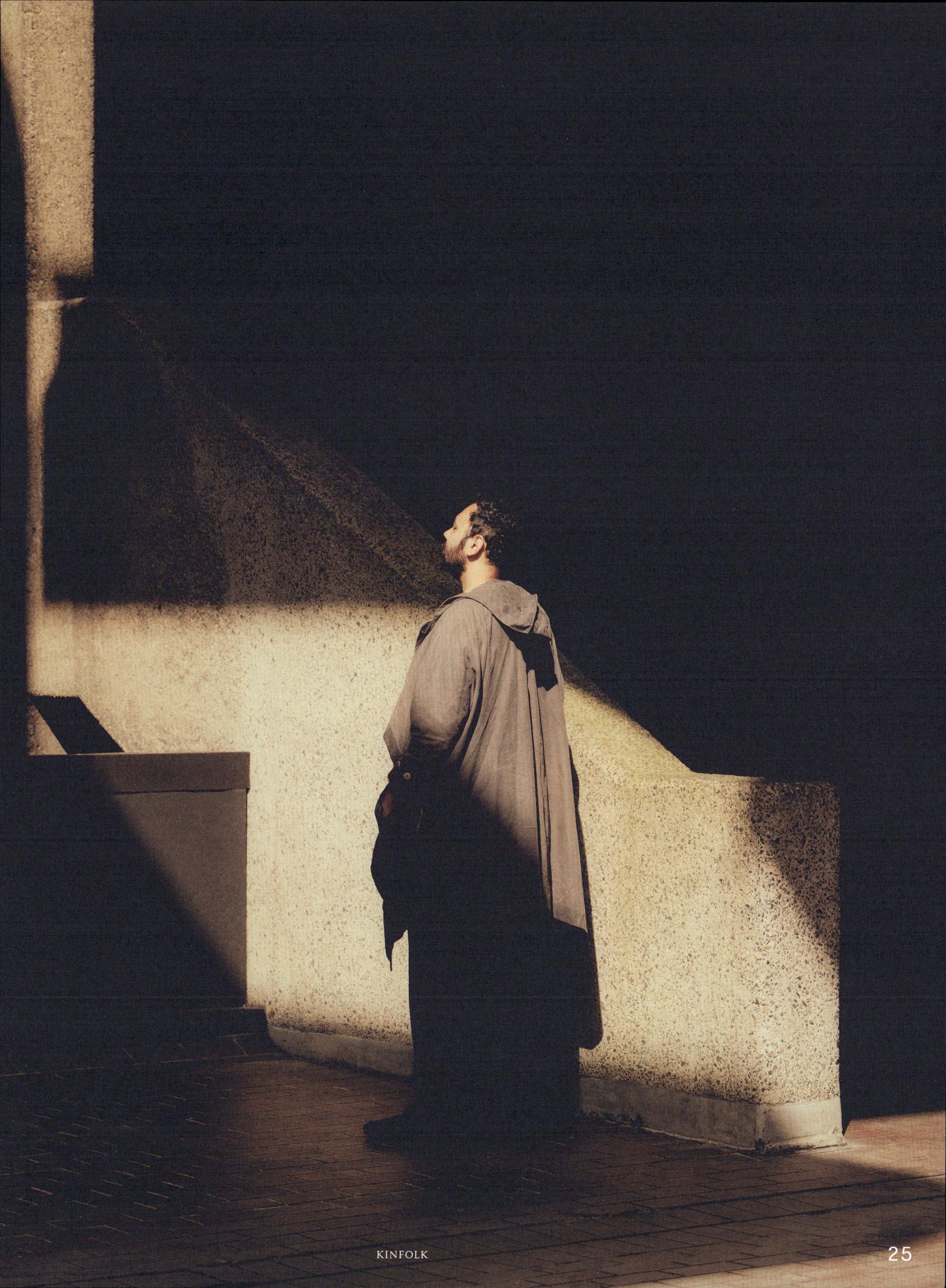

If it had stopped then, I would've said it had achieved its goal. It was just to have some fun during lockdown and see where it went. The fact that we're talking about it four years later means it has exceeded every expectation I had of it.

AS: How do you find the voices you publish?

JN: We have quite extensive pitching guides that describe exactly what we're looking for. All of us [on the editorial team] read a lot, so we often have writers in mind. Instagram and Twitter are quite useful for coming across people who clearly have a voice and have not been able to express it. I'd heard one of our recipe writers, Melek Erdal, talk on a panel about food and anti-capitalism during the pandemic. I was quite surprised that she wasn't already a writer—she wrote captions on Instagram for the food she made and it was clear she had a writer's sensibility. It's always a pleasure to work with a writer in developing their voice.

AS: What is it like working in a nontraditional publishing medium, especially now that the newsletter space is becoming increasingly saturated?

JN: Vittles would never have worked if it had been a magazine first. I'm very thankful for that—a newsletter is a great way to build a publication without having to pay too much and take on a huge amount of risk. At the same time, I think we as readers will reach a point, if we haven't reached it already, where we're subscribed to so many different things that we're going to say "Couldn't we just bundle the subscriptions into one place?" And then some will think, "Oh hold on, that's a newspaper." When that happens, we're maybe in a slightly better position because we're a magazine with a specialism, which I think works quite well.

AS: How do you suggest people get more adventurous when seeking out new restaurants?

JN: I have an ambivalent relationship to restaurant writing, which is funny because I'm a restaurant writer and it's my job to tell you where to eat. I think what people always want from me is a map and a list of places that are easily accessible. I'm very lucky that people engage with my writing in that way, but at the same time I have an uneasy relationship with the fact that I am taken at my word. When I recommend a restaurant, it often becomes just another place that people add to a list without engaging in everything surrounding the restaurant: the neighborhood, the community, in getting to know the city better. I would love the writing to inspire people to connect with their neighborhoods and their own likes and dislikes just by walking around and talking to people.

AS: What comes next for Vittles?

JN: We're coming up to five years in March, which is a big milestone. The obvious route for any food publication is to then diversify into video, podcasts and TikTok. I don't want to be a Luddite but I have no interest in doing that. I'd like to be looking backward to older forms of media and seeing how we can reappropriate that for a new age. We also can't rest on our laurels—we need to be constantly challenging ourselves. I would love us to be a very different publication in five years while also retaining something of those first few months of Vittles. I know we slip into a lot of the biases that are inherent in food media. We're not a perfect publication, and there's always an imbalance in food writing, and particularly restaurant writing, between those who get to write about it and those who are being written about.

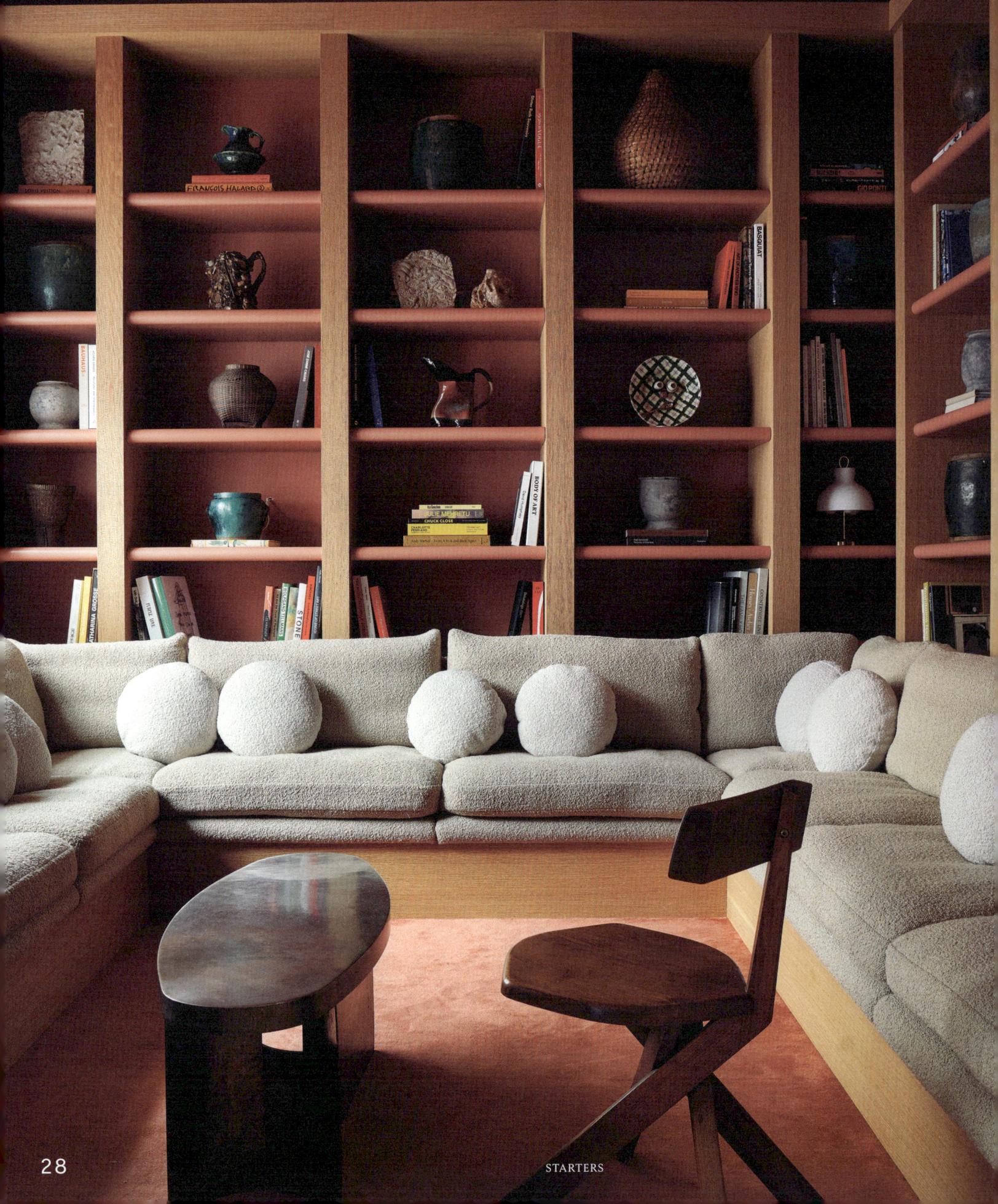

On TikTok, #BookshelfWealth is in the running to be the most talked-about interior design trend of 2024. Contrary to what the hashtag might suggest, the aesthetic goes beyond simply having lots of books. Bookshelf-wealthy homes are comfortable and lived in: As well as a carefully curated and—crucially—read, collection of books, they typically feature expensive built-in bookshelves, art (often hung in front of the books) and sculptures and ceramics acquired on trips abroad.

But TikTok users were not the first to extol the virtue of books in interior design. Grand libraries have been a staple of English stately homes for centuries, dating to a time when merely owning books (never mind having the education and the leisure to enjoy and make use of them) was itself a marker of social class.

Still, the trend seems to have taken root: At the time of writing, one book-forward video from interior designer Kailee Blalock has 1.4 million views. Which begs the question: What, if anything, does a well-presented collection of books say about their owners today?

It's not entirely straightforward. Libraries are not the only part of the home that can be used to show off money and prestige: When it comes to gardens, dining tables, art or even rugs, size matters. And bookshelf wealth isn't only about money—books can be collected cheaply secondhand and over long periods of time.

All the same, as many have pointed out, bookshelf wealth often sounds an awful lot like, well, wealth. The prestige of large book collections comes partly from the fact we associate books with a certain nobility of mind, but large libraries are much more attainable for those with generational wealth, and reading ability and book ownership remains resolutely linked to socioeconomic status.[1] Bookshelf wealth has also been employed as the cleansing fire that refines the tawdry fact of simply *having lots of cash*. A large private library, with its shelves open to visitors' inspection and judgment, implies intellect and, most importantly, taste—that most precious preserve of "old money."

But the literary world is bigger than private libraries, and there must be room for a more enlightened way of thinking about collecting books. After all, not everyone who accumulates books is ostentatiously wealthy; nor are they all more interested in the aesthetics of books than the content. Remember the many writers and thinkers (James Baldwin, for example) who fell in love with reading through the magic of public libraries. Or think of the book collectors who collect solely and quietly for themselves, happy to be surrounded by the work of people they admire. Whatever our books might communicate to visitors, they will always say more to those who have read them.

WORDS
OKECHUKWU NZELU
PHOTO
STEPHEN KENT JOHNSON

(1) In 2023, a study by the UK's National Literacy Trust found that one in eight children who were receiving free school meals said that they did not own a book of their own. This is an increase since 2022, when one in 10 said the same.

29

CULT ROOMS
The Water Museum.

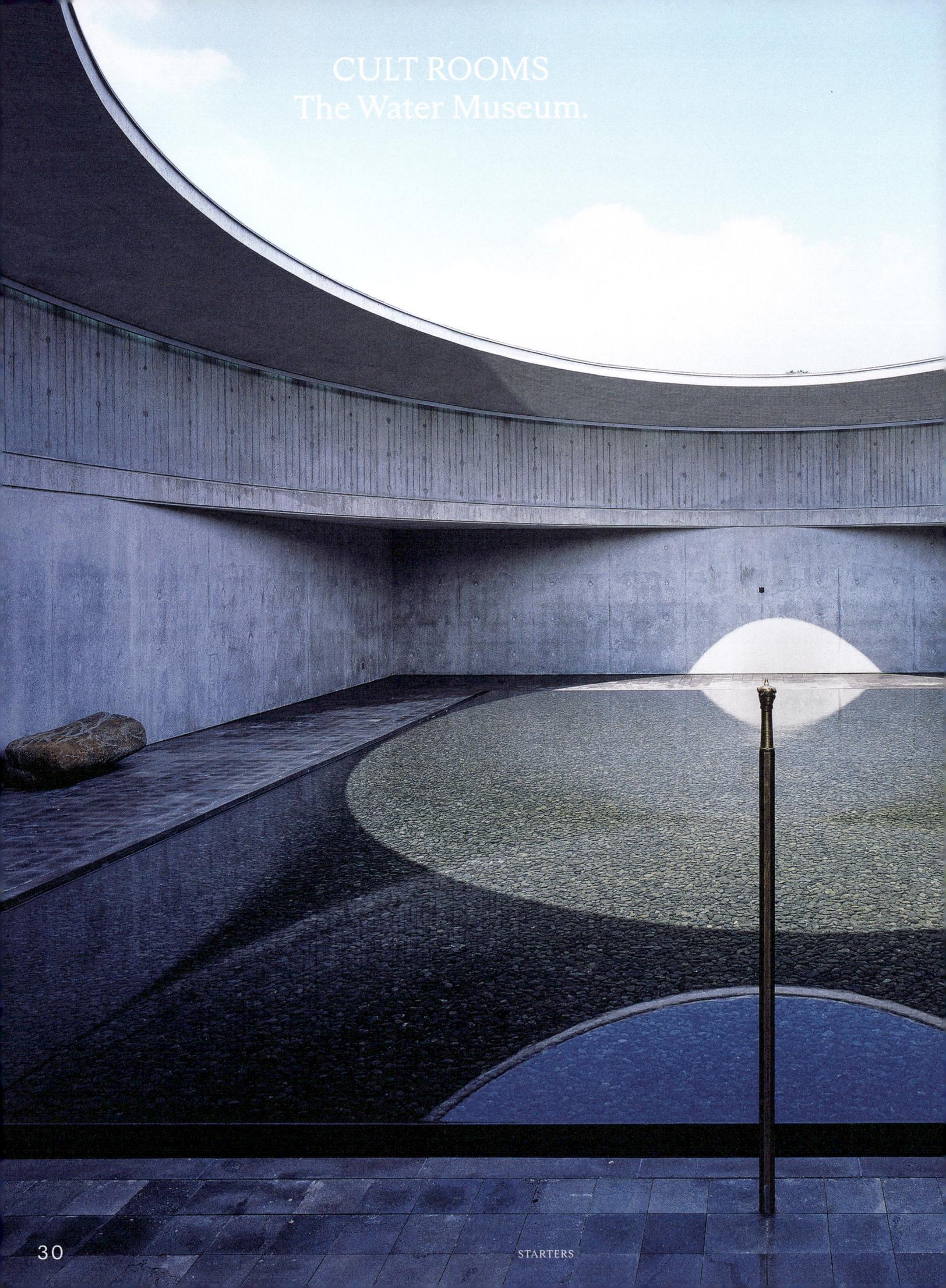

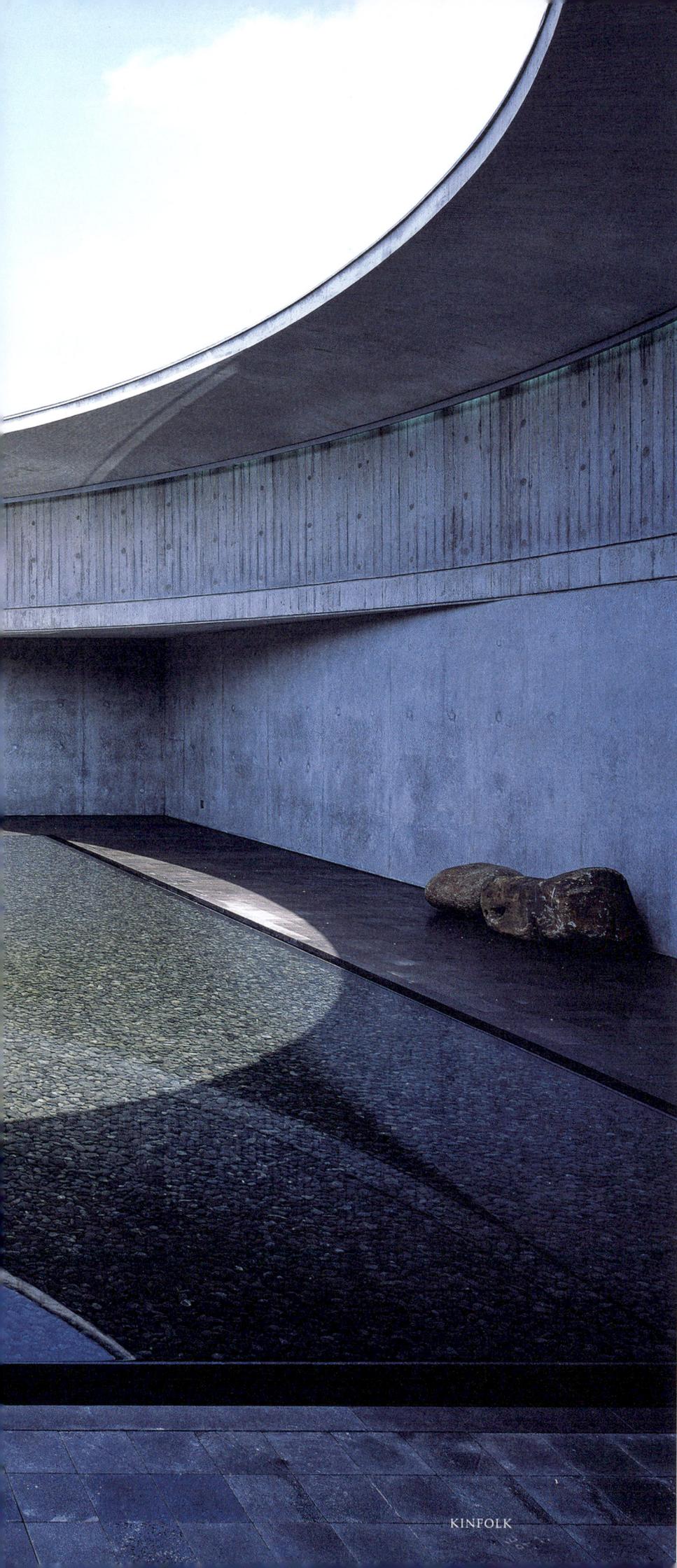

For architect Itami Jun, the windy Korean island of Jeju was a sanctuary. Born in 1937 in Tokyo to Korean parents and raised in Japan, Jun often felt caught between his Korean and Japanese identities. Jeju—located to the south of the Korean Peninsula and west of Japan—became a natural second home and Jun found solace in its rugged landscape.

It was here in the 2000s—the final decade of his life—that he built some of his most beautiful and critically acclaimed works: a golf clubhouse, a hotel, a church and a trio of art museums. Designed for the Pinx resort, the museums are dedicated to the elements that are omnipresent on the island: water, wind and stone. The largest of the three, the Water Museum, was completed in 2006 and is the perfect expression of Jun's belief that architecture should be a medium between humans and nature.

"The real measure of a space," Jun once wrote, "lies not in its function but in its ability to evoke a feeling of vitality simply by one's being there." The Water Museum is one such space. The simple rectangular concrete building is crowned by an oval roof with a huge opening at its center. Inside, a shallow pool of water serves as a mirror for the sky above. Visitors are invited to walk around a stone pathway that sits flush with the surface of the water, contemplating the clouds, the graceful arc of the roof opening and the gently rippling pool. In this church-like museum, Jun's architecture becomes art—a place that will change your way of seeing.

WORDS
ALI MORRIS
PHOTO
YONGKWAN KIM

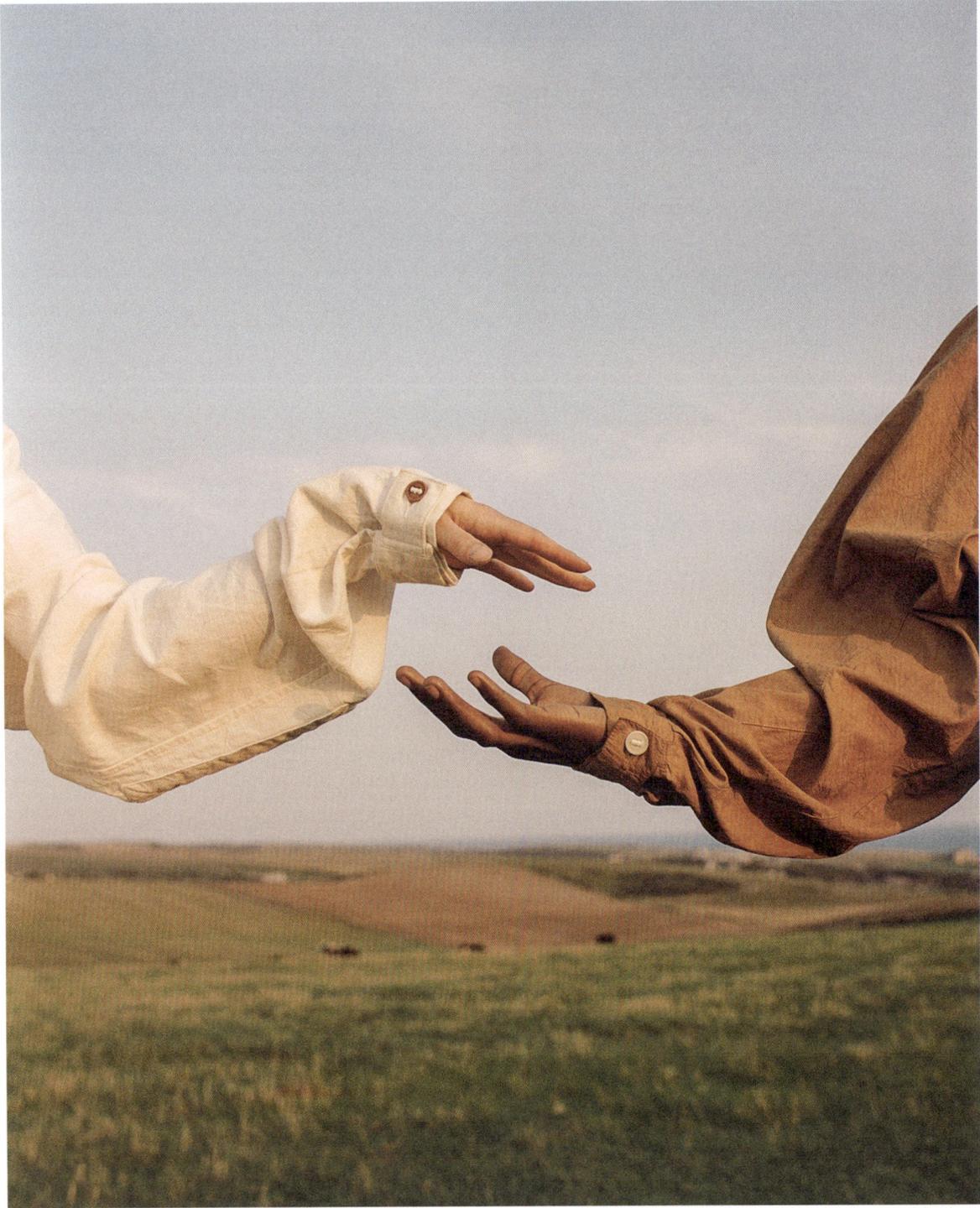

32

WORD: INYEON
In the past, a potential future.

WORDS
MONIKA KIM
PHOTO
HOLLIE FERNANDO

Etymology: Inyeon, Sino-Korean, from the Chinese *yinyuán*, meaning "change," "opportunity," "fate" or "destiny," which in turn derives from the Sanskrit *hetu-pratyaya*—"causes and conditions"—a concept in ancient Buddhist philosophy.

Meaning: It's hard to pin down a definition that conveys every nuance of inyeon. In a broad sense, it can mean fate or destiny, but it can also be understood as karmic affinity or cause and effect. In Celine Song's 2023 film, *Past Lives*, it's described as the idea that people are destined to cross paths because they shared something in a previous life.

In the film, Nora, played by Greta Lee, suggests that inyeon is just "something Koreans say to seduce someone." But the word doesn't necessarily have romantic connotations or mean you believe in reincarnation. For example, you might hear a Korean say, "It must be inyeon," when they run into someone they know at the post office.[1]

There's an old Korean proverb that says, "It's inyeon even if your clothes brush." In other words, even a passing, seemingly random encounter with a stranger is the product of fate. The concept is often symbolized as a red thread that ties two souls together. This thread, woven by an ancestral spirit, will connect you to all of the people you're meant to meet in your lifetime, ending finally at the pinkie finger of the person you're supposed to love forever.

It's important to note that the thread isn't foolproof. Over time, it might become loose or even fall off if you ignore those who are tied to you. But if you are lucky enough to make it all the way to the end and find your soulmate, it's because you have been slowly working your way to each other over thousands of lifetimes—Koreans would say 8,000 lifetimes, to be exact.

So the next time you're at the grocery store and happen to run into that one person you've been trying to avoid, just know that it's not a stroke of bad luck. It's inyeon.

(1) Korean is considered a "listener-responsible" language, meaning the onus is on the listener to understand what words mean based on context. As a word with many nuances, inyeon is open to all sorts of interpretations.

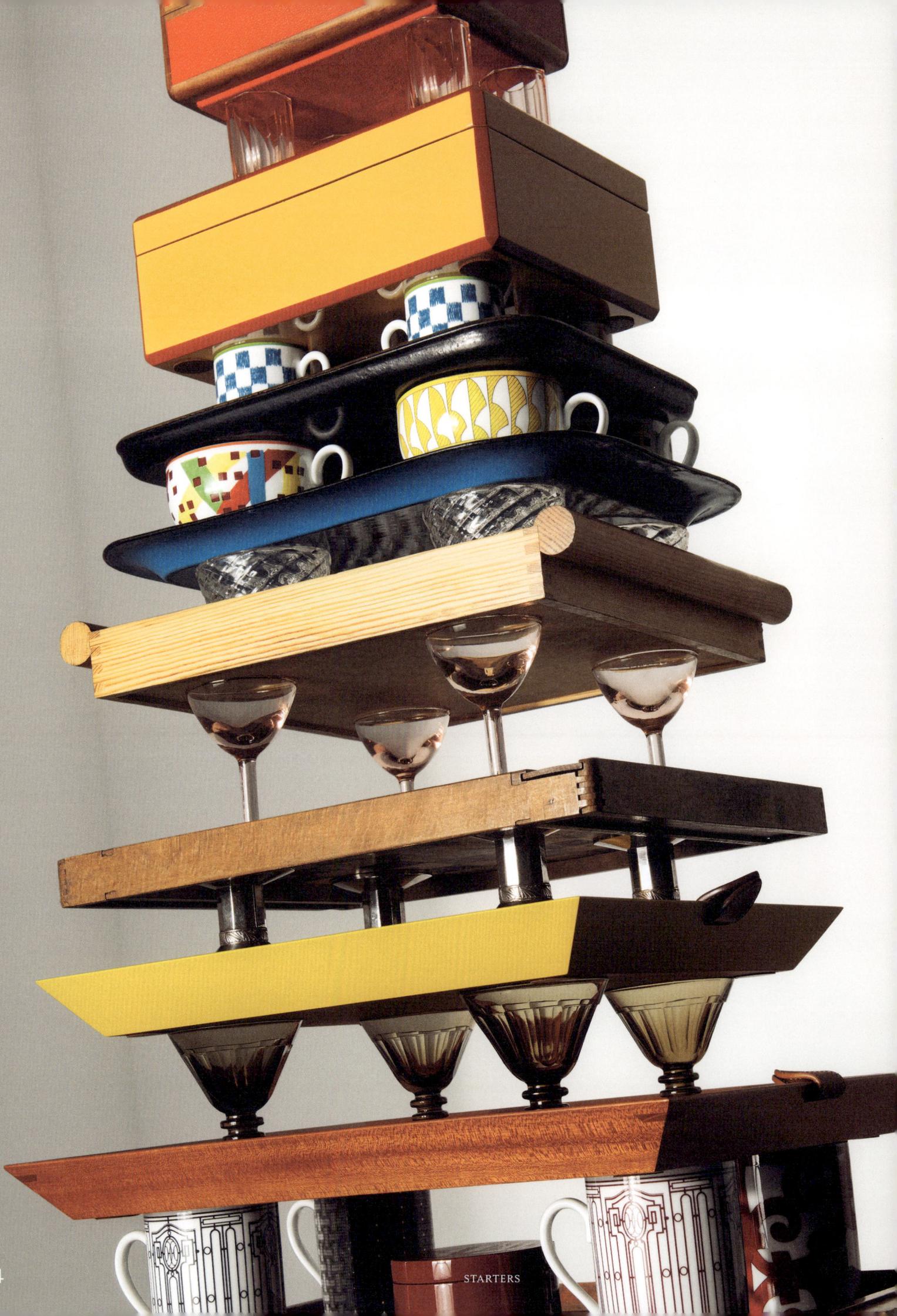

SUBTRACTION NEGLECT
When less is better than more.

WORDS
ROBERT ITO
PHOTO
CHARLY GOSP

Several years ago, the scientist and author Leidy Klotz was building a bridge out of Legos with his son when he noticed that one of the bridge's supports was longer than the other. Klotz began to search for more bricks to add to the shorter end, but his son came up with a faster, more elegant solution: simply removing a brick from the taller end.

"I wouldn't have thought about subtracting if my son hadn't been there," says Klotz, a professor of engineering and architecture at the University of Virginia. It inspired him to take a closer look at what he calls subtraction neglect, the seemingly universal human tendency to favor adding over subtracting when confronted with solving a problem. In Klotz's research, using Legos in varying configurations or grid patterns on computer screens, participants overwhelmingly chose to add things—even when subtracting would have solved the problem much more quickly and easily. Like Klotz, the idea of subtracting simply never occurred to them.

Klotz has several theories on why this might be: From a "building civilization" standpoint, adding things, like food or shelter or roads, is generally a plus. And then there's the matter of ego. When Klotz's subjects were asked to improve a piece of writing, they were more inclined to add an extra line or two, especially when it was their own writing they were asked to polish. "It's like that Stephen King quote about killing your darlings," he says. "Those are your darlings that you've written, or built."

An encouragement to subtract can be seen in various forms of the so-called slow movement, which include calls to reduce the length of the standard workweek from five days to four. The idea is a good one, but as Cal Newport argues in *Slow Productivity: The Lost Art of Accomplishment Without Burnout*, many employees aren't burdened by how many hours they work, but by how much work they're expected to do during them. What we need, Newport says, is to rethink how we measure productivity—as well as to reduce the volume of work employees have to do in the first place.

Like Newport's championing of slow productivity, Klotz's call to subtract requires a fundamental shift in mindset and practice. How do we remember to remove when we're hardwired to always add? Klotz suggests making "stop-doing" lists alongside your to-dos. You can also try something he calls a "reverse pilot" where instead of starting a new project, you try to get rid of something, and see if your organization or your life is better without it. "If you don't like the results, you can always add it back in," he says.

Despite advocating for subtraction, Klotz admits that he's actually more of an adder.[1] "If I had to choose one or the other, I'd probably choose adding," he says. "But we don't have to choose. There's nothing wrong with adding. The problem is when it crowds out even thinking about or considering subtraction as a way to make things better."

(1) In *Subtract: The Untapped Science of Less*, Klotz writes about his failed attempt to use subtraction to renovate the Cape Cod–style house he and his family had recently moved into. Even after soliciting suggestions from students through an "Addition by Subtraction" design contest, Klotz ended up appending a five-room, two-story extension to the rear of his home.

MARY LATTIMORE

WORDS
TARA JOSHI
PHOTO
KOURTNEY KYUNG SMITH

The experimental harpist.

When Mary Lattimore began playing the harp as a child, she never imagined she might one day use it to create spellbinding music and collaborate with indie stalwarts like Thurston Moore and Kurt Vile. Speaking from her home in Los Angeles ahead of a few months of film-scoring and a tour of Europe, she explains how she came to develop her experimental approach.

TARA JOSHI: I read that your mother is a harpist. Is that why you started playing?

MARY LATTIMORE: I started taking basic piano lessons when I was five. When I was 11, my mom said, "Okay, it's time for you to try to play harp." It got more serious as I got older—I was learning to read music and then practicing enough to get to a point where I could actually put emotion in and feel the notes when I was playing them.

TJ: The harp is typically associated with classical, jazz and folk. How did you begin playing in more contemporary and experimental spaces?

ML: I went to a classical music conservatory, but at the time I was really into bands. I worked at record stores and the local radio station, and was going to a lot of shows, becoming part of a music scene. When I moved to Philadelphia, some musician friends were like, "Why don't you add harp to this record?" The hard thing was trusting that I could write a harp part for these records. I got asked by Thurston Moore of *Sonic Youth* to play on his solo record, and everyone was very encouraging. I learned how to improvise and let go of that classical upbringing. From there I started to write my own music.

TJ: Are there misconceptions about your instrument?

ML: It looks intimidating—a lot of my friends say they're too afraid to touch it—but it's a great pleasure to usher someone in to sit and play! It's so fun to mess around and see how it feels under your fingers. People are making less expensive harps, and smaller, more portable ones; it's slowly stepping into the modern world. I still think it has so much potential to be heard in different kinds of music. There are harpists now experimenting with pedals, and I have microphones installed inside mine. Electronics are opening up a whole new world for the harp.

TJ: Why do you think the harp embodies something otherworldly?

ML: Growing up around the harp, I didn't really have a sense of its wonder until I got older and I was incorporating it into these unusual settings, playing for people who had never heard it played or seen one up close. It might be something to do with the sound of fingers on strings—you can hear this ancient human touch in each note. The harp is used in music therapy, care homes, hospices. People tell me they've used my music in psychedelic therapy, or when they're having a baby, or in mourning. A lot of harpists play for patients in hospitals. There is something about it that's really healing and resonant in this mysterious way.

Epitaphs—text carved into gravestones to honor the dead—have evolved over the centuries with changing religious and cultural beliefs. What once implored those passing to "remember this" now say "remember me."

In 18th-century America, evocations of skulls and crossbones reflected a bleak Puritan picture of the afterlife. Messages repeated throughout burial grounds urged the bereaved to repent and prepare for judgment with gravestone tympanum-top refrains of "O! Relentless Death!" and "Memento Mori" ("remember you must die").

But as Victorian ideals took hold in the 1800s, so did a romanticized view of mortality. Cherubs, flowers and bird symbology came to replace skulls, and cemeteries became landscaped parks where families picnicked among the dearly departed. Epitaph imperatives were softened to phrases like "Budded on earth to bloom in heaven," and "Gone home."

As life expectancies lengthened and engraving technology improved, epitaphs became more celebratory, reflecting the unique personalities of the deceased (as with hypochondriac B.P. Roberts' famous "I told you I was sick"). Alongside increased customization, an outlier emerged and, almost 30 years after its inception, went viral: headstone recipes.

The oldest example found so far dates to 1994 and features Christmas cookies; the trend spans over 20 burial monuments across the globe—from no-bake chocolate oatmeal cookies in Alaska and nut rolls in Israel to chicken soup in New York. The memorials all top the graves of women, signifying a reclamation of matrilineal legacies (a century prior, most were solely referred to as "wife of" on their headstones). They're also a cross-cultural reflection of how we cook to comfort those in mourning, and a testament to food as a unifier in both celebratory and grief-stricken moments.

Researcher Rosie Grant first shined a spotlight on these unique epitaphs through her recreations of recipes from gravestones across America. The project, which began in 2022, has garnered over eight million likes via her TikTok account @GhostlyArchive. She sees the recipes as gifts that keep the deceased's memory and heritage alive and conjure happy recollections of our own lost loved ones.[1]

In this way, our ancestors are no longer defined by a collection of fearful phrases chiseled into stone: Instead they pass down their culinary traditions before joining us at our kitchen tables, reminding us that life and death are the inseperable elements of a feast prepared by both the past and present.

(1) Another of Grant's research interests includes limb graves, which are burial plots for amputated body parts. In some instances, the owner of the buried body part was never interred alongside their amputated limb.

GRAVESTONE COOKIES
On recipes to remember.

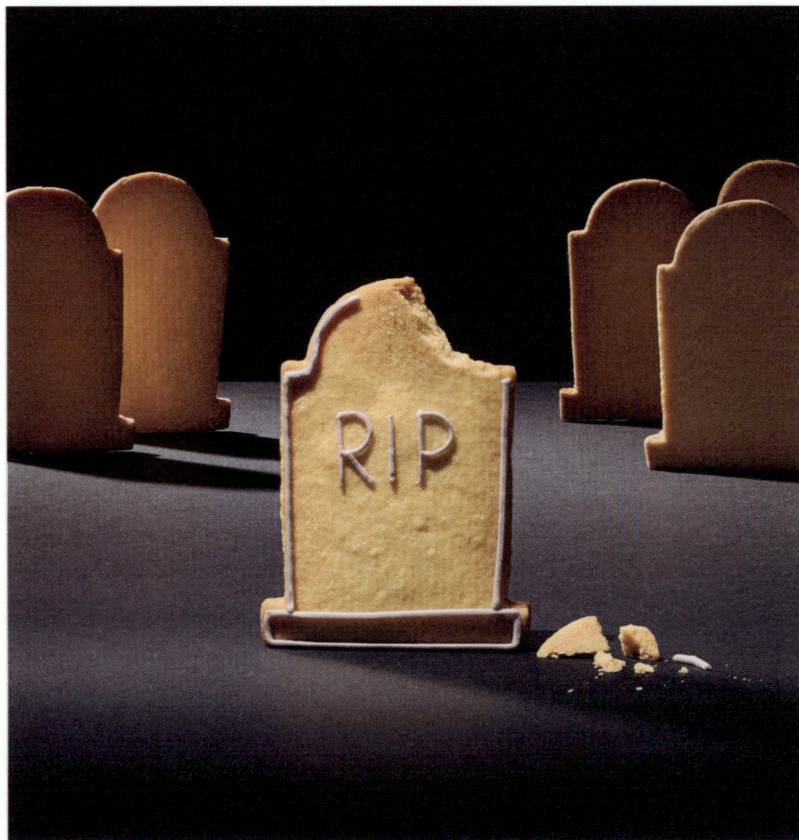

WORDS
KATIE CALAUTTI
PHOTO
AARON TILLEY

Food Stylist: Sarah Hardy

MURPHY'S LAW
A musing on misfortune.

As with anything sufficiently universal, the origins of Murphy's Law—which broadly states that anything that *can* go wrong *will* go wrong—are disputed. No doubt people have been expressing something similar for as long as there has been language and our cave-dwelling ancestors were wondering why it always rained on their woolly mammoth barbecue. Still, we know that the Murphy bit was coined by an American aerospace engineer, Edward A. Murphy Jr., after a mishap during the testing of a rocket sled in the late 1940s. As he said: "If there are two or more ways to do something and one of those results in a catastrophe, then someone will do it that way."

The inference—that there is human agency at work in the catastrophe—is subtly different from how Murphy's Law is more commonly used, which has a more fatalistic sense. The classic example is that a piece of toast will always fall on the buttered side. In this vision, all human endeavor is a Sisyphean struggle against a universe that wants to ruin your breakfast.

There may be an element of pessimistic selection bias at work here: We remember the things that go wrong more clearly than those which pass without incident, and it's always more amusing to talk about disasters than triumphs. But various experiments have been performed to put Murphy's Law to the test. One study concluded that a standard piece of toast, standardly buttered and dropped from a standard kitchen table, will tend to complete one rotation: Murphy's Law turned into simple physics. Murphy's Law also seems to echo the second law of thermodynamics, which says that entropy will always increase. No matter how organized you might be, a sock drawer will inevitably move toward disorder over time . . . and you *will* end up with mismatched socks.

If there is a lesson to be taken from Murphy's Law and its cousins, such as Sod's Law, it's that a little humility and forgiveness never go amiss. In copyediting, there is Muphry's Law, which states that if ever you criticize someone's proofreading, you will make your own mistakes in the process. And of course, when things go wrong, it may not be through malice or incompetence, but simply a natural order asserting itself. As frustrating as Murphy's Law can be to encounter (especially if you have a white carpet), it is ultimately proof of the fact that we are all in this together, doing our best as we travel through a cold and uncaring cosmos.

WORDS
ED CUMMING
PHOTO
SERGIY BARCHUK

THE MAGIC OF MEALTIMES
A guide to getting the family to the table.

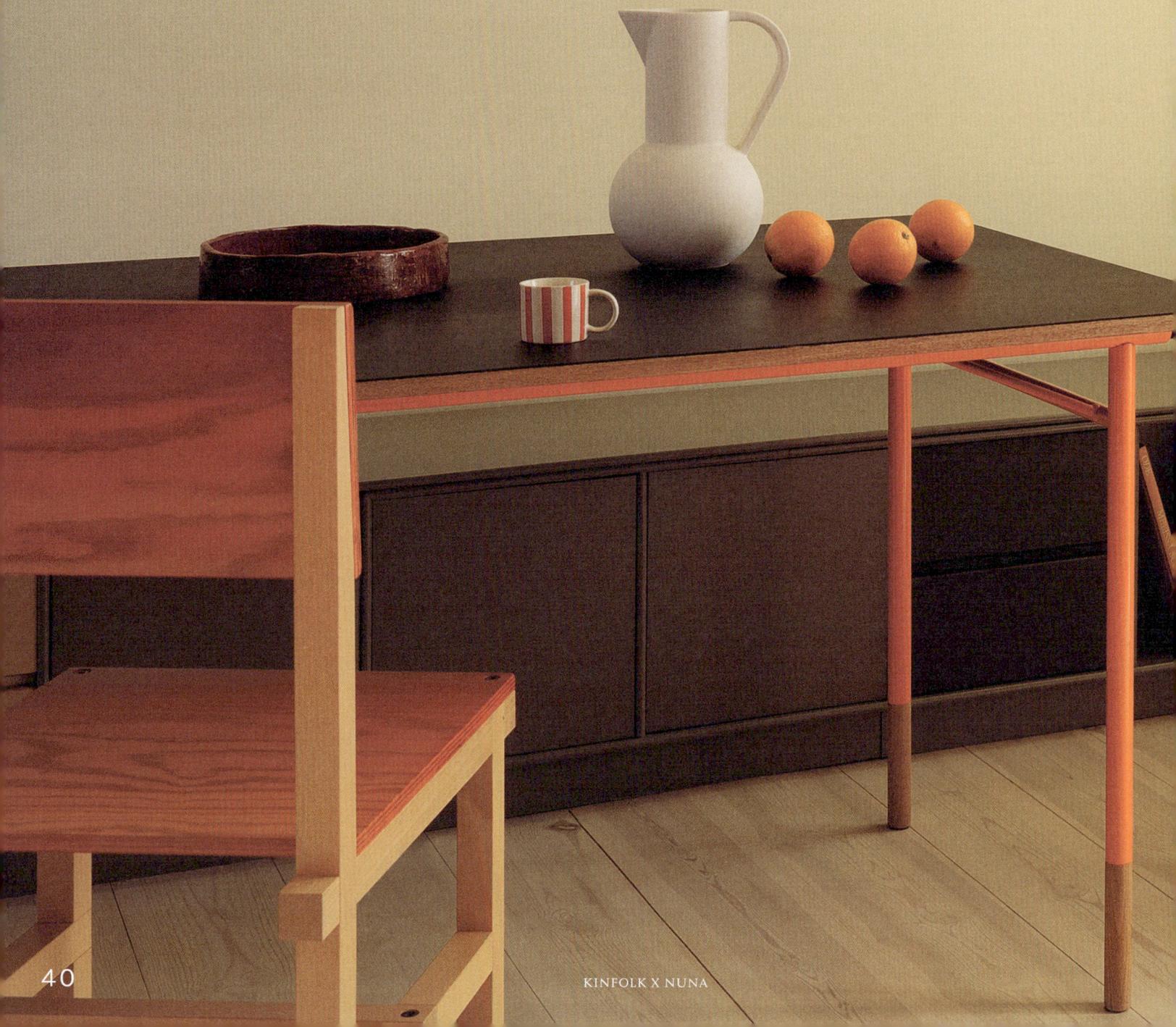

Stylist: Tine Daring

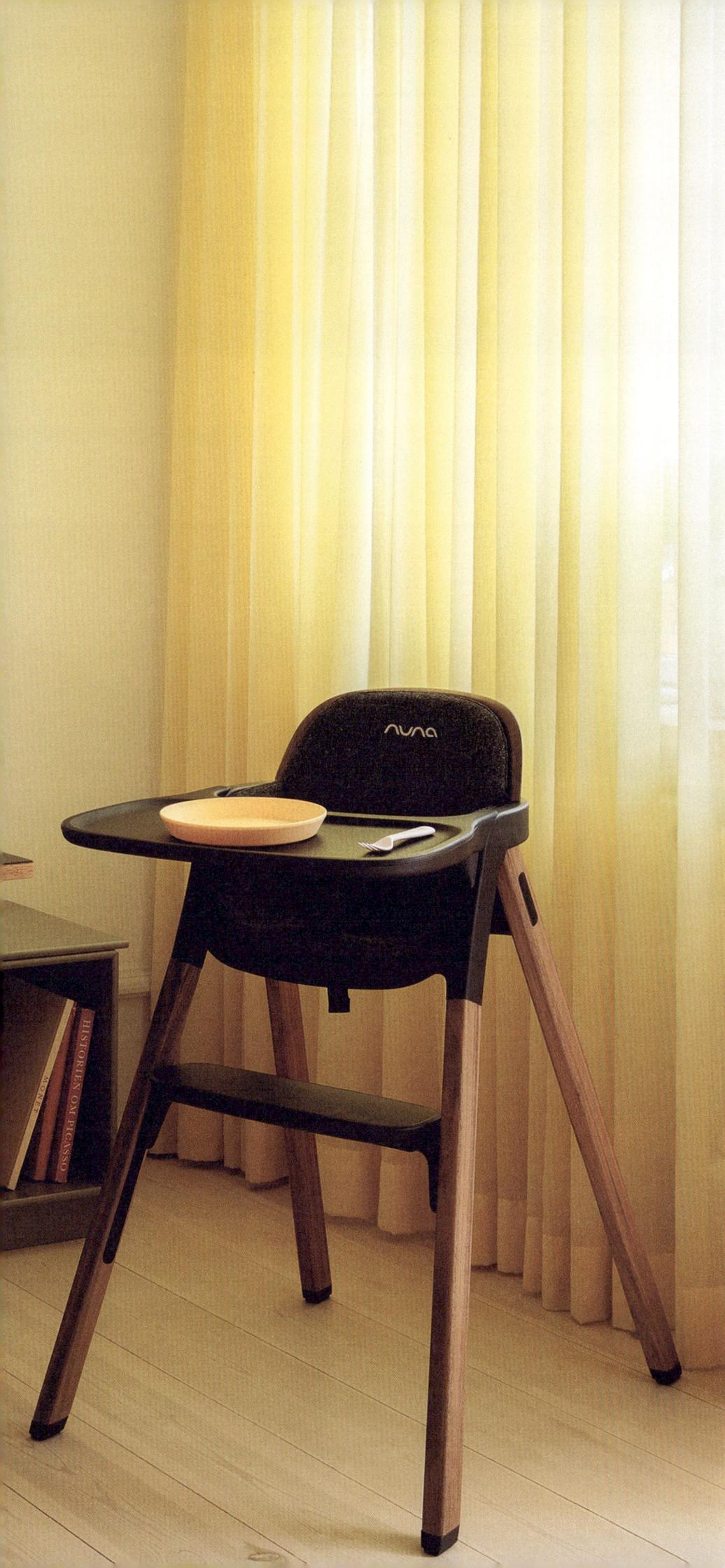

The American developmental psychologist Diana Baumrind gained international recognition in the 1960s for her research on parenting styles. According to Baumrind, the essential components of a happy home are structure and warmth, provided by a parent or guardian who takes pride in teaching their child the importance of good behavior while providing all the love and attention they need to build self-esteem.

Contemporary research has since backed that up—children raised in this way fare better in school, enjoy better mental health and are more likely to stay out of trouble than their peers. As any parent knows, creating the ideal conditions in which your children can thrive while juggling the demands of modern life is not always easy, but according to the psychologist and best-selling author Lisa Damour, shared mealtimes are a good place to start. After all, gathering around the dinner table is often the only time in the day when all family members can be together in one place—providing both a regular structure for meaningful conversations and familial warmth. Here, young children can be taught table manners, healthy eating habits and how to use cutlery, but it's also a place that allows you to bond as a family and share the small moments that can turn into lifelong memories.

Getting infants to the table is something that Nuna's BRYN highchair helps to integrate seamlessly into daily life. The wipeable tray can be detached, allowing children to be brought into the heart of the meal, and its modular design means it can be as flexible as you need it to be. The chair does not require any tools for assembly, and the easily adjusted harness and footrest allow it to evolve as your child grows, becoming a consistent part of mealtimes from the time that they can sit up unaided to around six years old.

The BRYN's clean lines and accents of high-quality wood—available in either black walnut or maple—mean that the highchair will also sit harmoniously in any design-conscious home, leaving you free to focus on the joy of parenting. While "planned meals are just one of many routine interactions that can weave structure and warmth into the fabric of family life," Damour writes, they are perhaps the most consistent way, as a family grows and changes, to create beautiful memories for both parent and child to treasure for decades to come.

This feature was produced in partnership with Nuna.

WORDS
BENJAMIN DANE
PHOTO
CECILIE JEGSEN

41

THE PERFECT PAIR
A study of the humble sock.

On the Piazza di Santa Chiara in Rome, there is a small, unassuming shop that has been in business since 1798. Over the centuries, Gammarelli has become the prime destination for the Italian clergy, who come to buy their chasubles, surplices, albs and cinctures. It's also where the pope has traditionally sourced his socks.[1] In recent years, Gammarelli has taken on something of a cult status—selling not only to the ecclesiastical world (black for priests, purple for bishops, red for cardinals, a special white knee-high for the pope) but also to a wider public that has cottoned on to the pleasures of slipping on their luxurious socks.

A sock is a curious garment. Often, it's an afterthought—the domain of multipacks and three-for-two offers, bought in uniform neutrals—that protects the foot without requiring much decision-making. Occupying a small amount of sartorial real estate, it is less attention-grabbing than a shoe but more necessary year-round than the other so-called "soft" accessories like gloves and scarves. If the accompanying trousers or robe is long enough, it will only really be glimpsed when sitting down. Sometimes, if, like the pope, you're indulging in a more deluxe and floor-length look, its primary benefit may be private—only for the silk-toed wearer. A shoe is for you, but a sock is for me, if you will.

Yet if foregrounded, the sock's limited presence can also be its visual strength. With bold colors, lavish fabrics or delicate patterns, a flash of ankle can upend an outfit or rebalance it, shifting the point of focus. Think David Hockney's mismatched color-clash stockings, or Princess Diana's chunky white sports socks worn with equally chunky sneakers. The challenge is to tread the delicate ground between novel and novelty, enhancing an outfit without lapsing into absurdity.

The wave of lay-person interest in Gammarelli perhaps hints at a renewed appreciation for the humble sock. And with the shift to "shoes off" policies for houseguests in the West, the sock could be entering interesting territory. Liberated from the shoe, what kind of statement could a sock make? It might feel a little undignified, but the informality of showing your socks could be something to play with: Casual but cozy in cashmere, or surprising in a green and purple patterned Dries Van Noten Tabi pair. Just watch out for rough floorboards, and other potential snags.

WORDS
ROSALIND JANA
PHOTO
ZHENYA & TANYA POSTERNAK

(1) In 2007, when he was the pope, Benedict XVI was voted "Accessorizer of the Year" by *Esquire*. The Vatican's official daily paper responded: "The Holy Father is not dressed by Prada, but by Christ."

43

Back in 2022, a spate of articles introduced the wider world to the term "doppelbangers." A play on "doppelgänger," the word has long been used by members of the LGBTQ+ community to describe couples who resemble one another. Since then, countless articles have pointed out "celebrity couples that look like siblings" and a popular Instagram account is dedicated to asking whether two people standing together in a photo are "Siblings or Dating." (It's harder to tell than you think!)

It's not a new phenomenon. People have long mused that couples often look alike. A 1987 study conducted by the University of Michigan even set out to prove the phenomenon, positing that the longer a couple was married, the more likely it was that they would have begun to look the same. Different academics have expounded on that theory since, suggesting that couples' features begin to merge over time due to a variety of factors, like hobbies, location, happiness, fashion choices, immune systems and age.

But in 2020, a study out of Stanford University found that, in fact, couples don't start to look more alike as they age. Instead, their research suggested that we tend to be attracted to people who already look similar to us, whether that's because they're in the same general level of attractiveness, same friend group, profession or local region.

Michal Kosinski, a computational psychologist who co-authored the Stanford study, says that it's natural for people to seek out the simplest explanation to a question, but that in practice, the reason couples tend to look alike is complex and a bit more socially restrictive. "People prefer to hang out with—and marry—similar others," he explains. "We prefer to listen to and read books by similar others, too, and when we say similar, we mean virtually everything, including age, gender, political orientation, personality, intelligence, religious views, affluence and so on... The same people end up living in similar places, going to similar schools and bars, and going to the same dating websites, where they choose to meet people who are just like them."[1]

And as to why you don't see more elderly couples that look wildly different? Kosinski has another fatalistic answer, saying that "similar couples tend to survive longer." Dissimilar couples—ones with disparate hobbies, for instance, or ones where one partner might live a more unhealthy lifestyle—tend to "disappear from the sample" over time, meaning that if you're a couch potato and you match with someone who's into base jumping, you might just want to keep on swiping.

(1) Research has shown that in addition to socioeconomic backgrounds, politcal views and hobbies, couples were also more likely to share a similar number of previous sexual partners and even whether they had been breastfed as a baby.

DOUBLE LIFE
Why opposites don't attract.

WORDS
MARAH EAKIN
PHOTO
OGHALÉ ALEX

Imagine you've set aside the time to bake something special—you've preheated the oven and started to mix the ingredients when you realize you're an egg short. Once, it would have been the most normal thing in the world to pop over to your neighbors and ask if they had one to spare. Today, not so much. If you live in a big city, you might not even know your neighbors' names and in any case, all manner of tech "solutions" have sprung up to save us from ever having to talk to each other. Why bother asking someone for a favor when you could have a carton of eggs delivered to your door in under 15 minutes?

Well, there might actually be a good reason, and not just because it could save your cake. In our increasingly atomized societies, asking for favors gives us a valuable connection with the people in our community. It can strengthen social bonds and provide an opening to forge new friendships. After all, favors are about more than the act itself. When someone picks you up from the airport, they don't just save you the bus fare; they give you the comfort of their presence on the ride home, a feeling of rootedness and the knowledge that somebody took time out of their day to make yours a little better. You might see it as a small act of care.

Need to ask for a favor? Here are some tips that might come in handy. First, judge the scale of the request appropriately. Go ahead and ask a total stranger for directions or a glass of water, but if you want $500, or a kidney, it's advisable to choose somebody you know well. When you've selected the right person, be polite but direct. It's fine to say: "I have a favor to ask," but give some context to your request, explaining why you're asking *them* in particular (you could employ a little tactical flattery at this juncture). Be sure to give them an easy way to refuse, and if they do say no, accept it courteously. Get it right, and you might end up with a new friend—somebody to lean on when you need something a little more important than a single egg. Just be sure to do the same for them when the time comes.

WORDS
TOM FABER
PHOTO
CHARLIE ENGMAN

HOW TO ASK FOR A FAVOR
Guidance on good deeds.

WHAT ARE YOU WORKING ON?

WORDS
FEDORA ABU
PHOTO
ALLEN DANZE

Fashion designer Evan Kinori.

He's one of the hottest names in American menswear—*GQ*'s editor in chief picked him to create his suit for the 2024 Met Gala—but Evan Kinori has little interest in being in the thick of the action. When we speak, he's in New York for an exhibition of his new furniture line at an art gallery on Broadway. But soon enough, he'll be returning to his stripped-back studio-meets-store in San Francisco's Mission District. There, heading up a team of five, Kinori creates workwear-style garments in small runs and from natural materials. Nine years in, with a cult following among fashion insiders, it's clear that going his own way is working out just fine.

FEDORA ABU: Would you describe yourself as a fashion designer, or something broader?

EVAN KINORI: For me, it's all about working with materiality, proportion, form, scale and color. You use the tools you have at hand and establish a language or a way of working. It could be the cup you drink coffee out of or the furniture that you sit on—all these things can be thoughtfully designed and made with care; I just discovered it through clothing first.

FA: Was it always your intention to do things differently?

EK: I've been trying to make the work that I like and the things that I want to wear. I'm not that untraditional in the schedule—I show two wholesale collections a year in Paris. But I request that things don't get put on sale and I push back on making early deliveries. It takes a lot of time to make a quality product, and to be rushed or to put some kind of expiration date on it is really fucked up to me, honestly. But it's not worth changing the calendar of when we show and deliver clothes. I mean, there are seasons, and we need to abide by nature.

FA: What can we expect from your AW24 collection?

EK: I'm pretty consistent: I only work with natural fibers; there's a color palette that I hang out in. It's more iterative. Increasingly now, I try to get closer to where fabric is developed and learn more about that process. It's about trying to make a better and more special product by any means necessary.

FA: Is the furniture you exhibited recently part of the plan for the brand's future?

EK: The furniture came out of the store renovation three years ago, when a carpenter friend was helping me with the built-ins and wooden pieces. It is more of an open-ended medium, and I felt like there was more space to play than in fashion. But it also begged the question of whether anyone else would like the furniture. If not, I'm happy just to have answered that question and I can keep making it quietly on the side for myself.

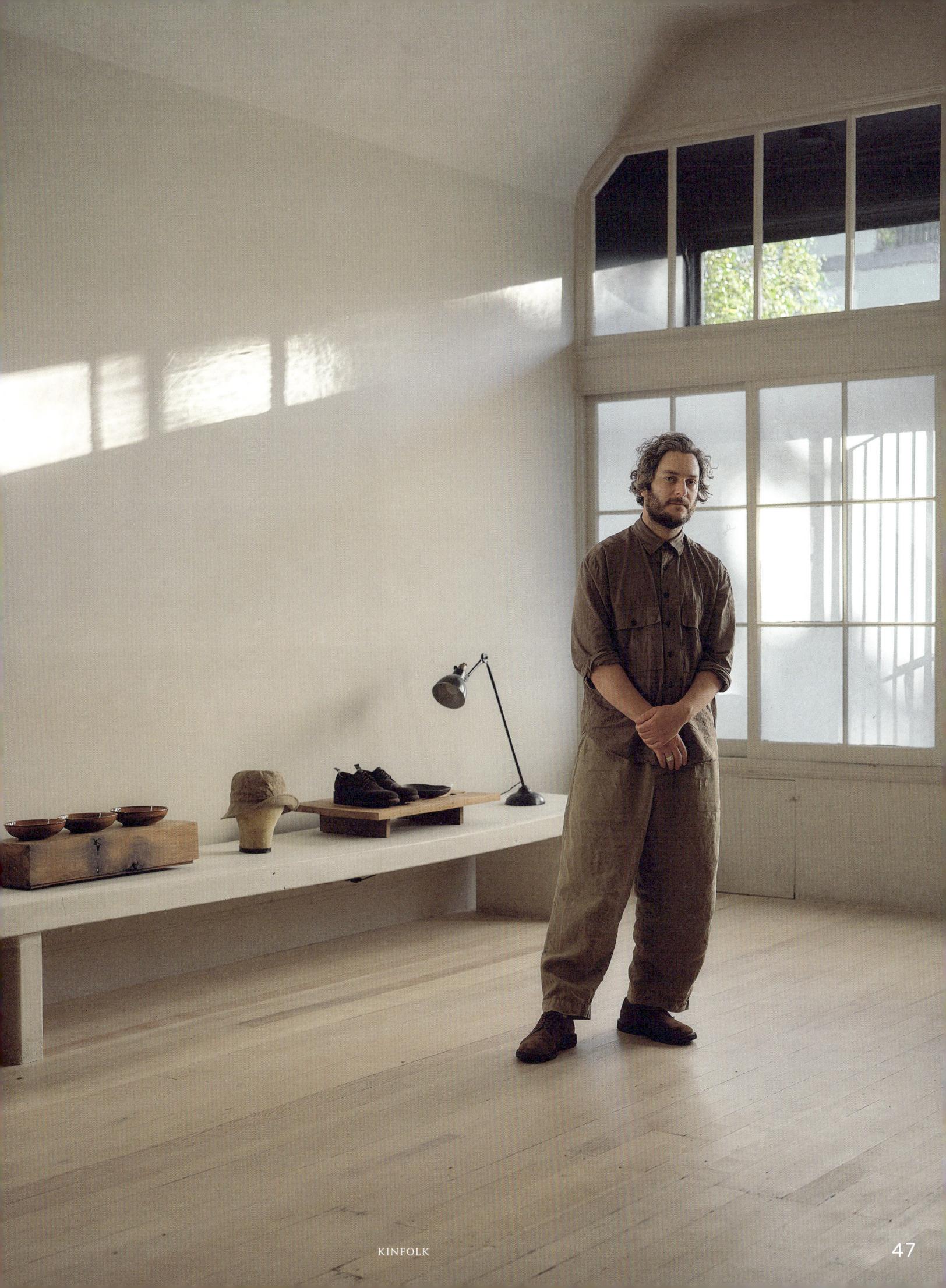

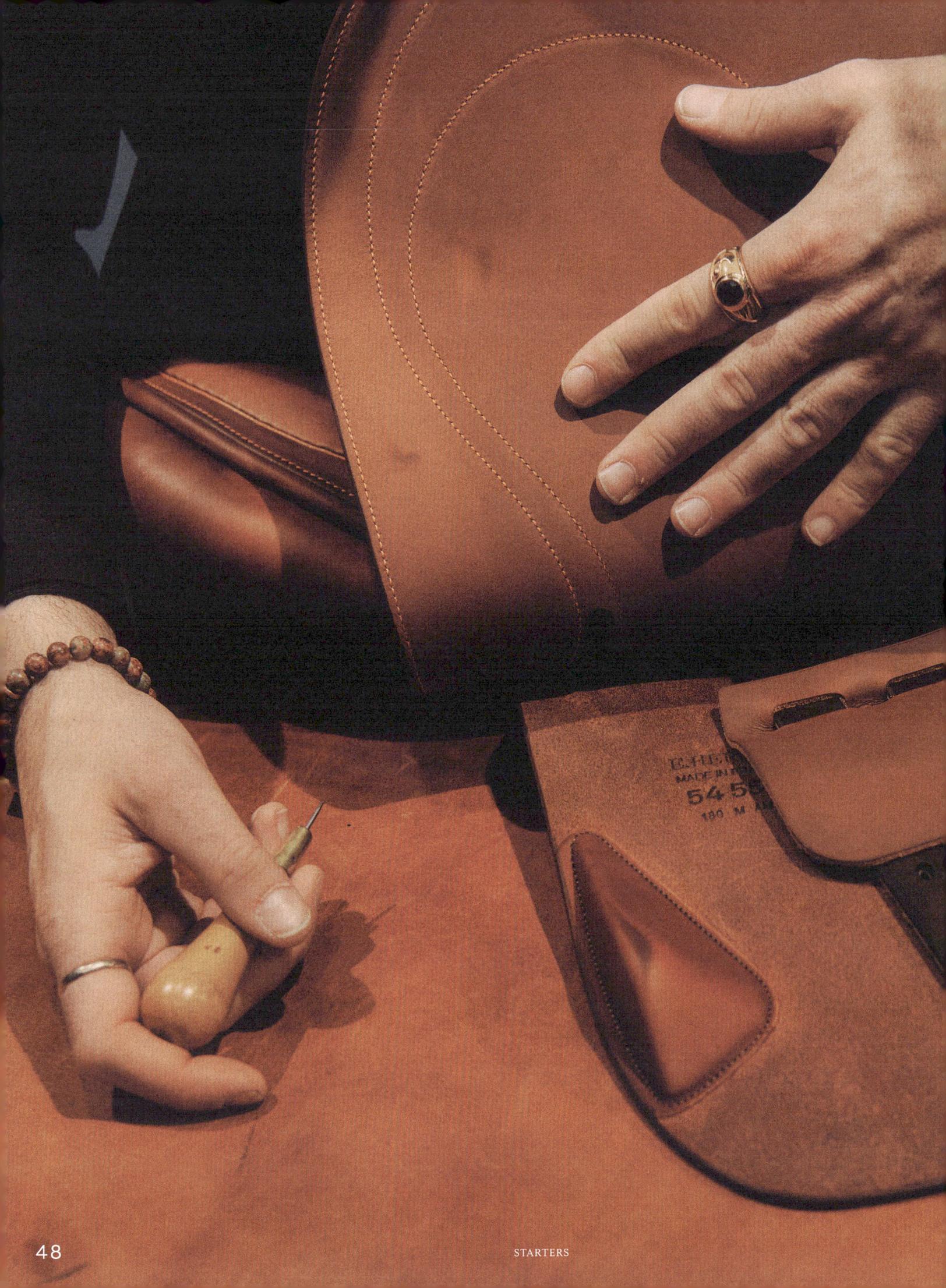

OBJECT MATTERS
Back in the saddle at Saut Hermès.

WORDS
GEORGE UPTON
PHOTOS
DUDI HASSON

The design of the saddle has evolved somewhat in the 3,000 years since people began using them to ride horses, but the purpose remains largely the same. "A saddle is the *trait d'union*, it's what unites a horse and the rider," explains Chloé Nobécourt, the director of the equestrian métier, the saddle-making department, at Hermès. "You can ride without a saddle if you're skilled, but it won't be comfortable for the rider—or the horse—for long. A saddle distributes weight, but really, the purpose is to create a connection, the perfect harmony, between you and your horse."

Hermès has a long history of exploring the changing bond between human and horse. Though perhaps better known today as a luxury fashion house, it began in 1837 by making leather harnesses for the carriages of European nobility. When the house started producing saddles in the mid-19th century, horses were still essential for industry, war and transport—some 80,000 are thought to have lived in Paris in 1900. But with the advent of the car, the saddle needed to evolve to reflect how horses were being used for sport and leisure. In response, the equestrian métier—which has been based on the top floors of the Hermès store on rue du Faubourg Saint-Honoré in central Paris since 1880—pioneered the design of the sports saddle.

Today, saddles used in equestrian competitions are usually "English saddles" and feature a design specialized to a particular discipline. Nobécourt gives the example of those seen during the show jumping spectacles at Saut Hermès, the international event hosted each spring by Hermès in Paris. Riders compete to cover a set course of obstacles in the shortest amount of time. "You need to get out of the saddle to follow the horse as it jumps, and so the flap is advanced," she says, referring to the position of the leather that hangs either side of the seat and that, when extended forward, allows the rider to adopt the correct position to jump with the horse. "Ultimately, a good saddle is one that you forget you're riding. Sometimes you get the sense that the horse's legs are almost your own. It's an incredible feeling."

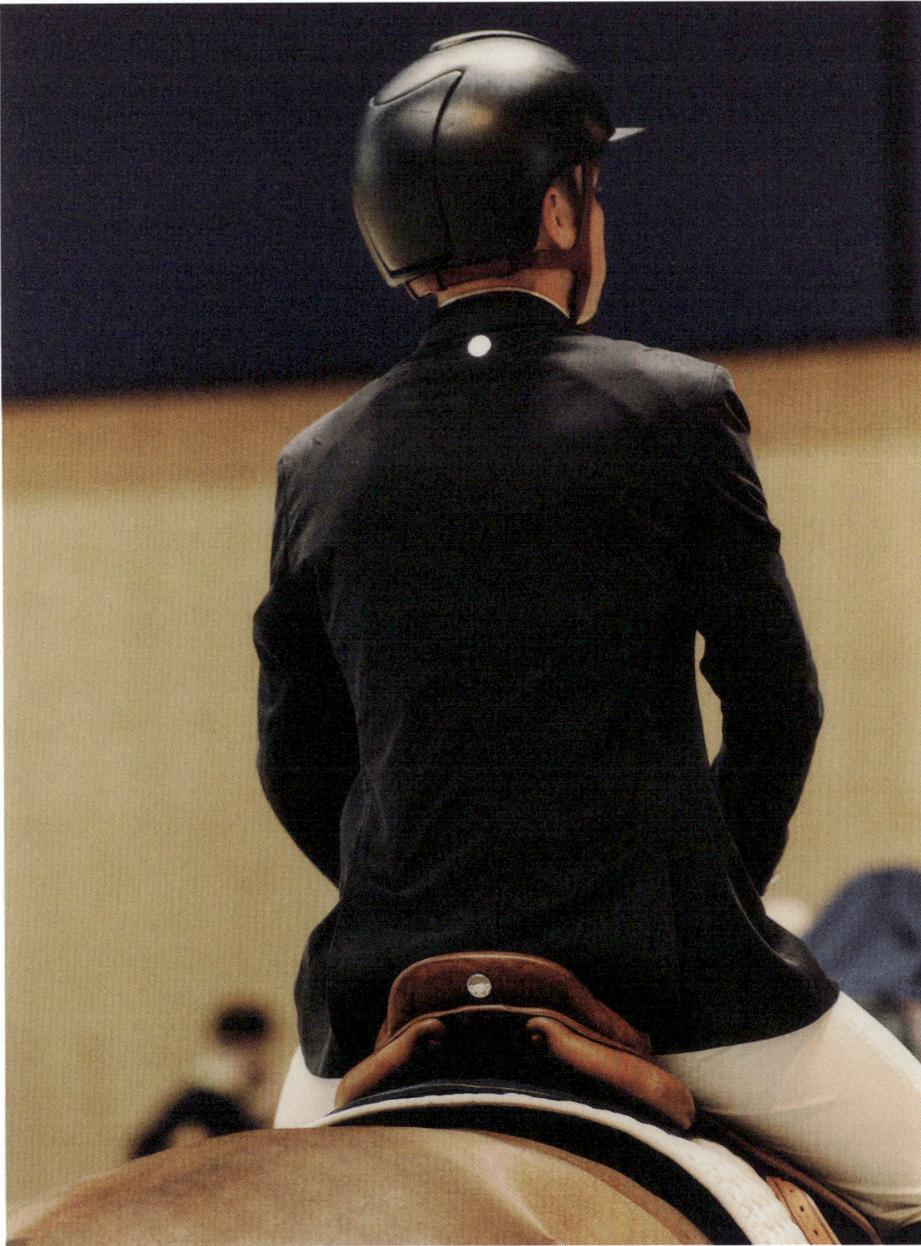

To achieve this sensation, saddles need to be made bespoke to rider and horse. While their design continues to evolve to meet the needs of both riders and horses, there is also much that has stayed the same. After experimenting with new materials like carbon fiber for the saddle tree, the rigid structure beneath the leather around which a saddle is built, the house returned to beechwood. "So far we've not found something that we believe is good enough to replace it," says Nobécourt. They also continue to use the saddle stitch, which involves using two needles, each attached to one end of a thread, that loop back and forth in a mirror image of one another—a process that is stronger and more flexible than a standard stitch and which cannot be replicated by a machine. "The notion is that if one thread were to break, which could happen—there's a lot of friction on the saddle—the other thread will keep the saddle in place. There's nothing better for durability and reparability."

It takes 35 hours to make a saddle in this way, from selecting a piece of leather without imperfections (calf leather is preferred, as it's more comfortable and provides more grip for the rider when they jump) to oiling, to nourish the leather. As is tradition, the whole process is done by one craftsperson to ensure quality and consistency. There are cheaper ways to make a saddle—using synthetic materials instead of leather and wood, for example, which has the advantage of being lighter, easier to maintain and adjustable. But those used in competition, where the bond between horse and human needs to be intrinsic, still rely on tradition, craftsmanship and expertise. "There's a quote I love by [pioneering French cavalry officer] Colonel Danloux: 'The cult of tradition does not exclude the love of progress,'" says Nobécourt. "Or in other words, as our artistic director says, there can be no creation without memory."
—

Features.

Words
TARA JOSHI
Photos
LUKE LOVELL

A folk troubadour for the digital age.

MUS

Styling:
TANA GROSSBERG

TÆA

Mustafa Ahmed is no stranger to tragedy. Since childhood, the Canadian-Sudanese artist has used his work—be it piercing adolescent spoken-word poetry or plaintive 'hood folk lullabies—to deal with the grief, poverty and systemic injustice he experienced coming of age in the shadow of conflict; whether it's what his family left behind in Sudan, or what he witnessed growing up in Regent Park, one of the oldest housing projects in Toronto.

So perhaps it's not surprising that in conversation the singer, songwriter and poet—formerly known as Mustafa the Poet, now going simply by Mustafa—seems far more enthusiastic when talking about the bigger picture than he is when talking about himself. As he says on a phone call in late May: "Community, to me, is the thing that keeps me alive."

As a kid, Mustafa experienced the loss of neighbors and peers to both structural and direct violence; as he got older, he began to lose close friends. His debut EP, 2021's arresting *When Smoke Rises*, memorializes them, creating space for his bereavements. Love and rage and mournful pleas are woven through the record, which melds elements of North American and Sudanese folk sounds.[1] The EP was a success internationally, but little changed in Mustafa's life in Toronto. In July 2023, his older brother, Mohamed, was murdered just streets away from their home. "They killed my brother in the very community I gave my life to," Mustafa wrote on social media at the time, before going into a period of isolation.

"I have a very complicated relationship with my 'hood," he says above the hubbub of the café he's sitting in. These days, he's mainly based in Los Angeles, though when we speak he's in the UK, where he's been working. He likes London, he says, because it's like Toronto "without all of the weight."

The need for distance from that weight is understandable after everything he has been through, but none of this means the 28-year-old is fully turning his back on where he comes from. "After my brother's murder, I honestly decided that I was never going to return to the community," he says. "I don't think that I ever will. But even still, my responsibility as an artist from the beginning was always to do everything in my power to preserve what is being lost. This community is being gentrified, my friends and family are dying."[2]

For all that this is deeply personal work, Mustafa is clear for the need to connect it to the wider world, rather than viewing his own losses in a vacuum. When he emerged from isolation following his brother's death, Israel was in the full throes of its assault on Gaza following the October 7 attack by Hamas. "I think of the amount of people that are being lost around the world," he says. "I've felt a lot of connection to the brothers and the mothers [in Gaza]. Those people are surviving being murdered in such a senseless and callous

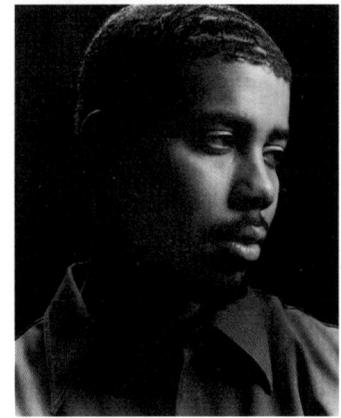

(above)
Mustafa wears a shirt by
JIL SANDER.

(opposite)
He wears a hat by NAMACHEKO
and a tank top by MARNI.

(previous)
Left: He wears a coat by BALENCIAGA
and a shirt by MARINA YEE.
Right: He wears a jacket by
MAISON MARGIELA.

(1) Mustafa sampled Sudanese musician Abdel Gadir Salim on the track "Imaan" and has cited fellow
 Canadian folk musicians Joni Mitchell and Leonard Cohen as inspiring his songwriting.
(2) Regent Park has undergone a $1 billion revitalization project over the last two decades. In May 2024,
 the last remaining buildings from the original 1940s urban plan were demolished.

Production.: CAMP Productions. Producer: Alicia Zumback. Production Designer: James Lear. Groomer: Ghost (Jessica Pudelek). Studio: Edge Studios.

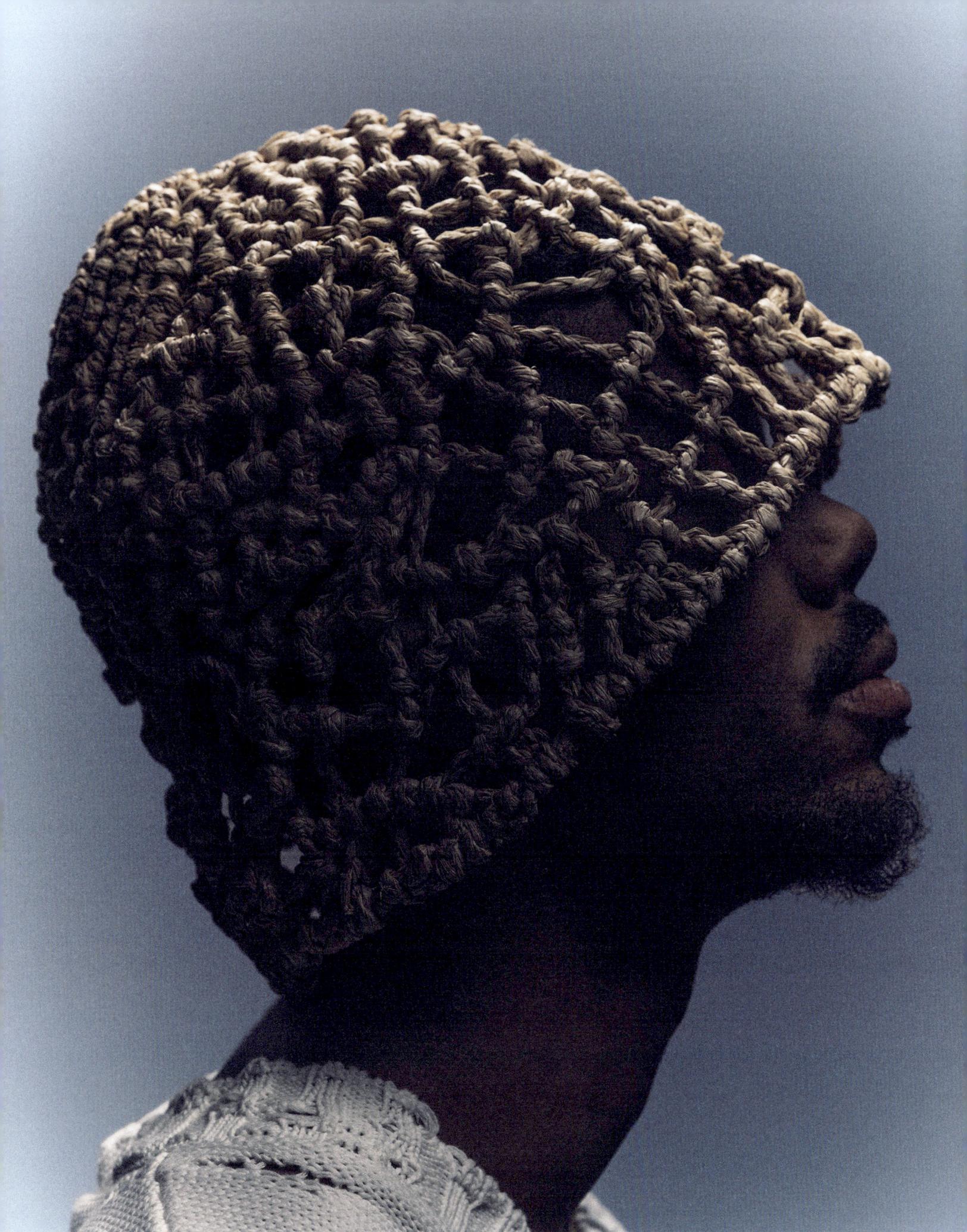

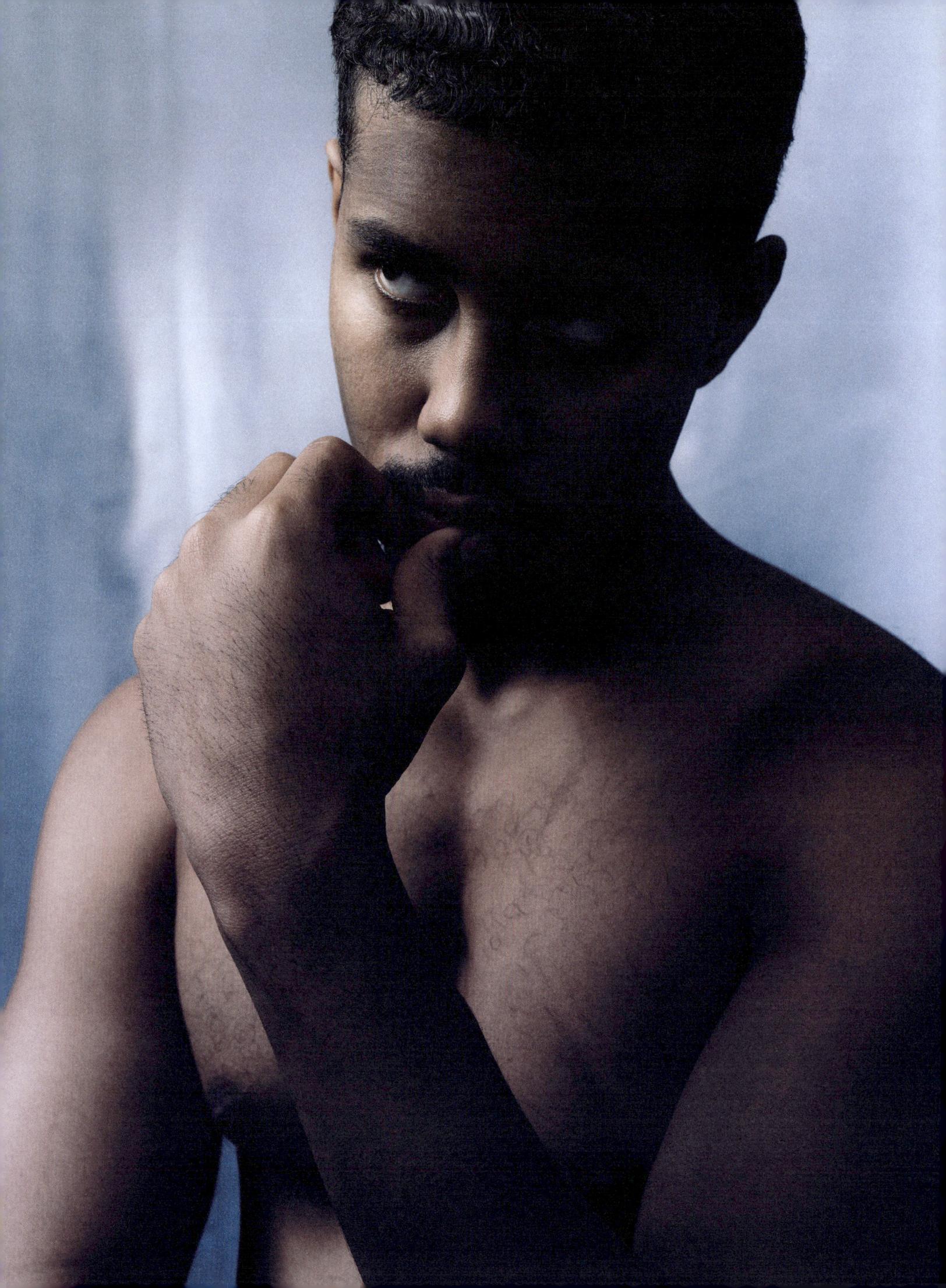

way, and so I feel a great privilege to be able to do what I do for the people that I lost."

It's not that his work is born out of a fear of him or his peers being forgotten, he clarifies. "I actually have no qualms with disappearing from every registry and from every memory. My grave fear is being misremembered." He speaks about how, for too long, the wrong people have been tasked with defining the lives of young working-class Black men, with racist publications framing his late teenage friends as criminal adults and often erroneously connecting them with gang activity. "I cannot delegate any of that remembrance to anyone," he concludes, "It has to be me."

It's still too painful for him to listen back to *When Smoke Rises*, though he recognizes the importance of continuing to perform these songs for an audience and eulogizing those he has lost. Mustafa's long-awaited debut album, *Dunya*, makes sense as a next step. In collaborations with musicians including Rosalía, Clairo, Aaron Dessner, Nicolas Jaar and the comedian Ramy Youssef, the grief, rage and love of his previous work still lingers, and yet he is widening the lens. As he puts it: "If *When Smoke Rises* was about the moments after my friends passed, *Dunya* is about the moments before they did."

Mustafa had been a difficult child. He recalls being disruptive in class and getting in trouble both in school and out of it. It was his sister who introduced him to poetry, in an attempt to connect with him. Though these days he feels fraudulent laying claim to being poet, it was the art form in which he first found a way to express himself creatively.

"Community is the thing that keeps me alive."

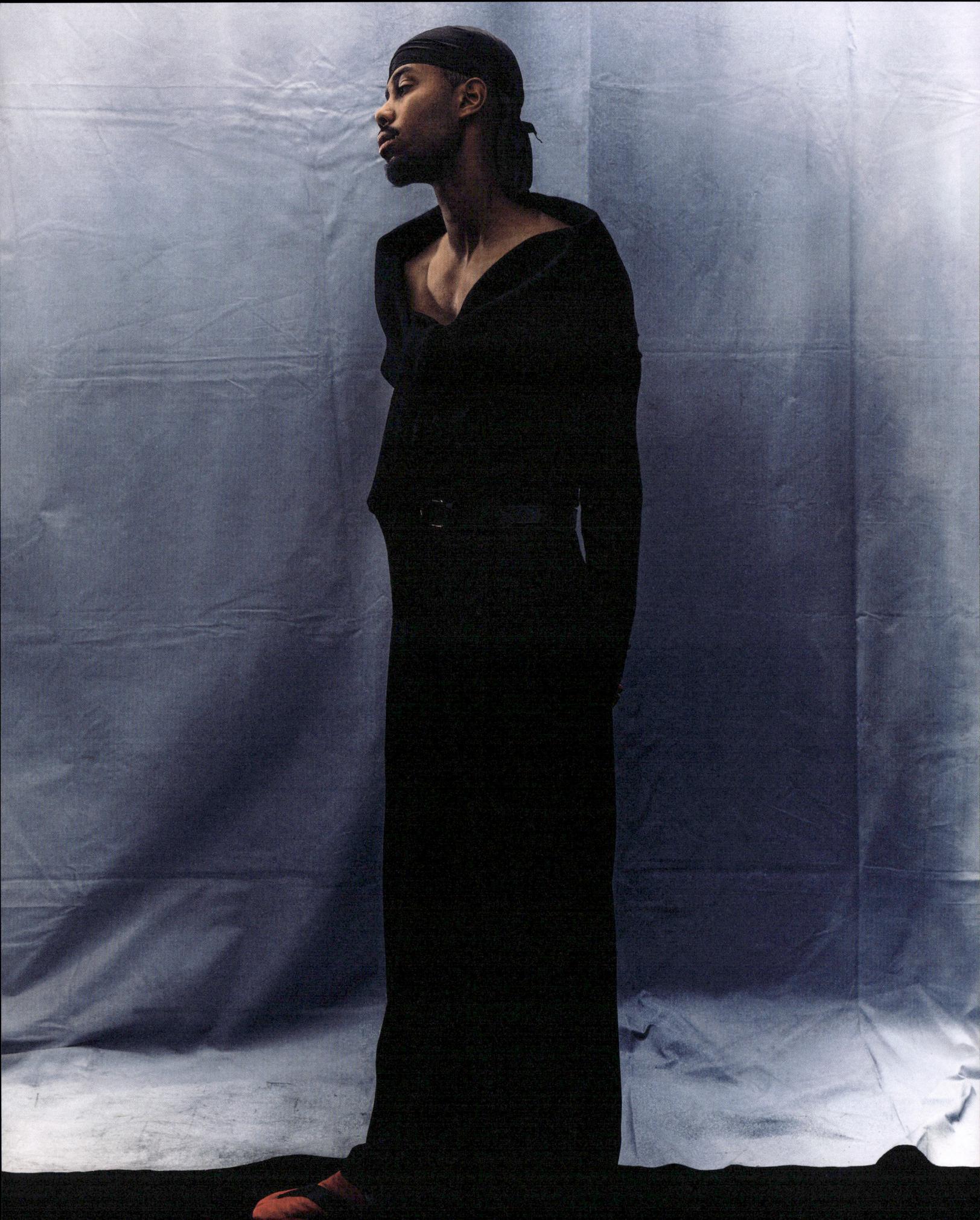

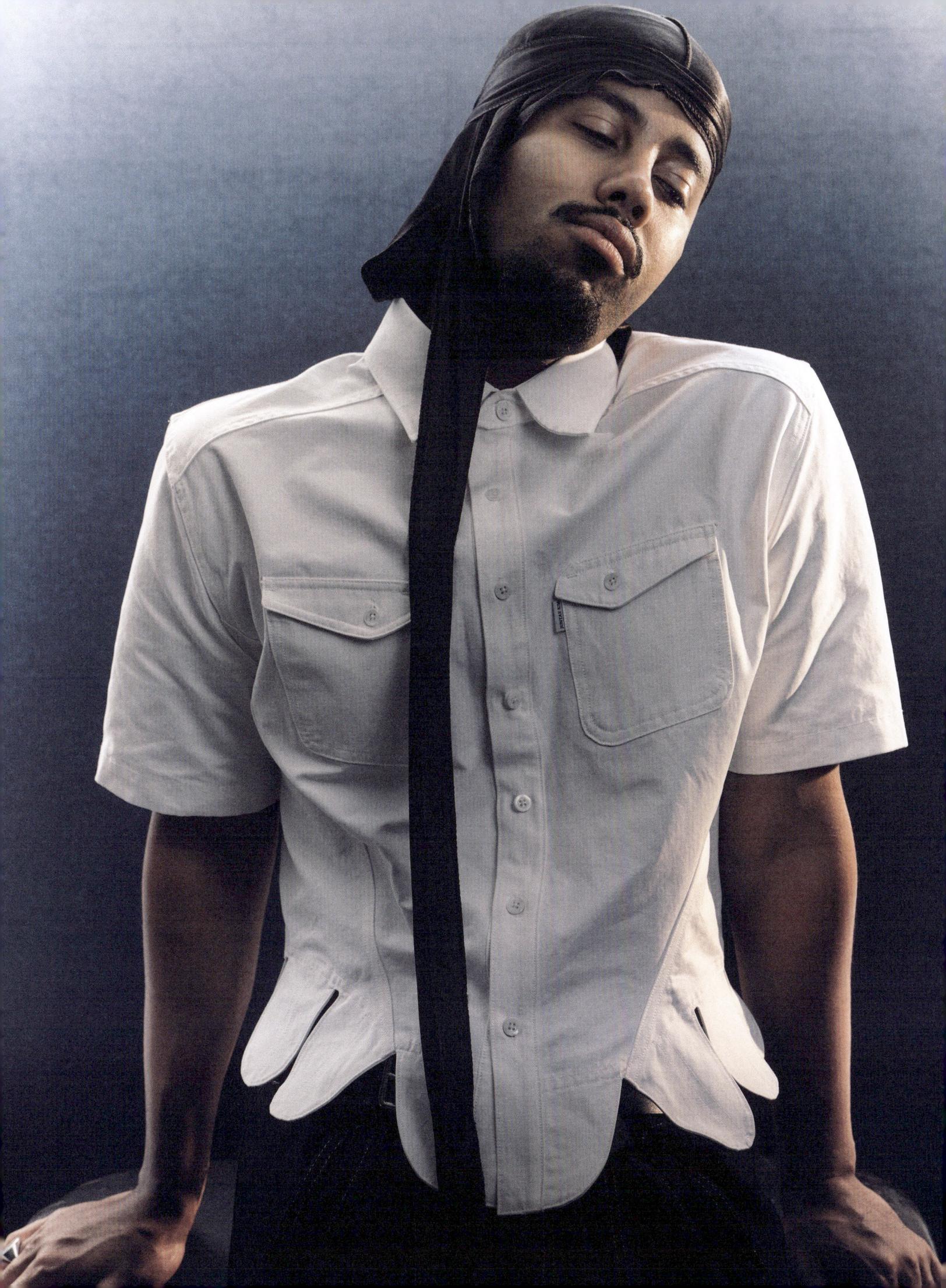

You can still find a video of a wide-eyed 12-year-old Mustafa reciting his poem "A Single Rose" on YouTube. In the incredibly earnest performance, he delivers lines like, "Can't we spare some time and share a life line / and let people know that life doesn't have to be a nightmare?" with precocious aplomb.[3] The directness of his poetry laid the groundwork for the lyrics he started writing when he was 16, though he considers it to be different than writing poetry. "They're individual skills which require their own time and attention," he says. "Songwriting comes with its borders, it comes with having to surrender to the chord progression or melodic structure—there are words that don't sing well; it's difficult to write effective poetry. But it's a form that can be boundless, there is no shortage of possibility in the way we can explore a poem; it is expression in its truest form."

> "There is no shortage of possibility
> in the way we can explore a poem; it is expression
> in its truest form."

One day, he hopes to return to poetry, but his history with the medium is not without its uncomfortable memories. It was the kind of thing that could easily be co-opted—Mustafa as a lone, worthy poet amidst his other, more troubled peers. Indeed, in 2016, Mustafa became part of Canadian Prime Minister Justin Trudeau's Youth Council, a move which he has since disparaged (he told Pitchfork in 2020: "I was on his council when I was young, naive, and thought that I was gonna advocate from the inside. But no one gives a shit about you, fam, and no one gives a shit about me").[4] "I think we have to be diligent about who we are choosing to be in community with," he says, reflecting on it now. "It's one thing for us to have a clear sense of the communities that we are from, but sometimes I think we underestimate the ways in which that can be diluted or contradicted by who we choose to stand beside."

Again, everything comes back to a sense of the collective for Mustafa. The past decade has seen "self-care" commodified as a hyper-individualistic pursuit, but it doesn't seem unwarranted to wonder how Mustafa makes time to look after himself when his working and personal lives overlap so much, and when he deals with his trauma in such a public forum. But for Mustafa, care is a communal pursuit. "Growing up among Muslims and East Africans, there

(3) After "A Single Rose" gained traction, *The Toronto Star* wrote a profile of Mustafa, noting how the 12-year-old's poems about poverty in Africa and violence in Regent Park "make white adults cry."

(4) Members of the Youth Council help guide the Trudeau government on programs and policies that might benefit Canada's young people, such as education, the economy and climate change.

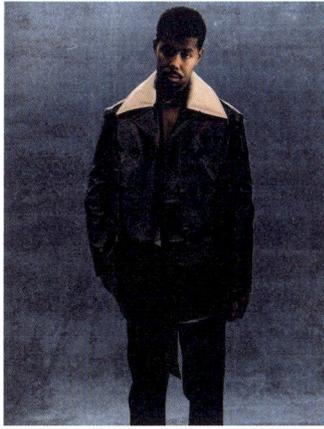

(above)
Mustafa wears a jacket, shirt and
trousers by GUCCI.

were those communal activities, gatherings and conversations, the sharing of food and feeling and beds and water; that was, in a lot of ways, what self-care felt like," he says. "The best I feel in the face of some of the vitriol is being able to nurture the love I have around me. As long as that love exists it is proof of living, that life has not lost all its color. Self-care requires an exchange, it's about giving."

It's a mindset that was evident in the benefit concert he organized for Gaza and Sudan in New York in early 2024, which featured performances by Clairo, Stormzy, Omar Apollo and Daniel Caesar.[5] Mustafa himself has consistently used his art as a political medium—on *Dunya*, there is a track called "Gaza Is Calling" about his childhood friend living in the occupied territory (with lines like "Every time I say your name, there's a war that's in the way"). In the course of our call, we talk at length about the unraveling of democracy and the cognitive dissonance of university students being taught about colonialism and genocide and yet being reprimanded for the campus encampments that sprung up in 2024. Still, he recognizes that it can be scary for an individual to step up and speak out: "It was why it was important for me to do the concert, to get a lot of artists together, so that their hesitation dissipates when they see how many of their peers are joining them on the stage."

To Mustafa, there is even something communal in his co-writing credits on songs by the likes of the Weeknd, Camila Cabello and Justin Bieber. "It has a kind of joy that I can't find in writing my own songs," he explains. "It's the function of making myself small in someone else's dream, you know? Being able to do everything in my power to help hold up a mirror to another artist is far less daunting than finding the tools to hold [a mirror] toward myself."

He pauses. "And I think in a lot of ways, that is the optimal way of living this life.... Seeing yourself as a small part in a larger thing that is moving."

In Islam, *dunya* refers to the temporal world, including all its flaws. "In Arabic, we often speak about struggling with the dunya," Mustafa explains. "And I think that speaks to how lost one can be in it."

On the album, Mustafa grapples with his faith after everything he's lost, all while trying to understand whether he should even be writing his songs when he is aware that for some Muslims, making music is considered to be haram.[6] There are certain corners of the internet where he is lambasted for conflating his faith with making music, and he is sympathetic to people's concerns. He speaks about the beauty of Sufism—a mystic form of Islam—and its music; how, whether you have faith or not, listening to it can make you feel connected to some higher power. "Sufi music inspires me deeply, and it's part of why I'm able to do what I do," he says. "There's a lot of different scholars that believe music [in Islam] can be permissible

(5) Sudan has been in the grip of a civil war since April 2023—a direct result of a power struggle between two generals within the country's military. Human Rights Watch has since expressed fears over ethnic cleansing in the country's Darfur region, where 15,000 people from Masalit and non-Arab communities were killed in 2023.

(6) "Haram" is an Arabic adjective that describes anything forbidden by Islamic law. Some Muslims believe musical instruments are haram and only vocals are allowed.

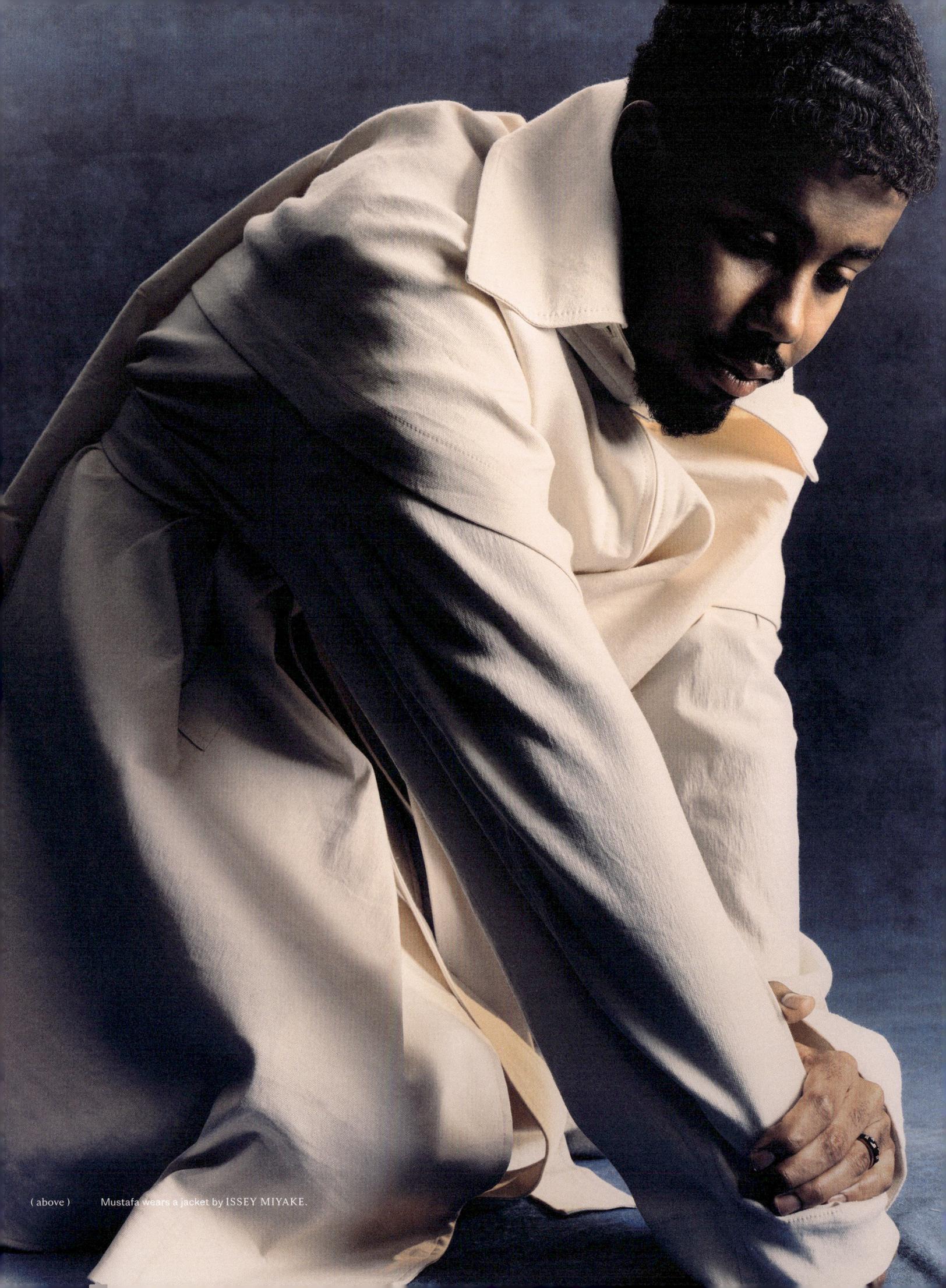

depending on what the message is, as long as the messaging is pure and not driving people away from the path of goodness and God."

For Mustafa, *Dunya* is not only about examining his faith but about reflecting the nuances of the lives in his neighborhood. As he puts it, "the dunya is quick!" Rather than reducing people to their deaths, to the ugliness of fear and vengeance, he wants his work to focus on the fleeting beauty of it all. The warmth and intimacy he has shared with his loved ones are given new life and light with textures of oud, folk singing, bird song and spoken word. There's one particularly harrowing moment on the song "Leaving Toronto," where he sings over gentle guitar that, if he gets killed, people should make sure he's buried next to his brother, and make sure that his killer has enough money for a lawyer. He wants to connect people and their struggles, to encourage solidarity and people coming together in community, but most of all, to make space to remember the truth of it all: to recognize the failure of systems rather than individual people. He nods to Toni Morrison, who, before writing her own novels, spent years of her life as an editor at Random House amplifying voices from the Black Power and women's movements:[7] "I think that that documentation is our responsibility. Like, to be a recording artist, our responsibility is to record a moment in time as it's happening."

Mustafa stresses the importance of music in this pursuit. "Sometimes you look at a photo, and you can't remember what you were feeling when that image was taken," he muses. "You know it was taken, you're smiling, but sometimes you need someone to remind you what the emotional landscape was. For me, that is what song is for. Song is an emotional account in an infinite form. I need that sonic remembrance."

"That is the optimal way of living this life…. Seeing yourself as a small part in a larger thing."

(7) Morrison's work at Random House can be viewed as a political project in that she helped to create a lasting record of the work of activists, marchers and protesters long after their activity had subsided. She edited the work of Black Power activists, including Muhammad Ali, Huey Newton and George Jackson, and was responsible for seminal works associated with the women's movement, including the radical *Lesbian Nation* by Jill Johnston.

AT WORK WITH: RYM BEYDOUN

A cult fashion label takes root—and blooms—in Ivory Coast.

Words ROSALIND JANA
Photos NUITS BALNÉAIRES

Rym Beydoun spent much of her childhood making art, attending classes where most of her peers were in their 50s. "We would go and paint by the sea," the fashion designer says, reminiscing about growing up in Abidjan, Ivory Coast.

They were taught to use natural materials, incorporating sand, shells, beads and raffia. The imaginative freedom would come to be a formative experience. "From a very young age I remember feeling grateful for both being an artist and being from Africa," she says. "It was really at the core of my upbringing."

Beydoun is speaking from Abidjan, where she returned to live last year after more than a decade traveling between Beirut and Ivory Coast. Her roots run deep in both countries. She left Abidjan in 1999 with her mother and siblings for Beirut following a coup in Ivory Coast—a reversal of her father's journey in the 1970s, when he departed a wartorn Lebanon at the age of 14 for Abidjan.[1]

Super Yaya, the cult fashion brand that Beydoun founded in 2015, draws heavily on Ivorian culture. "I wanted to translate what it means to dress in a West African way," she explains. "Here people still buy fabric and do things themselves. There's this DIY culture." After studying fashion design at London's Central Saint Martins—having originally planned to study fine art—and spending part of her placement year back in Abidjan working with tailors and in wax print

" The starting point is the textile: It can become a chair... It can be a bag, and it can be a shoe."

factories, Beydoun set up an online shop for her studio. Customers could choose between different styles and materials to create garments which were then made to order. The approach kept overheads low and allowed her to "test the market."

Next came T-shirts, emblazoned with slogans like "100% Africosmic" and "Super Yaya 100%." ("Yaya" is a common name for boys in Abidjan but is used by Beydoun in a unisex context. The "100%" is a nod to the exaggerated tone of Ivorian advertising.) A bold branding exercise, the T-shirts signaled the "merging of fashion with popular culture" that has become a distinctive part of her brand since. Stockists like Maryam Nassir Zadeh and Opening Ceremony came calling, and their success allowed Beydoun to scale up to producing full collections. These slick, offbeat garments featured fabrics sourced in Abidjan's markets, which were often hand-dyed and printed in Ivory Coast, before being sent for production in Beirut, where Beydoun has a studio.

From the start, Super Yaya's collections have had a distinct vernacular—absorbing the varied sights and sartorial modes of Lebanon and Ivory Coast to create clothes that are ambitiously silhouetted and slyly elegant. They prioritize texture (ruffles, pleats, cutouts, ruching) and juicy color combinations, taking inspiration from African modernist architecture to '90s photography. For the past couple of seasons, they have largely been made from bazin, a type of hand-dyed West African cotton known for its stiff, damask sheen.

As well as reflecting her approach to design, Super Yaya has also been shaped by Beydoun's belief in taking things as they come, or, as she terms it, practicing an "acceptance philosophy." She was among the thousands of people injured in the devastating explosion in Beirut in 2020 and endured a long, bedbound convalescence.[2] Yet Beydoun is circumspect.

"I was really burnt out before the blast. I really wanted to take a break . . . I needed to understand why I was doing what I was doing," she says. Her long recovery gave her the opportunity to reset. "I'm not going to say that it was peaceful and restful, because it was a very painful experience, but I thought I would never have another time in my life to sit for six months in bed and play with the cats." Later she loops back to correct herself. "I mean, I say that I stopped working, but it's not true . . . there are pictures of me in bed packing boxes."

Still, being confined to one room gave Beydoun precious pockets of time to do nothing and to adjust to her new physical needs. "I had to learn how to dress again," she says. "I still had to look good in my clothes." In 2022, she released "Recovery," her first collection since the explosion, which riffs on a 1999 Louise Bourgeois artwork of the same name. The clothes are audacious, sexy and beautifully crafted while still being easy to wear: lemon posset yellows and pre-dawn blues; elaborate basket-woven skirts and shirred trousers—designs at once playful and sophisticated.

Operating outside of the traditional fashion centers of London, Milan, Paris and New York is central to Beydoun's work ("Chanel—I don't think they needed me," she says dryly at one point), but it's also not without its challenges. The recent political instability in Lebanon precipitated her move back to Ivory Coast. "A war can break out, we're all nervous. This week alone, [there were] two days my workers couldn't come because they were afraid on the road," she says.

Aside from practical problems, like sourcing fabric and zippers, working from Beirut and Abidjan does limit the kind of casual, productive encounters one can have with a wider community of peers, buyers and the press. Super Yaya now employs 14 people full-time and five people part-time, and presents a collection each year in Paris during Men's Fashion Week, but for the rest of the year, it's a more isolated experience. "It does work in your favor sometimes," Beydoun considers. "It's slow growth, but it's an underground brand." They don't pay for press and the celebrities pictured in Super Yaya—Kendall Jenner, Solange Knowles and Alexa Chung—have all bought the pieces for themselves. The brand has expanded on Beydoun's own terms, constantly shifting and flexing in slightly different directions.

It's been almost 10 years since Beydoun founded Super Yaya and she is itching for the next stage. When we speak, she is deep into archival research, looking at daily modes of West African dress and textiles from the 1980s and '90s: "The type of things that you never find online, and we don't have a library to search for these images." She's talking to designers like Aïssa Dione, a Senegalese textiles maven who is best known for creating exquisite upholstery, and she's also dipping a toe back into the art world via works like *Super Limbo*, a large-scale installation of woven panels of calico cotton staged in a deserted mall during the 2023 Sharjah Architecture Triennial in the United Arab Emirates.[3] Last year, Beydoun also collaborated on a four-piece capsule collection for Gohar World, the surrealist tableware brand of celebrated food artist Laila Gohar.

"The starting point is the textile: It can become a chair, it can become a shirt, it can be womenswear, or it can be menswear. It can be a bag, and it can be a shoe," Beydoun explains. "It's all literal material."

In this way, Beydoun's label becomes a vast umbrella—or even a billowing canopy—encompassing an ever-shifting number of projects and possibilities beneath it: "Super Yaya was intended to be able to showcase any kind of product. In the beginning, I went so far as to think that it could even be on rice, you know?" She might not be on supermarket shelves yet, but with Beydoun's vision, it feels like it wouldn't be all that surprising.

(1) In December 1999, President Bédié was overthrown in a military coup that shook Ivory Coast's reputation for stability. It was followed by two major military uprisings, tumultuous elections and a wave of killings.
(2) Beirut was rocked by an enormous blast on August 4, 2020, when hundreds of tons of improperly stored ammonium nitrate exploded in the city's port. It was one of the largest non-nuclear explosions ever recorded, killing more than 200 people, wounding thousands more, and devastating swaths of the city.
(3) *Super Limbo* was produced in collaboration with Dominique Petit-Frère and Emil Grip of Ghanaian spatial design studio Limbo Accra and artist Anne-Lise Agossa.

(opposite) Beydoun's creative vision extends beyond fashion and textiles. Alongside creating an art installation for Sharjah Architecture Triennial 2023, she also recently designed the interiors of Café Continent in Abidjan.

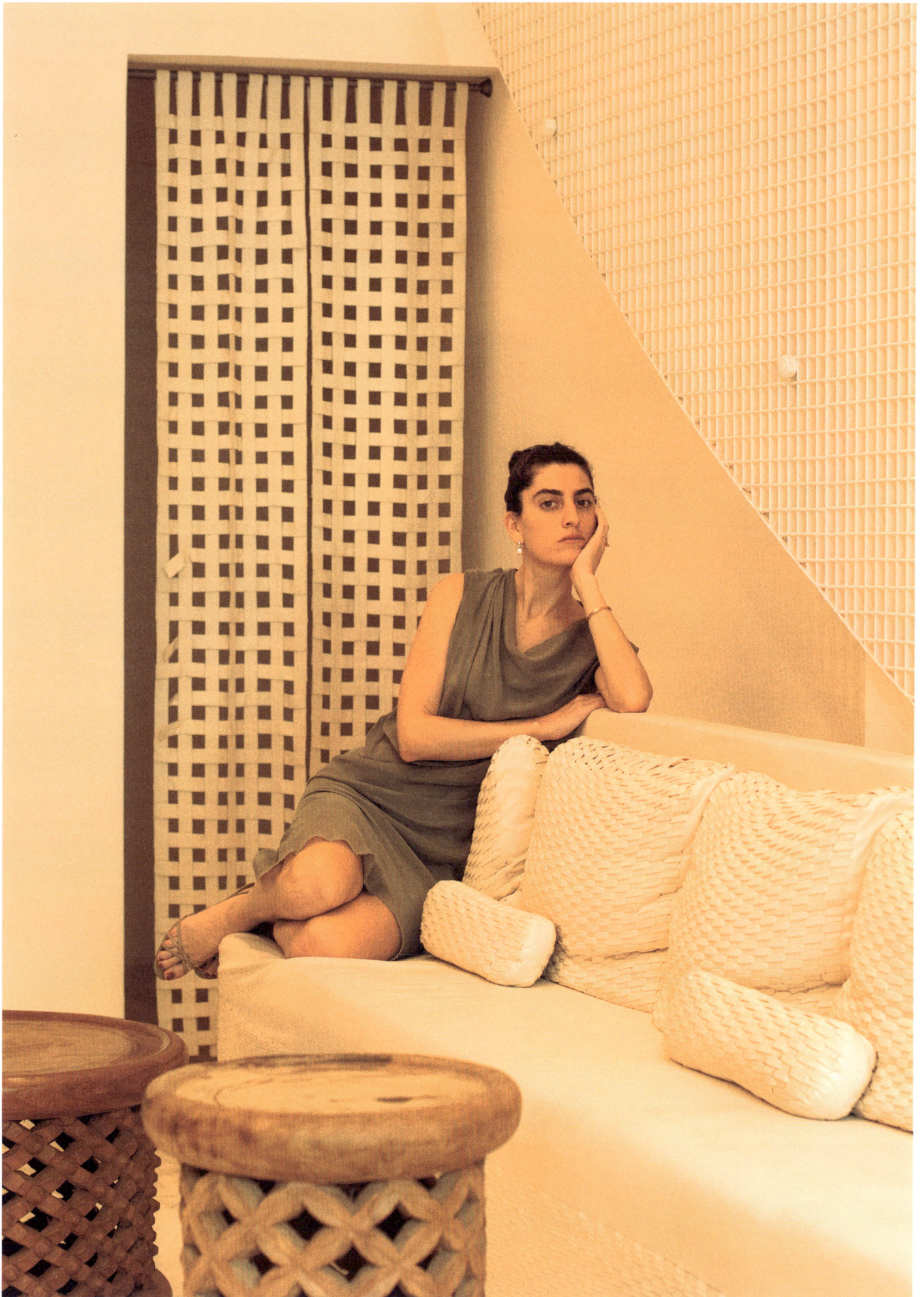

On the hotel-ification of home.

ESSAY:
INN STYLE

Words
ALI MORRIS

Interior designers have found themselves fielding an increasingly familiar request in recent years. In Sydney, New York and London, private residential clients are asking for restorative bedrooms, spa-like bathrooms, restaurant-style dining spaces and, in some cases, breathtaking entrance hallways—in short they want their homes to feel more like hotels. With everything short of room service on the wish list, it would seem that these clients want to feel as if they are anywhere but home. Yet this curious trend also offers a window into the contemporary experience, reflecting how various aspects of modern life are converging and changing the way we think about the spaces we live in.

Alex Hawkins, a strategic foresight editor at the Future Laboratory, a trends intelligence consultancy, believes the "hometel" trend, as it has

spaces during the pandemic, and an increased focus on home life, showed us that even small design touches could create moments of escape at home, reinforcing an already growing trend that associated spatial design with self-care. "In other words, people are looking to replicate the restorative experiences they've enjoyed in hotels within their own homes," says Hawkins.

The lines between residential and hospitality interiors were already blurring in the years before the pandemic. Ett Hem, for example, is a 25-room, Ilse Crawford–designed luxury hotel in Stockholm, that opened in a 100-year-old home in 2012.[2] Guests often liken their stay to spending time at a (very wealthy and hospitable) friend's house. Every element of the hotel is designed to foster a sense of intimacy and ease: You are free to help yourself

" People are looking to replicate the restorative experiences they've enjoyed in hotels within their own homes."

come to be known, has its roots in the COVID-19 pandemic. Confined to our homes, we were able to give greater focus to the routines and rituals that gave shape to our days. Formerly mundane tasks were reframed as simple pleasures: brewing a morning coffee, making the bed with fresh sheets or taking a long soak in the tub; and as normality gradually returned, some have found themselves strangely nostalgic for that quieter life.[1] There is an urge to hold on to a time that allowed us to bond with family and hone new domestic skills. "The pandemic fundamentally changed how people perceive their living spaces," Hawkins says. "People now want spaces that offer calm, comfort and a touch of luxury—essentially turning their homes into personal sanctuaries, wherever they can afford to."

Once we would have sought this sanctuary in a hotel but the lack of access to hospitality

to anything, from the food in the kitchen to bicycles and raincoats for trips out. Furnishings are relaxed and homey, arranged as if they have been collected by the owner over a lifetime rather than sourced by a design team.

This "softening" of hospitality spaces has since given way to an altogether more fluid approach to domestic spaces. "The pandemic definitely challenged the notion of home, not just from a work/life balance, but in the demand of the home to accommodate other areas of life, like

(1) According to Krystine Batcho, a professor of psychology at Le Moyne College in Syracuse, New York, nostalgia plays a role in maintaining emotional stability. Lockdown nostalgia can be understood as a response to conflicting emotions about the end of the pandemic: relief that restrictions had been lifted, but lingering unease about the economic uncertainty it had created and the threat of catching the virus.

(2) Crawford also led the design of Ett Hem's 2022 expansion after two neighboring townhouses came on the market. As part of the project, three apartment-style suites were created for long-stay guests.

relaxation and fitness," says Jejon Yeung, the principal of Brooklyn-based architecture and design firm Worrell Yeung. Requests from the firm's clients have ranged from the practical—integrated reading lights next to the bed—to the decidedly decadent, with one recent project including a "spa shed" complete with jacuzzi, outdoor shower, dry sauna and gym. Yeung also sees the trend as part of an ever-growing wellness industry that was estimated in 2024 to be worth $1.8 trillion. "The desire no doubt comes from a narrative of luxury, fitness and wellness, and [our clients] wanting that incorporated into their daily environment. Comfort is always a top priority in our conversations."

Aside from convenient space-saving features and wellness amenities, the mood of a luxury hotel can be captured in unconventional approaches to design. "Boutique hotels can make guests feel at home given their more intimate scale, but their added bonus is that they often offer unique features most homeowners may feel less confident about including in their own residences," explains Yasmine Ghoniem, director of Australian interior

" When you leave a space that's beautifully designed, you want to bring some of that back with you."

design studio YSG.[3] This can include "eclectic furniture, daring tones on walls or even ceilings, and paying particular attention to lighting." For a home project in Mosman, a suburb of Sydney, for example, clients wanted a "tranquil, tonal and textural intensity" and a focus on areas for rest and respite; the studio used a rich palette of dark wood, travertine and neutral colors enlivened with jewel tones, a bold approach typically the preserve of statement design hotels.

(3) The term "boutique hotel" was coined by hotelier Steve Rubell in 1984, when comparing the size and more intimate feel of a small hotel he had opened with his business partner, Ian Schrager, to a small boutique instead of a department store. The pair had previously opened the iconic Manhattan nightclub Studio 54.

(4) Social media has been credited with making interior design more accessible and democratic, but it has also led to the rise of a "fast-homewares" industry that has a significant environmental impact; each year, Americans throw out more than 12 million tons of furniture.

An undeniable factor in the popularity of "hometel" is the proliferation of the trend on social media, where airbrushed and even AI-generated hotel-inspired interiors proliferate endlessly, and where content creators set up guest rooms like hotel suites, replete with stacks of fluffy towels, travel-sized toiletries and the sort of snacks and bottled drinks one might find in a mini bar. Digital media has made consumers more design-conscious than ever before, not to mention more easily influenced.[4] Hawkins references the renewed popularity of *Architectural Digest*, which he said "has become a star player in [media company] Condé Nast's portfolio" by leaning into "a new wave of celebrity house content"—namely its *Open Door* video series, which allows the public to peep inside the homes of the rich and famous.[5]

The founders of Danish interior design firm Space Copenhagen, Signe Bindslev Henriksen and Peter Bundgaard Rützou, have observed this phenomenon with a mix of despair and optimism.[6] "There is a growing desire to incorporate picture-perfect experiences into our personal living spaces," they say, reflecting on how social media is creating a homogenized global design landscape. "However, we have also noticed a countertrend that prioritizes human-centered values and choices in the spaces around us. This is a response to the fast-paced and shallow consumer society that lacks permanence and genuine value."

At good neighbor in Baltimore, which started as a café, founders Shawn Chopra and Anne Morgan have been slowly growing a retail store and hotel that offers a more intimate and personal experience, rooted in its community. Its seven shoppable guest rooms include products by local makers as well as carefully chosen pieces from further afield. "The idea was to create a spot that feels like home," says Chopra. "It allows people to live with these objects; to touch and to feel them. When you leave a space that's beautifully designed and has an amazing feeling, you want to bring some of that back with you."

It's proof that, while informed by contemporary influences—social media, the global wellness movement and the lasting impact of the pandemic—the "hometel" trend is rooted in something deeper, reflecting an enduring search for comfort and connection in our homes. As the world becomes noisier, faster-paced and more screen-based, our craving for slowness, mindfulness and well-being will only grow. Whether we find solace in a home that emulates the luxury of a hotel or indeed the reverse, the "hometel" trend is a timely reminder of the role of our homes in nurturing our contentment and happiness.

(5) Some of the most memorable moments from *Open Door* episodes include rapper Wiz Khalifa's weed bar, tennis player Maria Sharapova's regulation bowling alley in her basement and the revelation that actor Maggie Gyllenhaal plays the theremin.

(6) Space Copenhagen's notable projects include 11 Howard—a Manhattan hotel that was designed to feel more like a home than a hotel—and the redesign of the three Michelin-starred Copenhagen restaurant Noma.

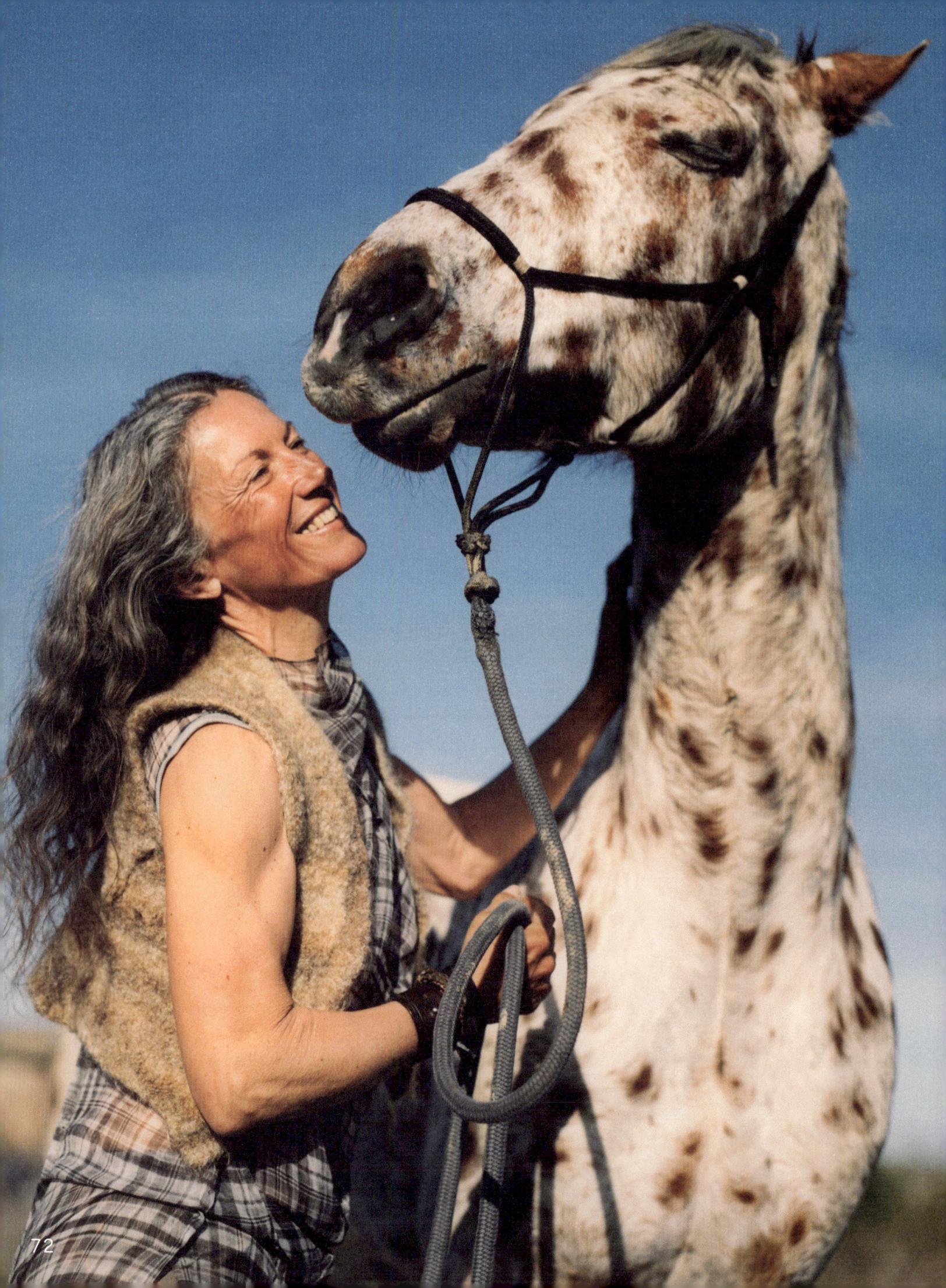

SPI RITO

A free-spirited journey on horseback along Italy's ancient pathways.

LIB ERO

Words
GABRIELE DELLISANTI
Photos
BEA DE GIACOMO
Styling
YOSEPHINE MELFI

Paola Turello was watching television as a child at her home in Moncalieri, a town a few miles south of Turin, when a commercial caught her attention. It showed a majestic white horse galloping along the shore of a lake, across a lush stretch of countryside and down a long sandy beach. "I was instantly struck by its freedom and independence," she says. "It's a feeling I have carried with me ever since."

Last year, Turello gave up a two-decade-long career in architecture to establish an equestrian center, Spirito Libero, as part of a mission to explore the relationship between humans and horses. Now, at the age of 51, she is undertaking an impressive 900-mile journey across the Italian peninsula with two of her horses, Jakarta and Dream; a trip that takes her from the foot of the Alps to Mount Etna on the east coast of Sicily.

As she takes a break by a lake north of Rome, halfway through her journey, Turello shares what she's learned so far.

GABRIELE DELLISANTI: When did you decide to cross Italy on horseback?

PAOLA TURELLO: I've been taking my horses to the Alps, across the beautiful valleys close to where I'm from, for years. We'd regularly embark on three or four day-long trips but I began to feel the urge for something more. So, last summer, I started planning a different kind of journey.

GD: What's the purpose of the trip?

PT: To understand my horses in a new way. I've dedicated much of my time to studying the relationship between humans and horses, and while shorter trips have offered an insight into their

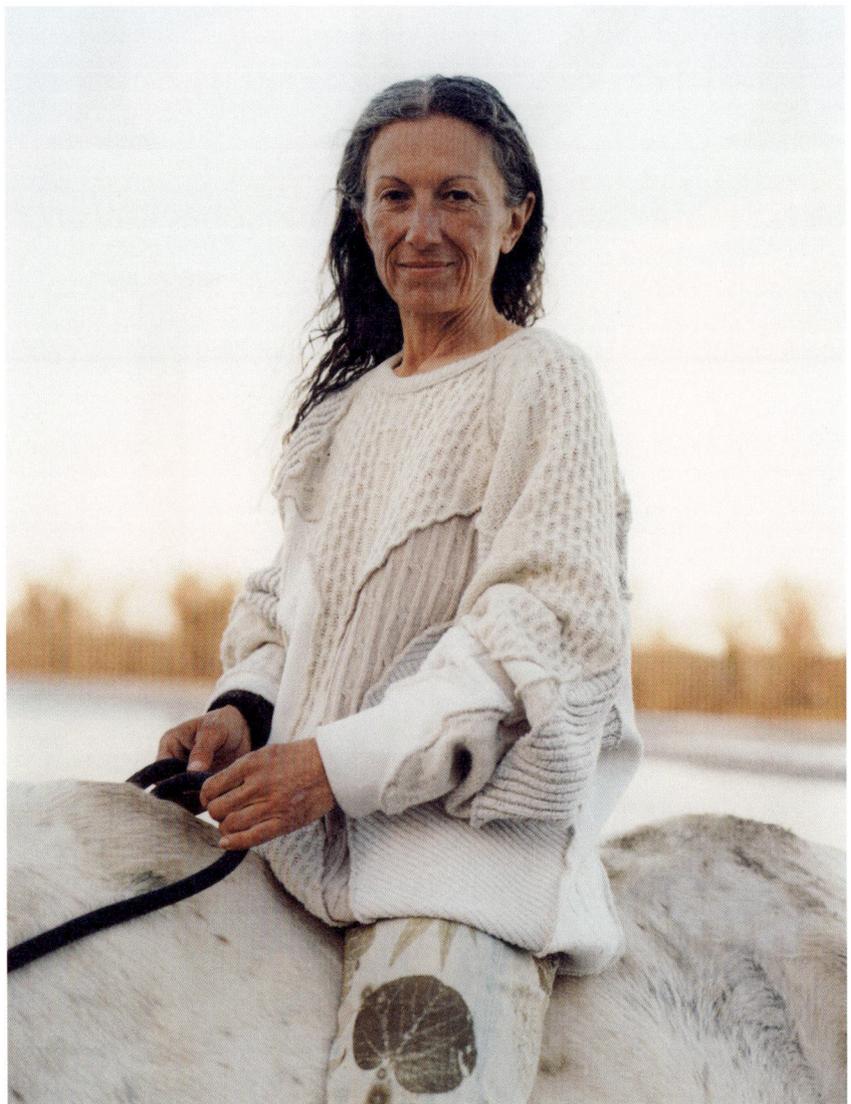

(above) Turello wears a sweater by LOUTRE and trousers by LALAZOO ARTELIER.
(previous) She wears a vest by GARBAGE CORE and a dress by ACNE STUDIOS.

"One of the most important things I've learned about horses is that they always have a best friend."

(above) Turello wears a shirt by APRÈS SKI, a dress by GARBAGE CORE and her own riding boots.
(opposite) Above: She wears a jacket by CAVIA. Below: She wears a vest by APRÈS SKI, a top by GARBAGE CORE and trousers by OLDER STUDIO.
(overleaf) She wears an outfit by OUR LEGACY.

Makeup: Serena Congiu. Hair: Davide Perfetti.

dynamics and interactions, I knew a journey across the country would offer fresh and exciting perspectives. It took months of preparation. I conducted extensive research, sought advice and carefully planned our route. Instead of busy roads, we've opted for historic paths that were once Italy's main arteries. These routes now go along rivers and through picturesque countryside and the occasional small town. We started out doing 15 miles per day but soon reduced that. I quickly understood that I can't make a strict schedule; every day comes with its own challenges to overcome.

GD: You're traveling with two horses. Why is that?

PT: One of the most important things I've learned about horses is that they always have a best friend. You can observe this when they roam freely with other horses; they're incredibly social creatures. During my time running the center, I realized that Jakarta and Dream were close so, naturally, I took both with me.

GD: Have you brought any specific equipment with you?

PT: One of the most crucial elements is the saddle, which is custom-designed by a friend. It's an innovative design that minimizes pressure on the horse's back, as it lacks a traditional saddle tree. When it comes to provisions, we're trying to travel light. Those who have taken similar journeys have had a van or car accompanying them, stocked with food and first aid, but I prefer to do things by myself.

GD: Why did you open your equestrian center?

PT: Like many, I began riding horses at a stable when I was younger. Initially, I saw horses as most people do: as leisure animals that you ride occasionally before returning them to their stables. Over time, however, I started to see them in a new light and developed a deeper interest in understanding horses beyond being entertainment for humans.

GD: What have you learned from your experiences with horses?

PT: I find it funny to remember the misconceptions I once had. I've come to appreciate their incredible capacity for connection, their adeptness at mediation and their instinctive aversion to conflict. I've witnessed how they adapt to various social and environmental contexts; how they respond to the world around them. Their resilience has been particularly evident in our journey so far, notably during a challenging encounter with a landslide, where my horses were remarkable at navigating the situation.

78

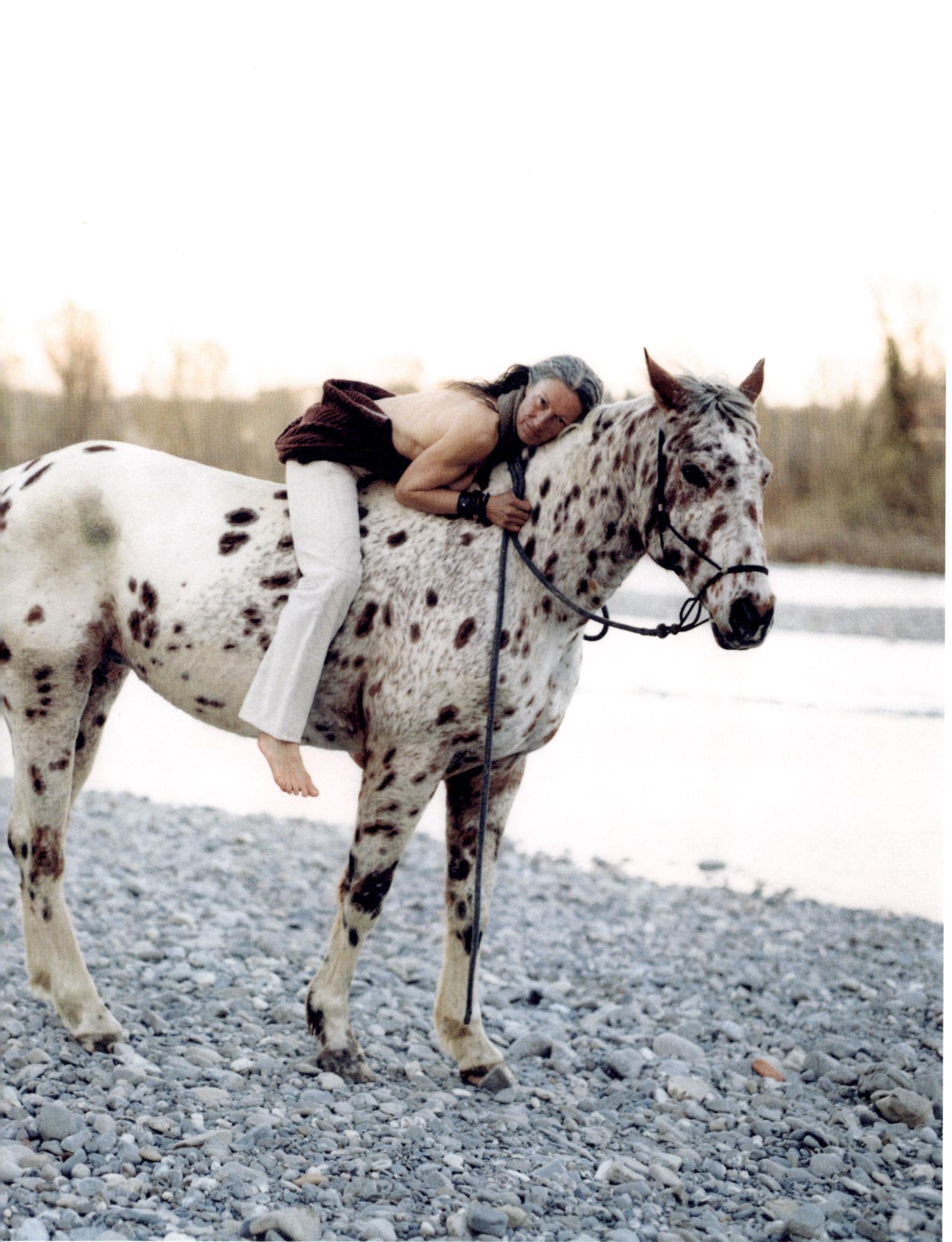

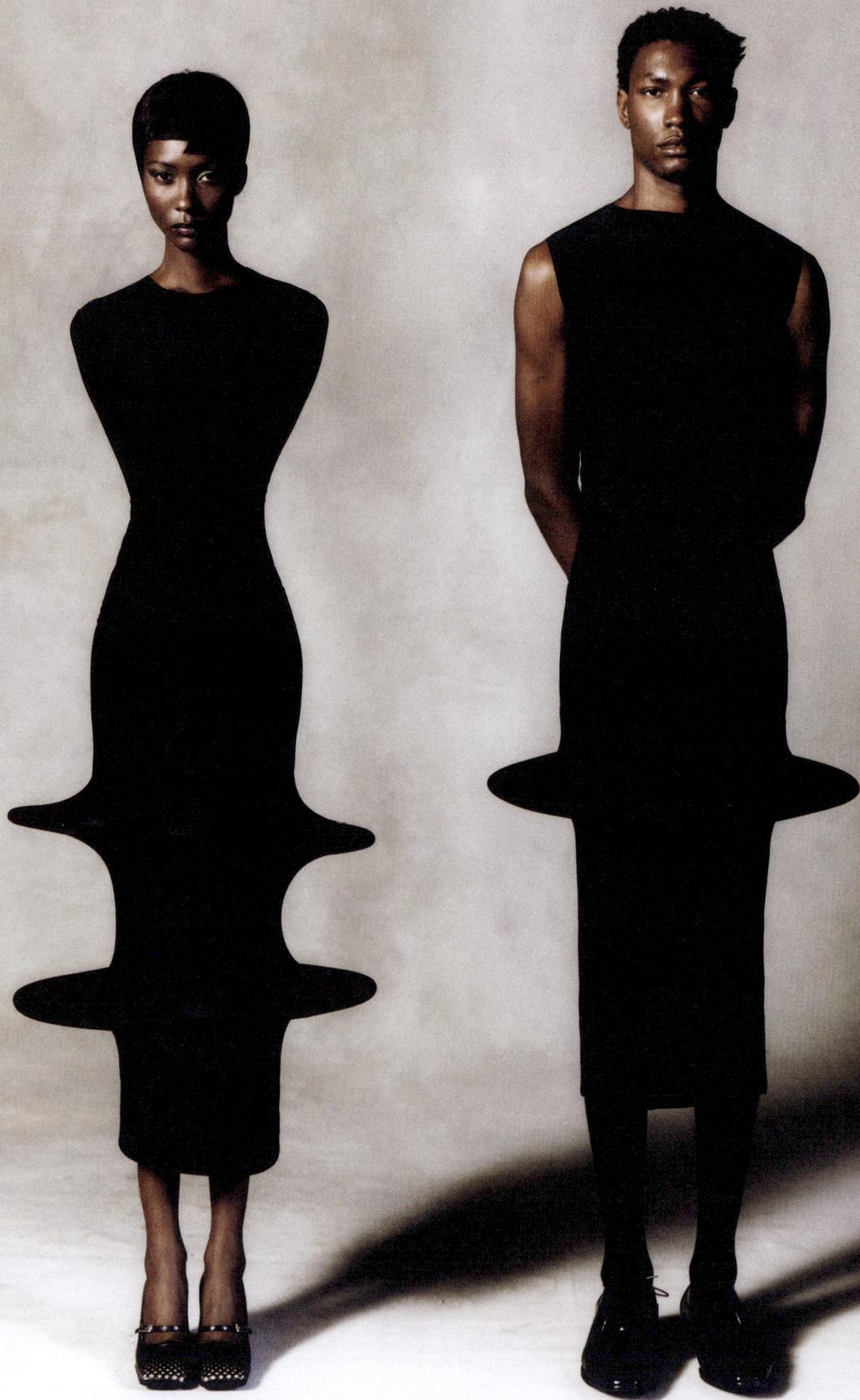

Fashion takes a new
shape in São Paulo.

81 À LA MODE

Photography
MAR+VIN
Styling
MAIKA MANO

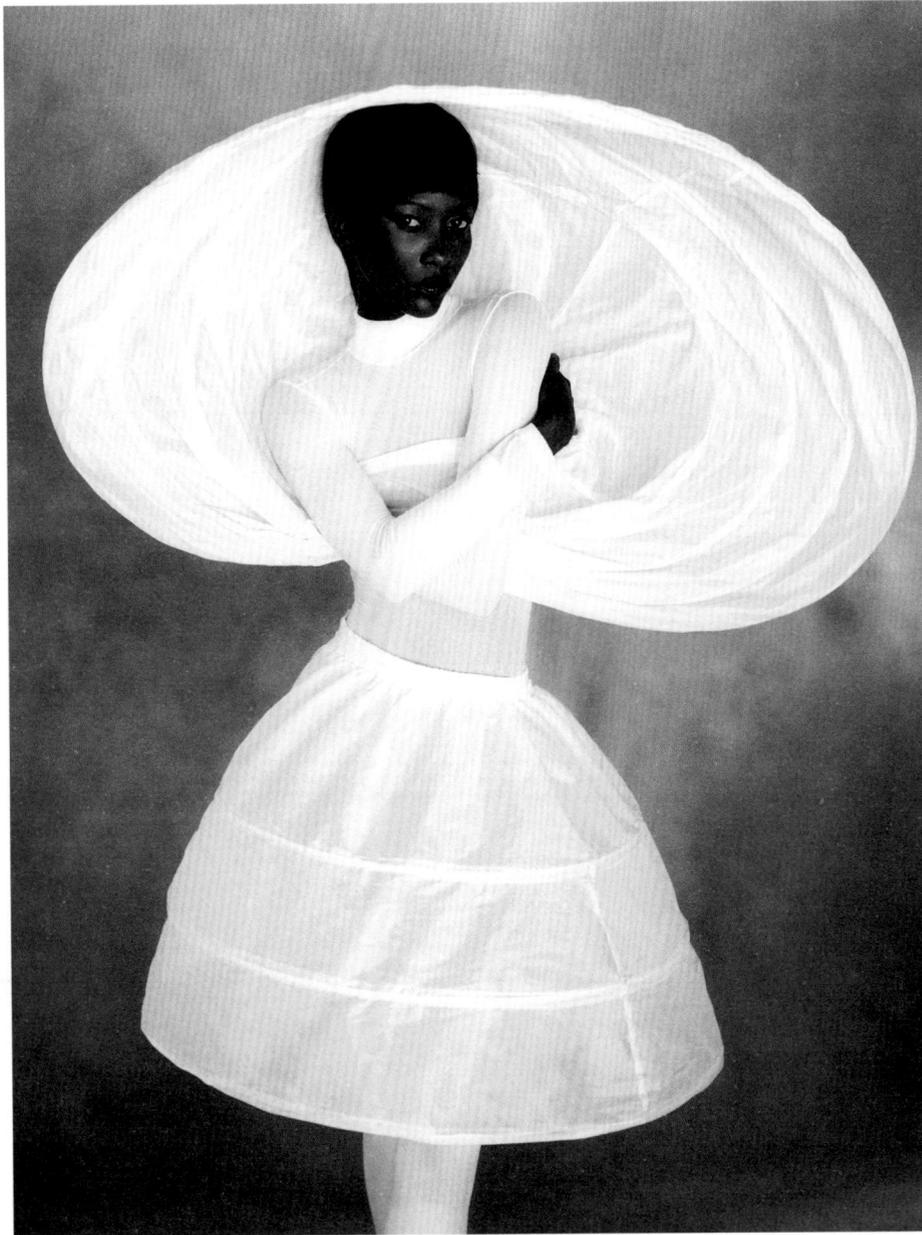

(above) Mahany wears an outfit by PENHA MAIA.
(opposite) Mahany wears a dress by WALÉRIO ARAÚJO, stockings by CALZEDONIA, shoes by MINHA AVÓ TINHA and a headpiece designed by the stylist.
 Danyllo wears a headpiece by PENHA MAIA, sleeves and stockings by CALZEDONIA and vintage shoes by PRADA.
(previous) Mahany and Danyllo wear dresses designed by the stylist.

FEATURES

Hair & Makeup: Piu Gontijo. Models: Mahany Pery & Danyllo Pery

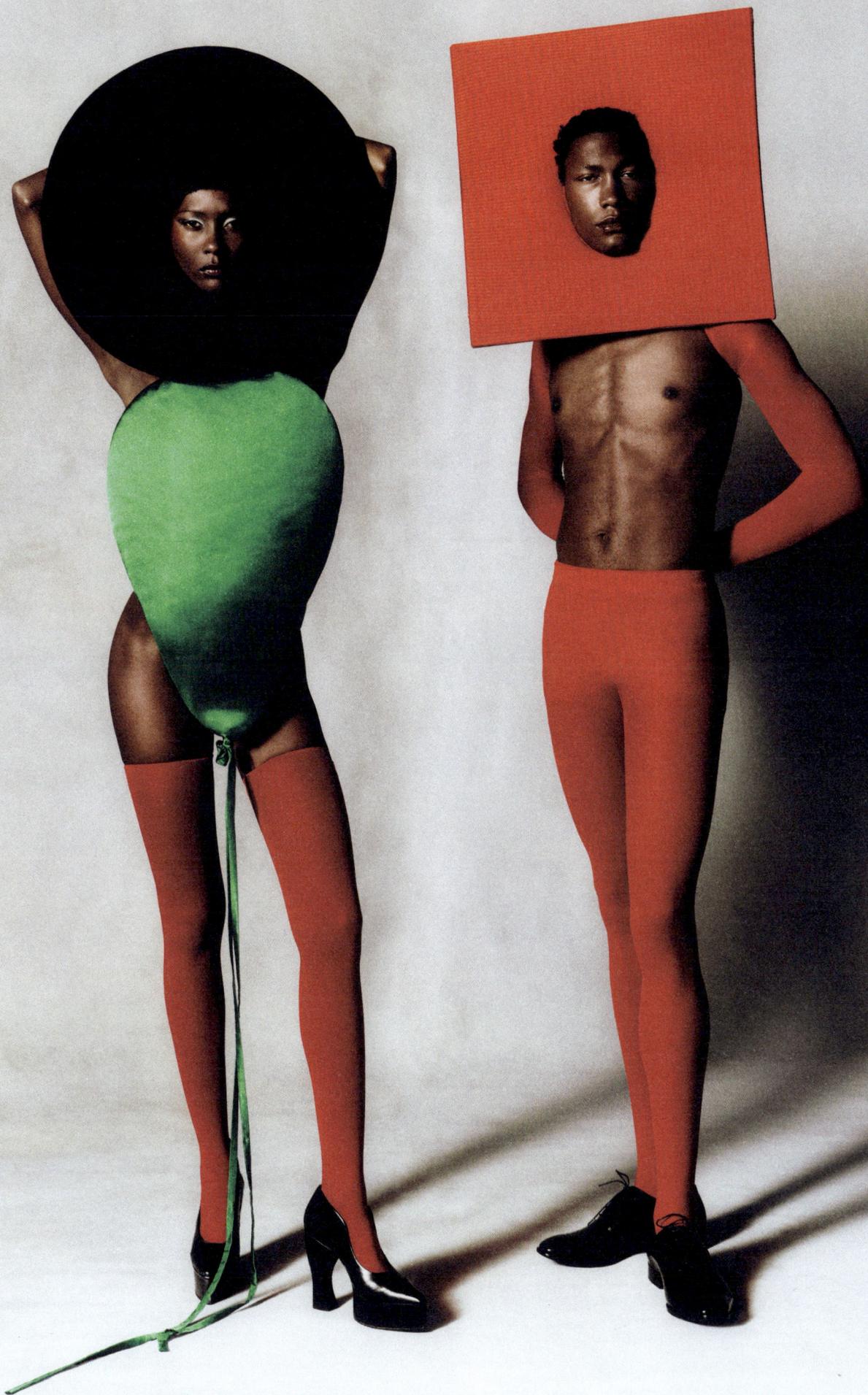

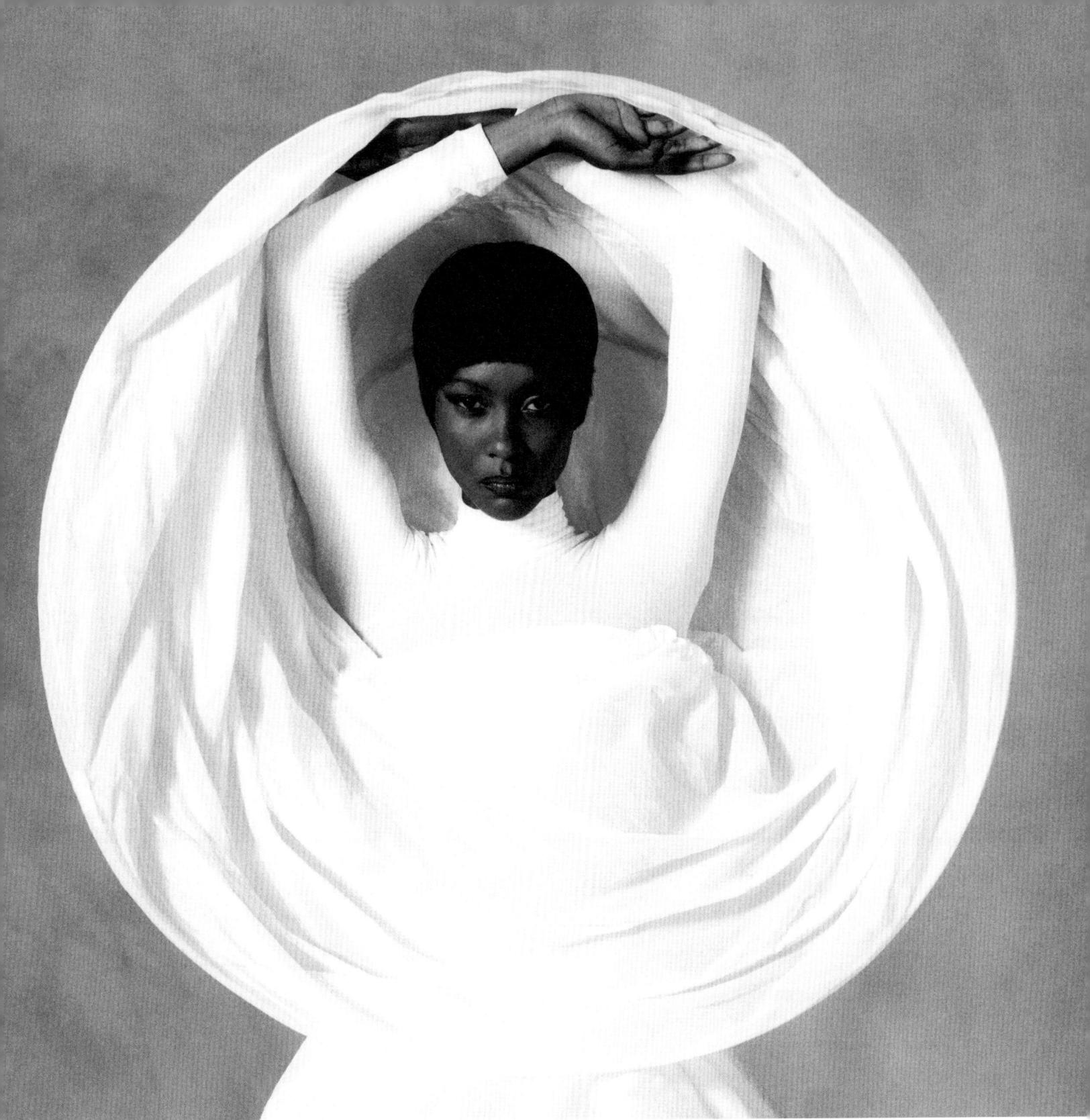

(above) Mahany wears an outfit by PENHA MAIA and shoes by MINHA AVÓ TINHA.

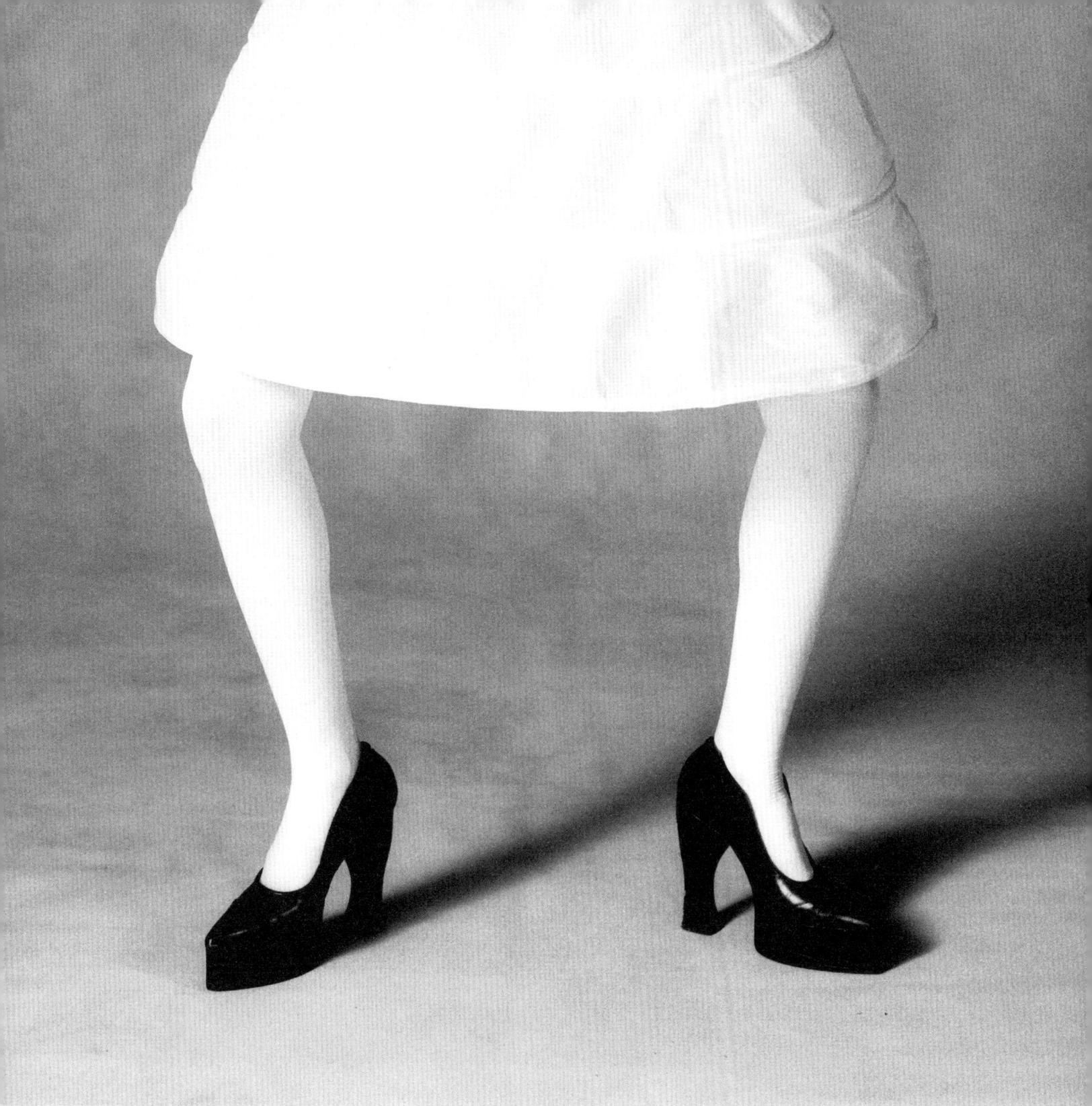

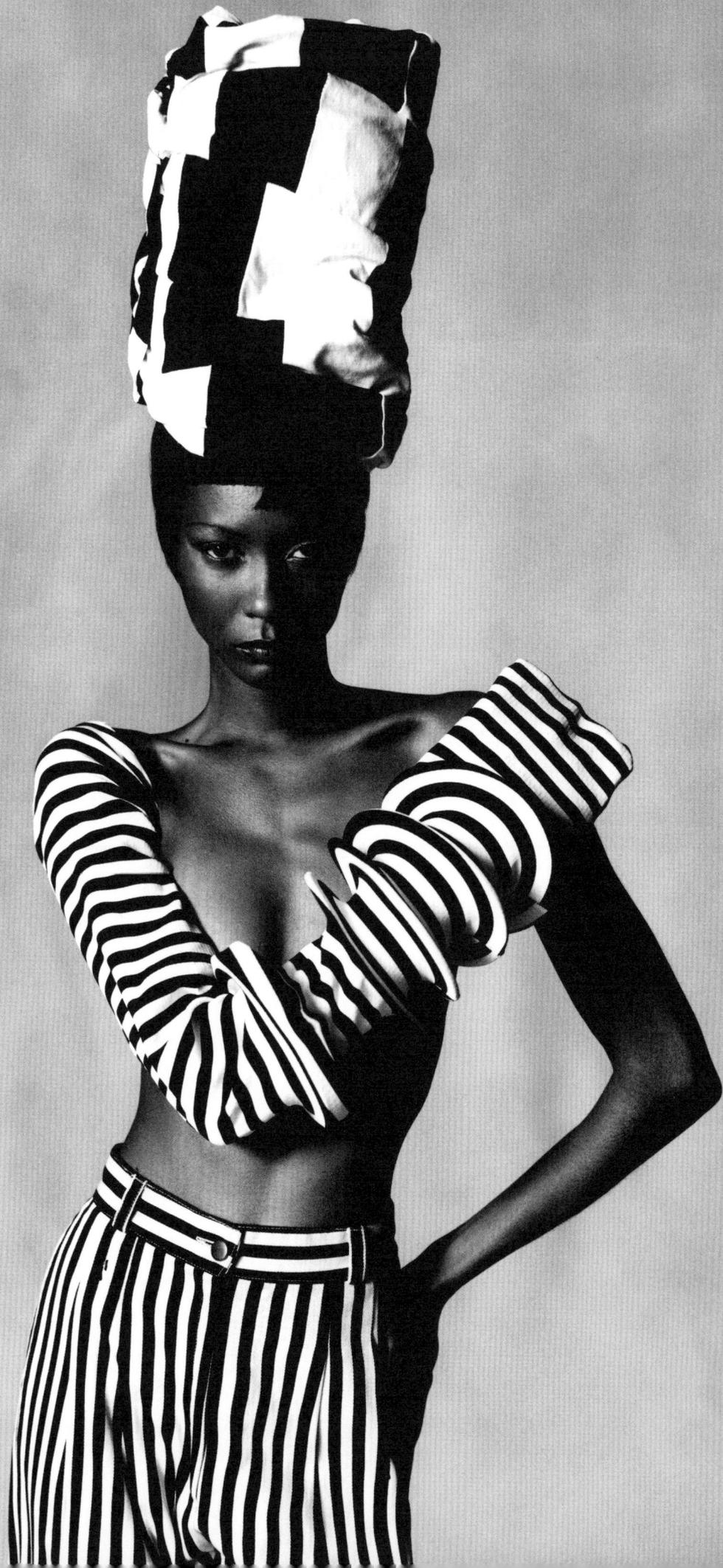

Mahany wears trousers by CASA JUISI, sleeves by PENHA MAIA and TUBAN DELLUM, shoes by MINHA AVÓ TINHA and a headscarf designed by the stylist.

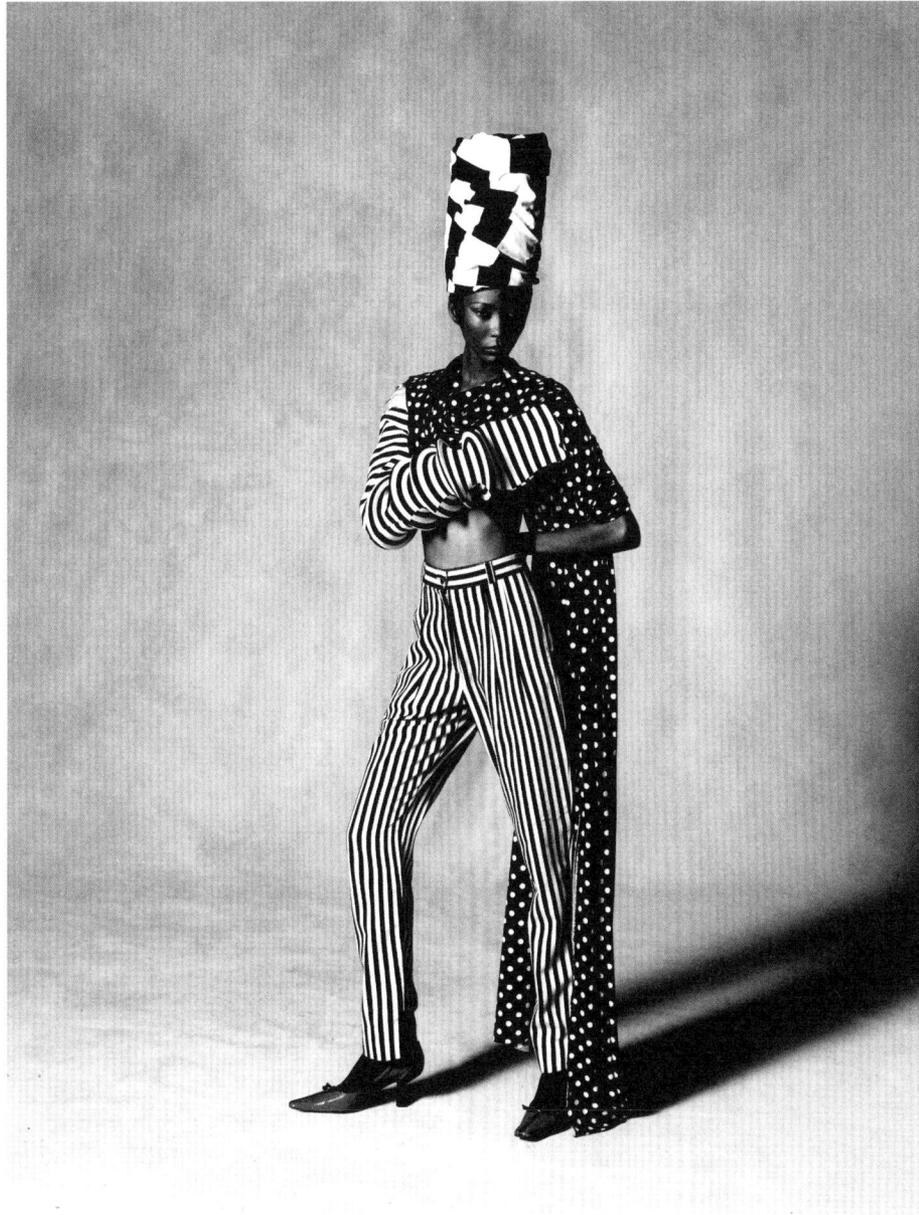

STUDIO VISIT: HAIDEE BECKER

Inside the London studio—and home—designed to provide all the inspiration one painter needs.

Words
PRECIOUS ADESINA
Photos
ALIXE LAY

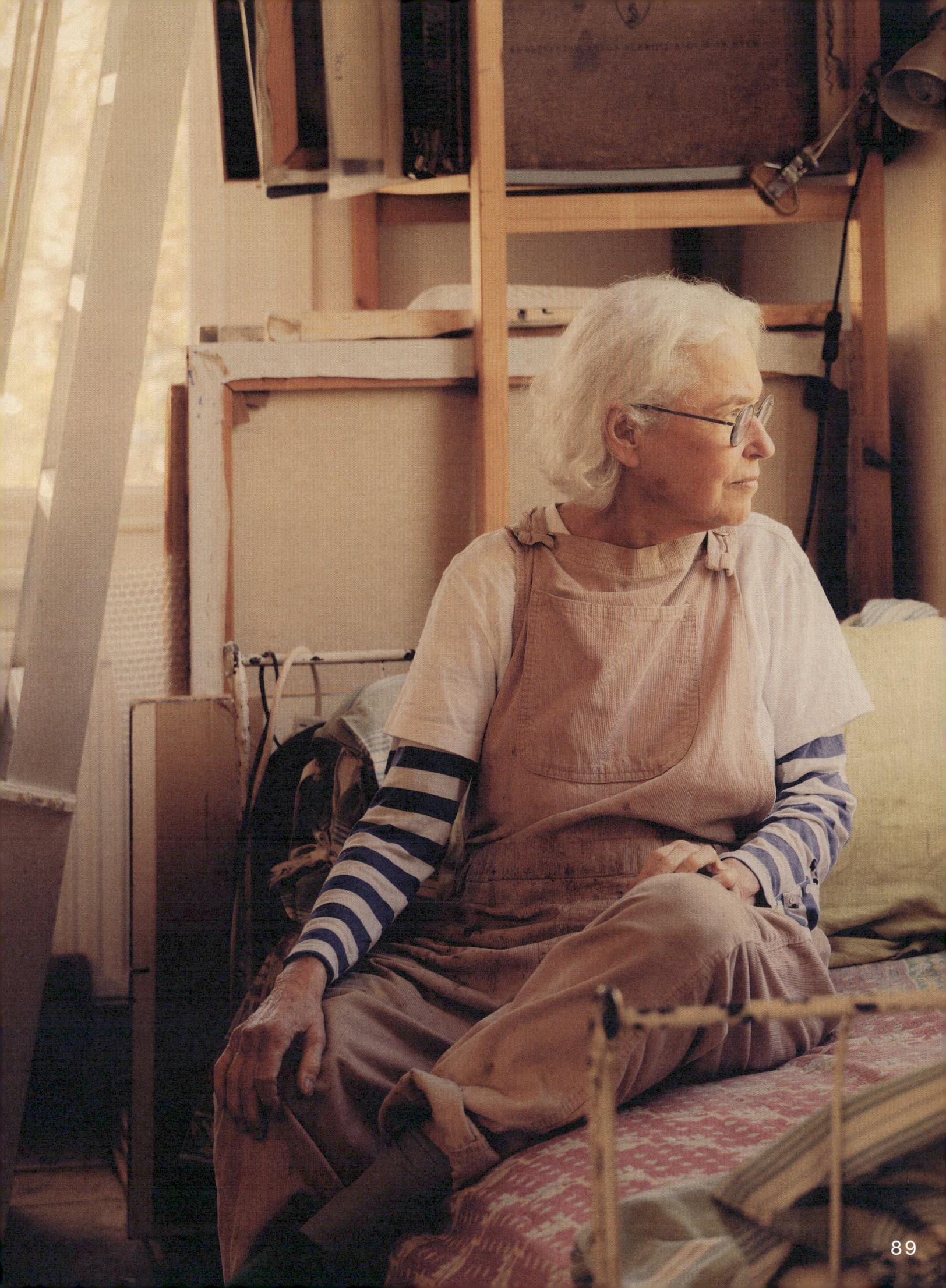

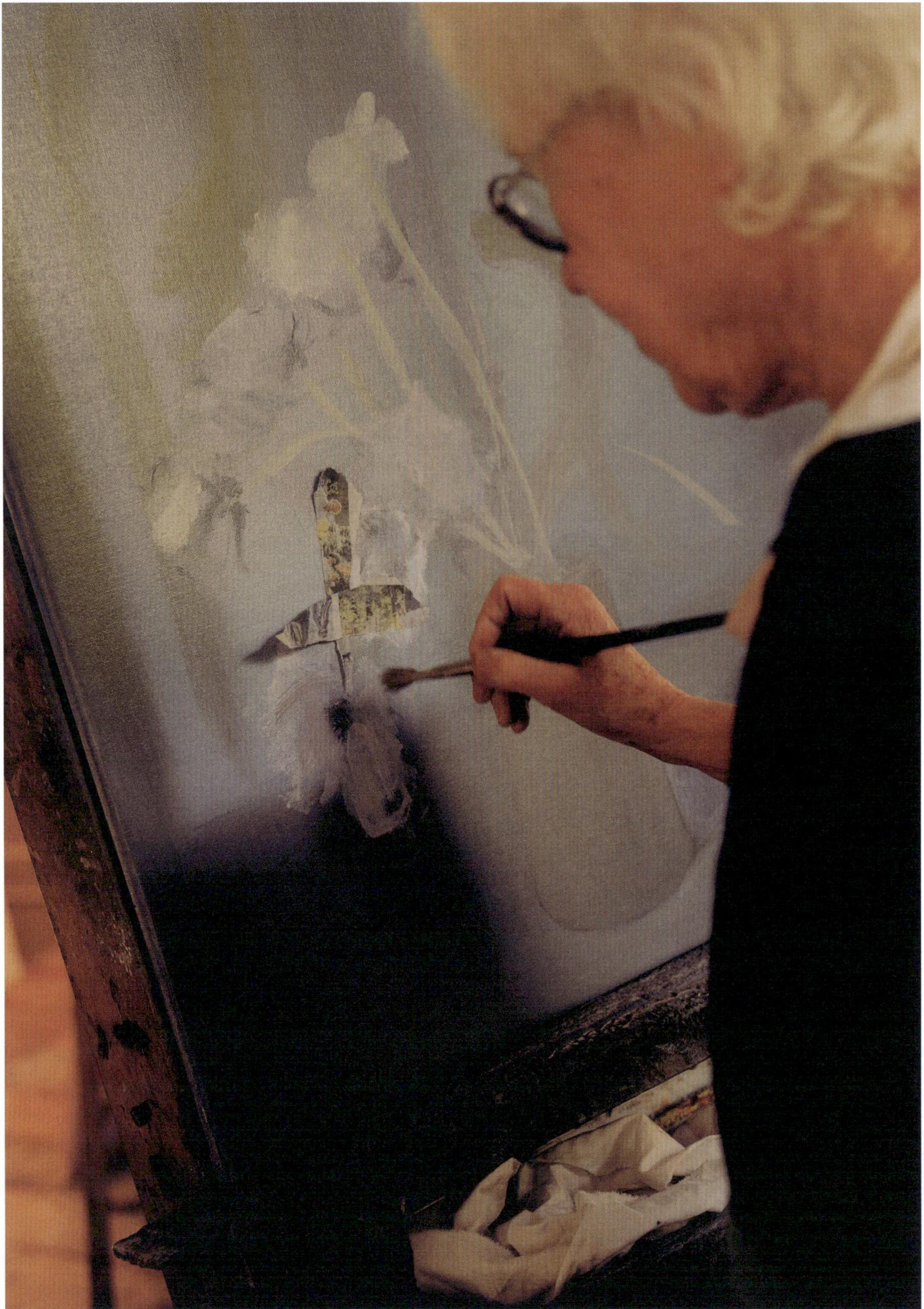

FEATURES

The first thing you notice as you enter Haidee Becker's quaint north London home-cum-studio is the large folding screen standing next to the stairs in the hall, painted with bold abstract shapes. "Don't you think that's amazing?" says the 74-year-old artist, noting that the work has stopped visiting art dealers in their tracks. "They would say, 'Oh, that's really good. Do you have anything more like that?'"

The work, as it turns out, was made not by the celebrated painter, in what would have been a departure from her carefully observed still lifes and portraits, but by her son, Jacob, when he was eight years old. "I learned to close it up and put it away when [the dealers] came," Becker jokes. Yet the screen sets a welcoming tone for the Victorian home that Becker now shares with Lobos, her dog. Her light-flooded studio, which occupies most of the second floor, is filled with Becker's paintings: contemplative works that cover the walls, rest against workbenches and are stacked on shelves. In the rest of the house, wherever the walls are not lined with books, she has hung art by friends and family, including other pieces by her now adult children—offering a chance, she explains, "to get away" from her own work.

Becker was born in Los Angeles and raised in Rome by her parents, the writer and gallerist John Becker and the Hollywood actress Virginia Campbell, before the family settled in London.[1] She began painting in the summer after her final year of high school when, as she says, she had little else to preoccupy her. "I started to do watercolors and I just got hooked." In place of a formal education, she copied paintings at the National Gallery. ("I went one day to an art school and I hated it so much.") The portraits and still lifes she has produced in the five decades since capture the beauty of the everyday, turning slabs of meat and fresh vegetables into searching meditations on life and death. The late poet Ted Hughes once wrote that her paintings have an "essential quality.... The revelation of a passionate inwardness."

Becker moved to her current home in 2019 after her partner, the British author Clive Sinclair, passed away, but she already had been looking for a new place prior. The previous home—a Georgian house—was impractical. "It was on four floors with one room on each," she says, explaining that there was never enough space for both of them to work and that she found herself bouncing from studio to studio. "I moved 10 times in 10 years because the studios didn't have the right light or were too small. It was just a nightmare."

Here, however, she has been able to design the space around her work as an artist. Little needed to change on the ground floor, which has an airy, high-ceilinged living room and study, and a kitchen with a dining area in a modern extension that leads out to the leafy garden. Upstairs, however, Becker enlisted the help of architect friends

(1) In Rome, Becker's parents hosted glamorous parties during which they staged marionette theaters. The pair made a strong impression on the film director Federico Fellini, who, according to Becker, offered her mother (and the puppets) a role in his 1960 movie *La Dolce Vita*. Campbell declined, but Fellini based two intellectual characters— the Steiners—on Becker's parents and replicated their apartment (even using their paintings) in the film.

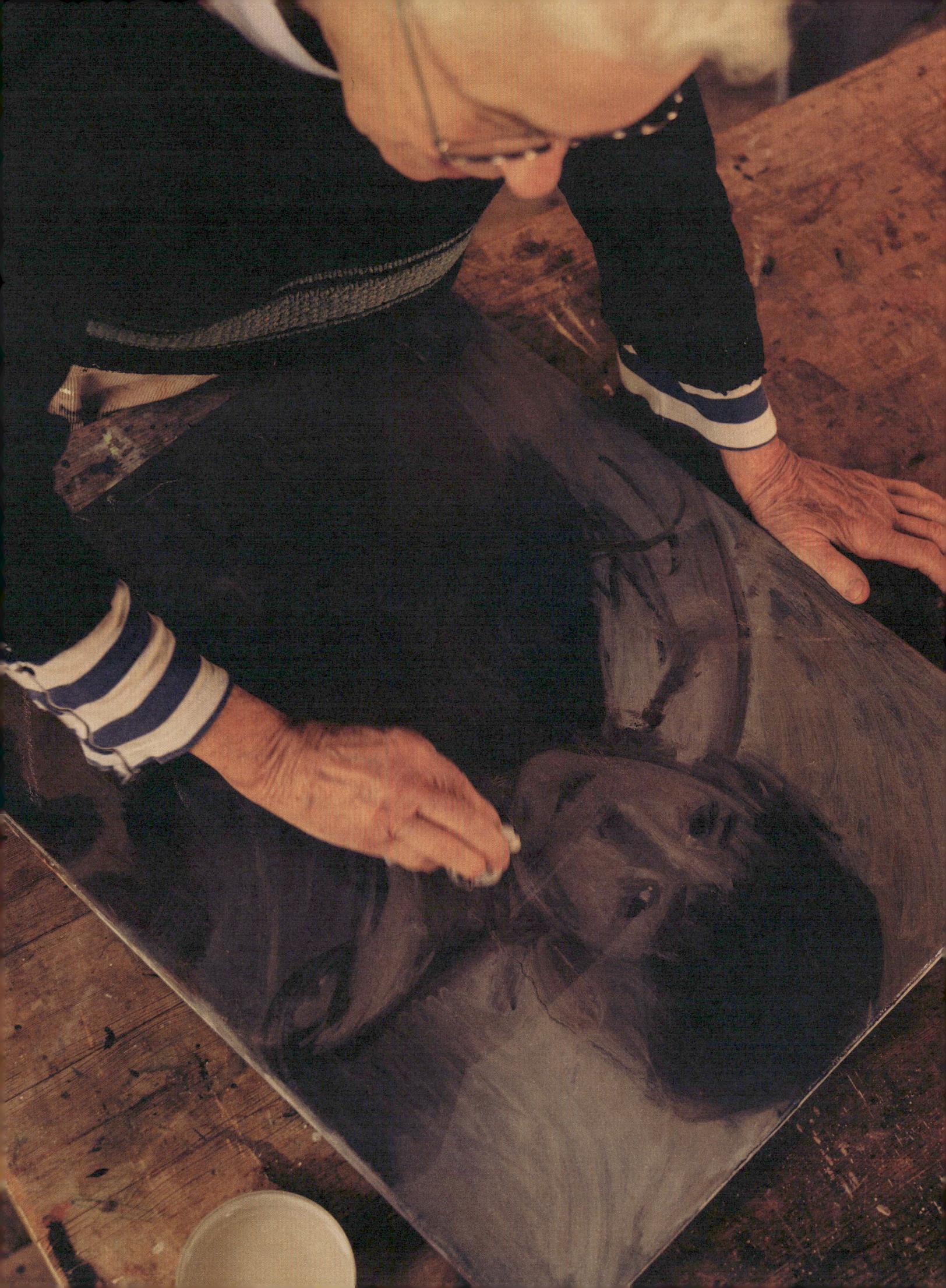

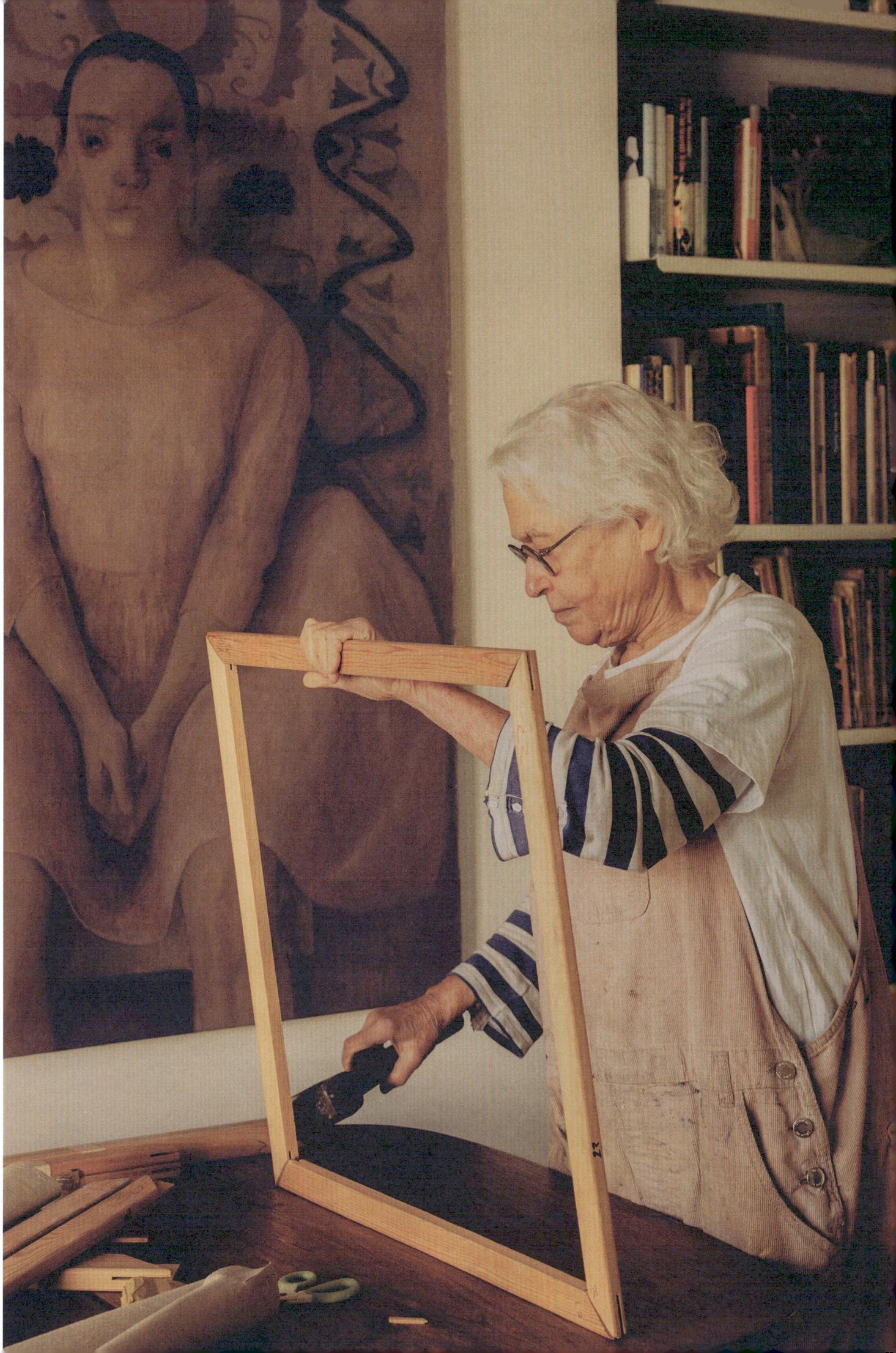

Johan Hybschmann and Margaret Bursa to create a spacious studio that, along with a small bedroom and bathroom, occupies the second floor. Even so, despite having "so much" space in this new studio, she still feels as if she could do with more. "There's not much room to hang paintings," Becker says, looking around at her work.

Two paintings made two decades apart do hang in the studio, however. *stewart 1* (1985) is a closely cropped portrait of friend and fellow artist Stewart Helm, who is depicted sitting in front of one of his own paintings and gazing into the distance. The brushstrokes are loose, the varied colors and shapes that compose his face made with quick precision. "When I was younger, I had a lot of anger and energy," she says. "It was much more passionate and explosive." It forms a contrast with *rachel* (2008). The subject, Becker's daughter, is sitting in a corner of the canvas, grinning at the viewer while slicing an artichoke, with vegetables and flowers scattered across the table in front of her. The painting appears to have been more strategically composed and the artist's hand is less apparent. "Now [my paintings are] much more contemplative and passive," she says. "I let the world in, which is, for me, a small world. It's the flowers or the plants or the meat, and people speak to me rather than me trying to dominate them."

(opposite)
Becker frequently uses flowers as still-life subjects. The British poet Ted Hughes once wrote that her works possessed an "essential quality" that revealed "a passionate inwardness" which he attributed to "a psychological depth of great sweetness, gently and powerfully focused."

"I let the world in, which is, for me, a small world."

The flowers and the other objects that litter the various worktops in her studio—plant pots, seashells, pieces of fabric—are echoed in more recent works. *hellebores in jug* (2023), is reminiscent of Van Gogh's still lifes, the muted greens and purples of the wilting flowers painted with bold and expressive gestures. "I usually go to Columbia Road [Flower Market] once every three weeks and get a shitload of flowers," she says, explaining that she'd been the day before, which is why the flowers were particularly fresh. "I paint a lot of flowers as [those works] sell best, but I go on painting them [after they begin to wilt], and they become very interesting to me in a different way." She relates the dying flowers to her own experiences of aging. "It's very strange getting old because you look at your body, and you don't recognize it, and it happens quite rapidly," she says. "Luckily, I like it. It is a strange, interesting process of disintegrating and changing."

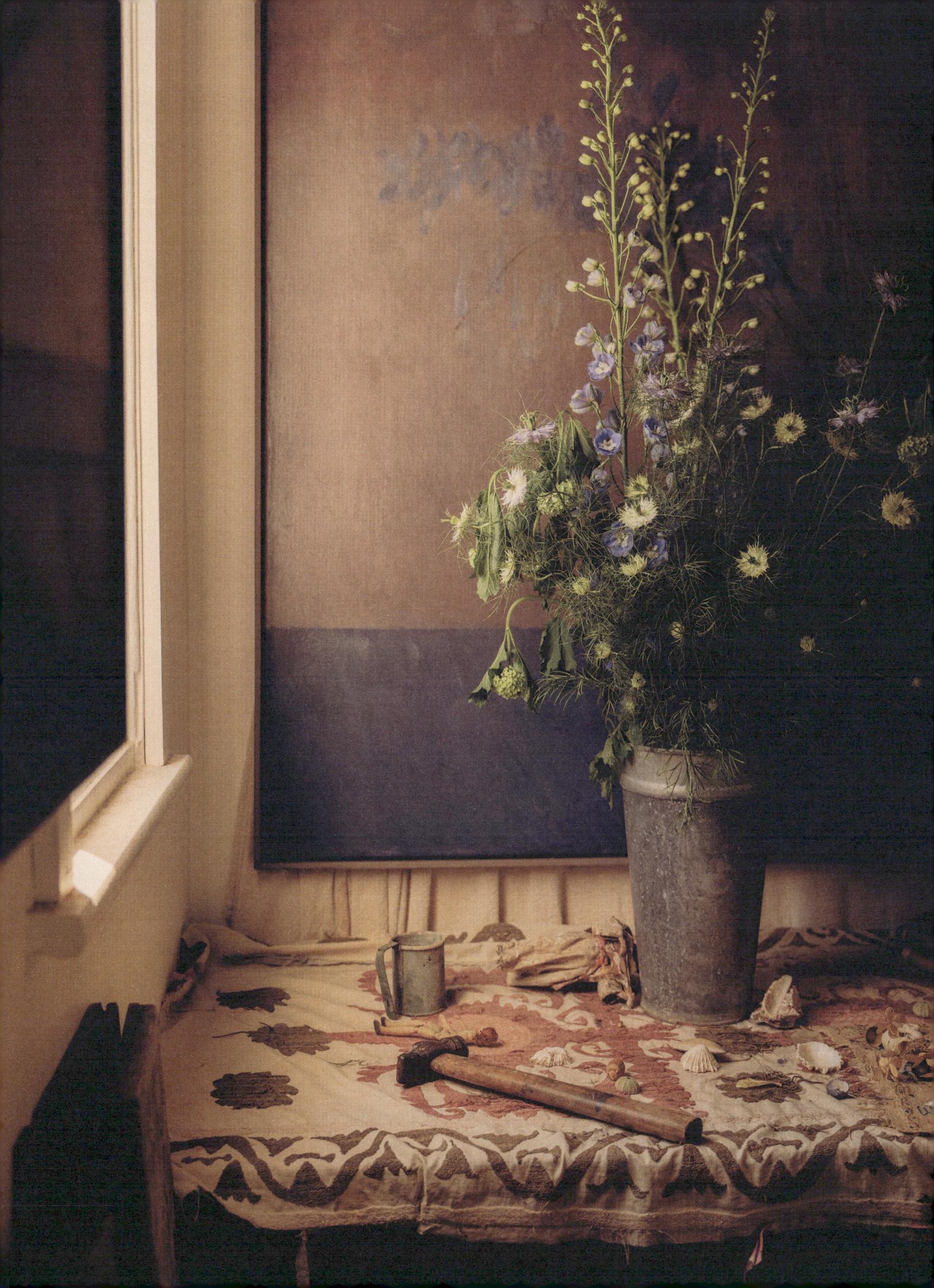

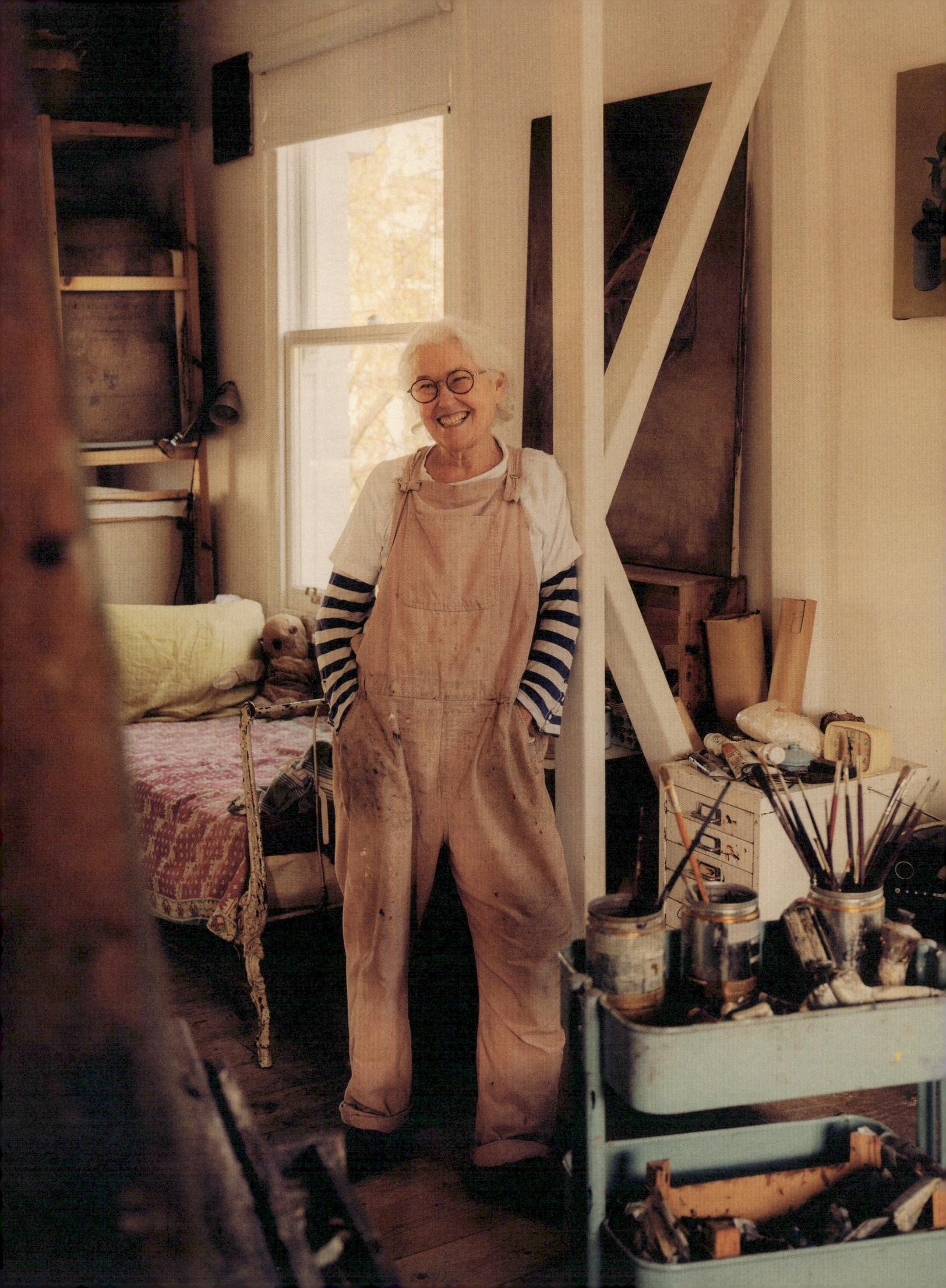

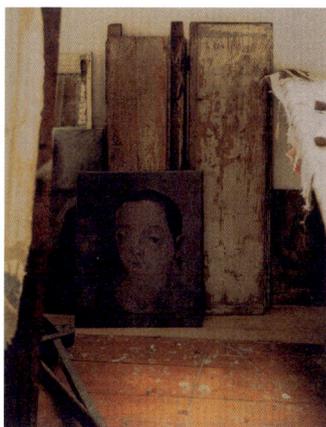

(opposite)
Becker at her current home in Stoke
Newington, where she has lived and
worked since 2019. "I work best in
places that have been used and are
old," she told Inigo's *Almanac* last year.
"A lot of the things I have in my studio
I've had all my life."

The artist says she tends not to place too much meaning on her work: "I read a lot, but I'm not a cerebral person, so I don't put anything into words—I find that if I try, it belittles it." But that hasn't stopped others offering their own interpretations. "People have said that they're not really about flowers. They're a story, and some of them are very dark." She pauses to think and adds, "I've been to very dark places, so I suppose I do express it in my paintings." Becker highlights the potential references to death. "You see the duck," she says, pointing to *meat and bay* from 2022, a large painting—it's almost six feet wide—depicting a table holding birds, eggs and a large slab of meat. "It's dead." She moves to another still life of meat from Bocca di Lupo, her son Jacob's restaurant.[2] "There's a lot of meat [in my work]," she says. "It has life and death."

Despite how some might interpret her paintings, Becker has carved out a space in her home and studio that's filled with joy and gives her essential time for contemplation. "One of the main problems of being a painter—and writers have written about it, too—is that in order to work, you have to turn your back on life outside, though what makes you want to work *is* the life outside," she says. "So you're constantly stuck in this conflict of inside or outside, or being engaged or solitary." Her friend encourages her to leave the house more, saying that what keeps one alive and young is meeting and talking to people. "It's not good for you to be on your own," she tells Becker.

Becker points to Lobos, who has spent the past hour and a half following her every move. "But, you know, everybody's different. And I'm not on my own. I live with him."

"I've been to very dark places, so I suppose
I do express it in my paintings."

(2) Becker's son is chef and restaurateur Jacob Kenedy, who opened Bocca di Lupo in London's Soho neighborhood in
2008. Off the back of its success, he has since opened a gelateria, Gelupo, and Plaquemine Lock—a gastropub on
the Regent's Canal that has received Michelin's Bib Gourmand award three years running. He is also the author of
three cookbooks, including *The Geometry of Pasta*.

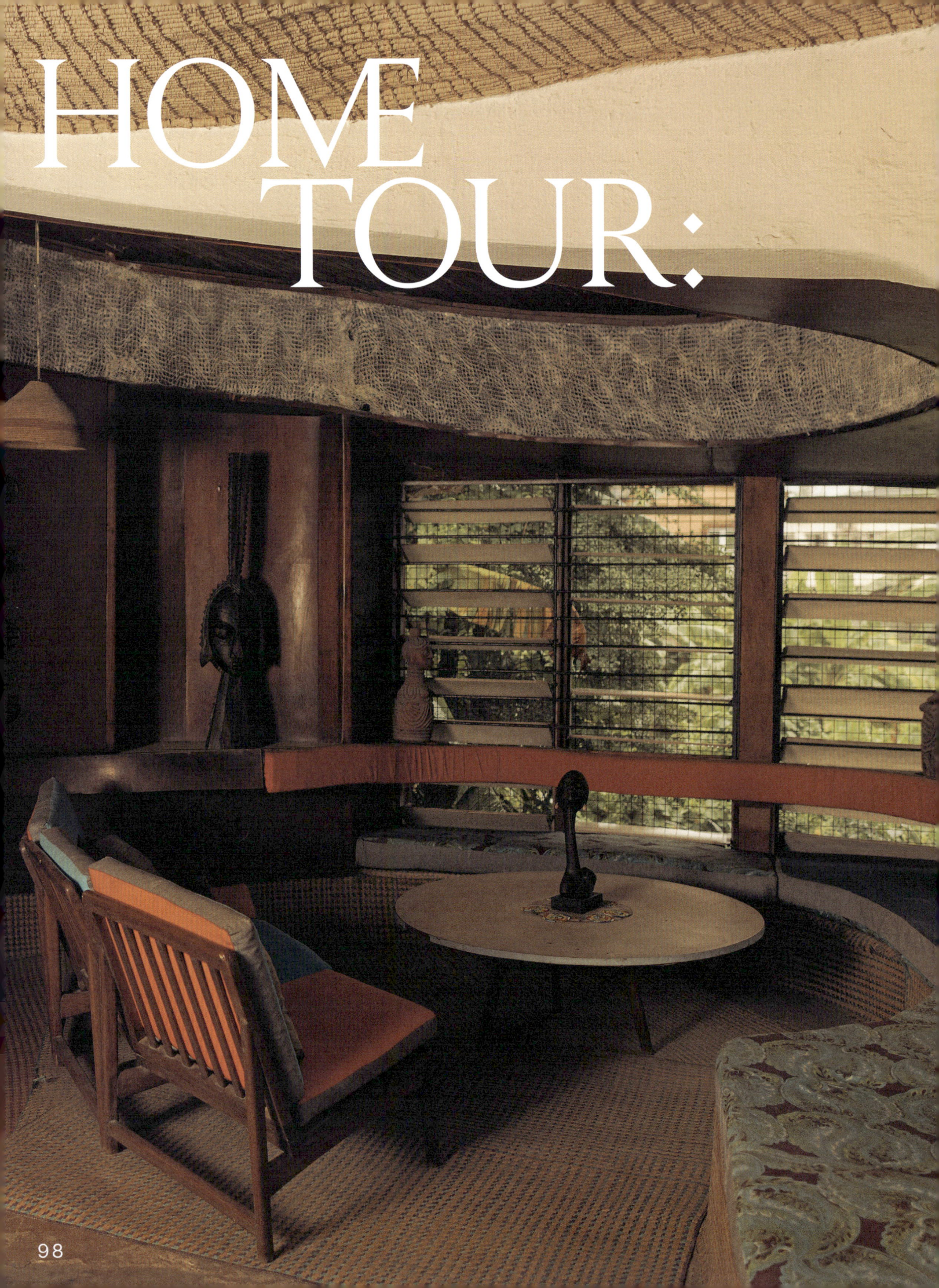

HOME TOUR:

THE ALAN VAUGHAN-RICHARDS HOUSE.

Words JAREH DAS Photos CHRISTINA NWABUGO

Standing defiant against the city that has grown around it, one architect's experimental Lagos home has become a quiet monument to the ideas and family he built it for.

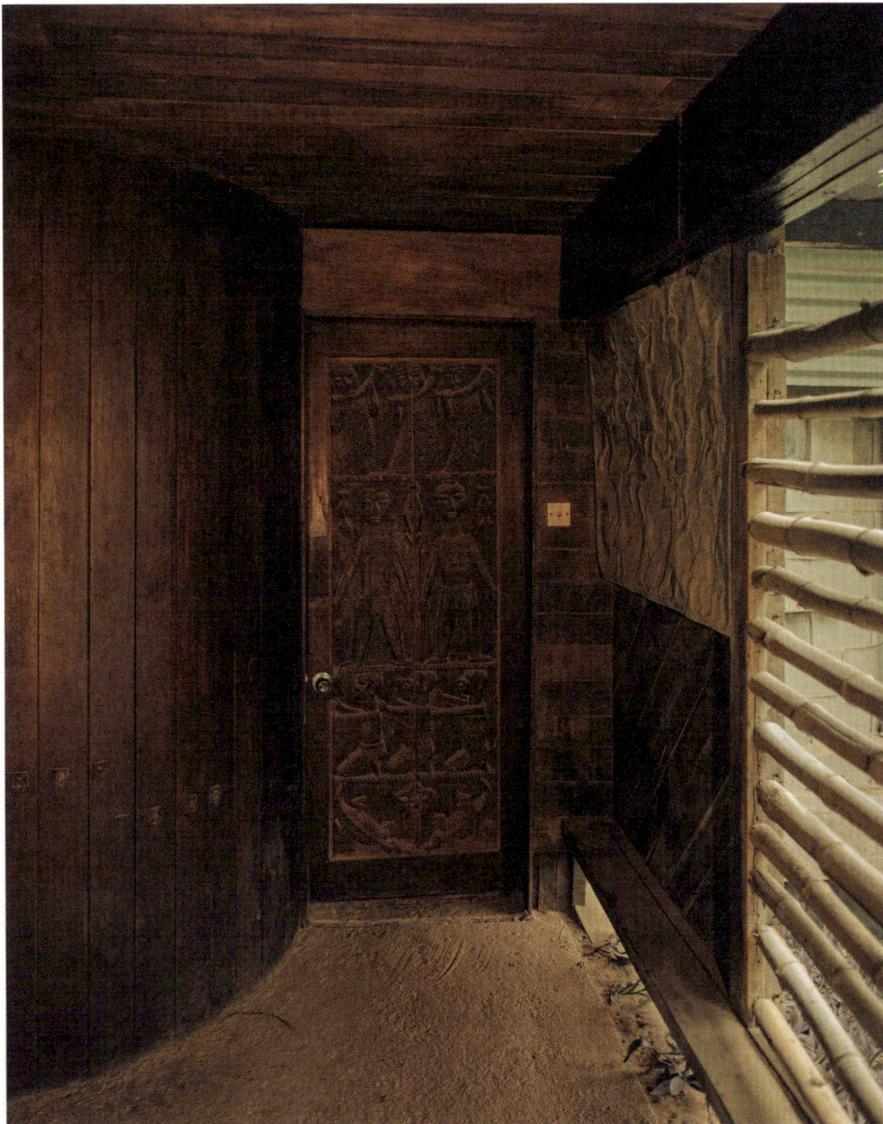

Alan Vaughan-Richards first came to Lagos in 1956 as a fledgling associate with the Architects' Co-Partnership, a firm of recently graduated students from the Architectural Association School of Architecture in London. He had already spent time working with the Iraqi Development Board and on projects for Oxford University, but it would be in Nigeria that he would make his mark. Over the next 30 years, he would come to play a key role in shaping the city's urban fabric—first with Architects' Co-Partnership and then, following Nigerian independence in 1960, leading his own practice and helping to develop a distinctly Nigerian form of modernist architecture.

Along with the masterplan and various buildings he designed for the University of Lagos, the house Vaughan-Richards built for his family in the affluent neighborhood of Ikoyi is considered one of his most notable projects. It originally consisted of just five circular interconnected spaces made from concrete: The first, Vaughan-Richards' office, leads to the primary bedroom and then to the children's room. The fourth area is divided in two—a narrow corridor with a bathroom that leads from the children's room and a kitchen, both of which open onto the fifth space, a living room with a seating area cantilevered over a vast garden filled with fruit trees, plants and flowers. There are few straight lines anywhere in the house.

"The house really flows from one room to the next," says Remi Vaughan-Richards, a filmmaker and the architect's daughter, who still lives in the house. "But there was no privacy for us growing up—it was very much a home for a couple with young

children." Later, Vaughan-Richards added a second floor, accessed via a solid wood spiral staircase, with additional bedrooms and a study, each with large, louvered windows that shaded the rooms from the sun while enabling cross ventilation.

It's just one of the many ways that the house responds to its environment, a key tenet of tropical modernism, which adapts the principles of modernist architecture to tropical climates. Vaughan-Richards had studied at the Architectural Association's Department for Tropical Studies, which had been established in 1954 by leading modernists including Maxwell Fry and Jane Drew to promote the style. For them, West Africa had been a laboratory—a place to experiment with the use of louvers and brise-soleils to manage the heat and humidity—but they had neglected to engage with local architectural traditions. Fry even wrote that "there seemed to be no indigenous architecture" in the region; that it was up to Western architects to "invent an architecture which specifically met the needs of the West Africans." The Vaughan-Richards house demonstrates that that was never the case.

"Tropical modernism influenced my father's ideas, but he challenged their design principles with this house," says Remi. "He moved away from the rigidity of lines and geometry characteristic of the movement. Instead, he expressed himself by modifying the house as our family grew with it." The techniques to shade the windows and encourage ventilation may have been drawn from tropical modernism, but other elements take inspiration from traditional Yoruba architecture, such as the ceilings of the circular rooms, which are made with palm fronds. Vaughan-Richards also collaborated with various artists and sculptors to produce the furniture, pillars, decorative panels and the carving on the front door, which depicts the house, surrounded, as it once was, by the lagoon, complete with fishermen and a forest with monkeys. The house is also filled with local Yoruba and Indigenous artwork; the masks, figures and earthenware pots curated by Vaughan-Richards and his wife, Ayo. "It is very much an experiment in mixing the two cultures," Remi adds. "He was really ahead of his time."

Thanks to Remi's efforts to preserve her father's legacy, the house remains a testament to that experimental and open-minded vision. Little has changed since Vaughan-Richards' death in 1989, even if the city outside its unassuming concrete walls and gates adorned with motifs inspired by traditional Yoruba textiles is unrecognizable. "The area was once a sleepy fishing village, with a lagoon right in front of the house and accommodation for University of Lagos professors on our street," says Remi, explaining that the lagoon has now been reclaimed and is being developed.

Still, there are plans to open the house further, and the geodesic dome in the garden was recently host to an exhibition of contemporary art, something Remi was motivated to do when she discovered her parents begun to hold exhibitions at the house shortly before her father's death. With more exhibitions in the works, the house is set to have a new lease on life, albeit one that will be very much in keeping with its past.

" My father expressed himself by modifying the house as our family grew with it."

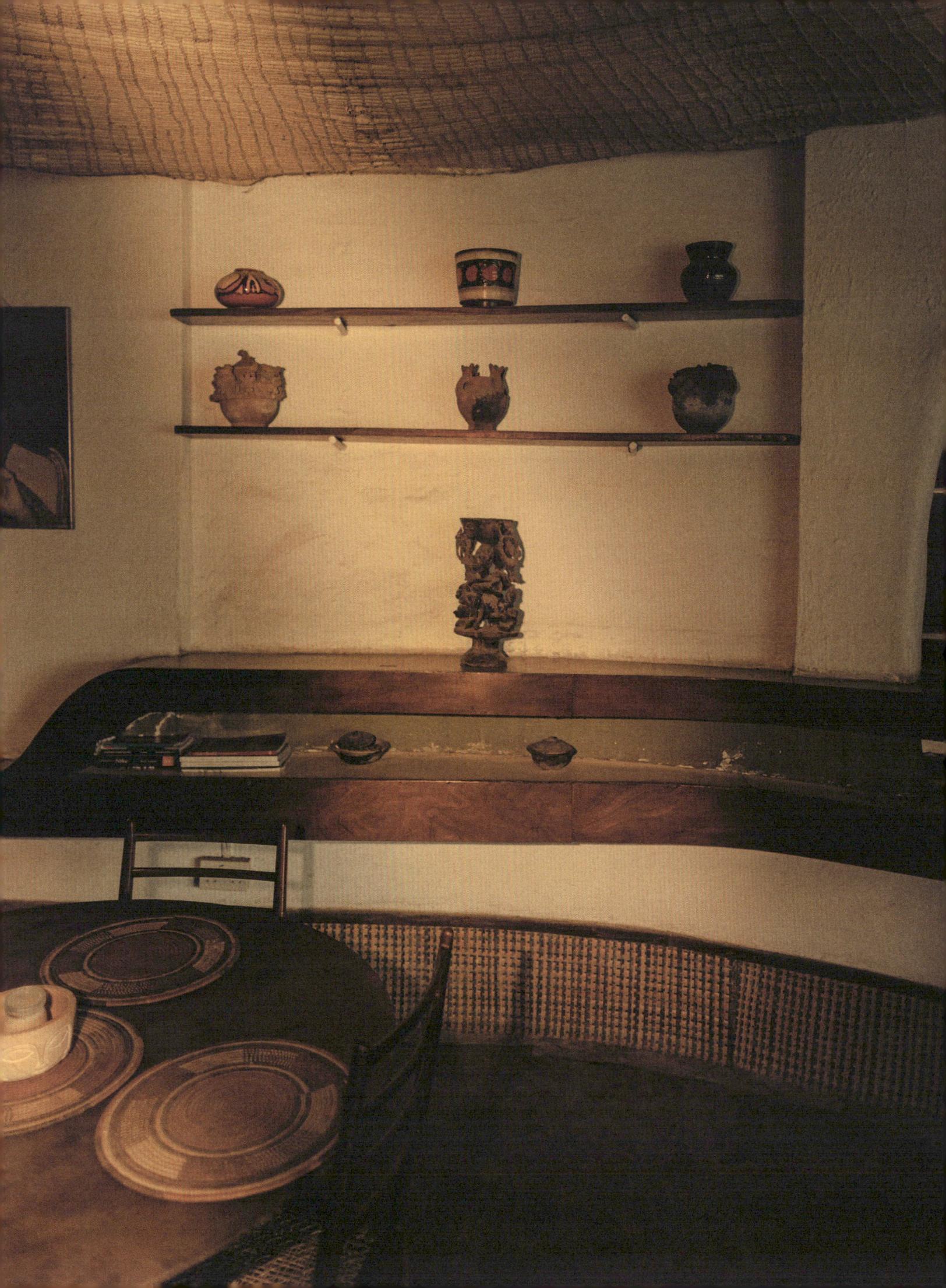

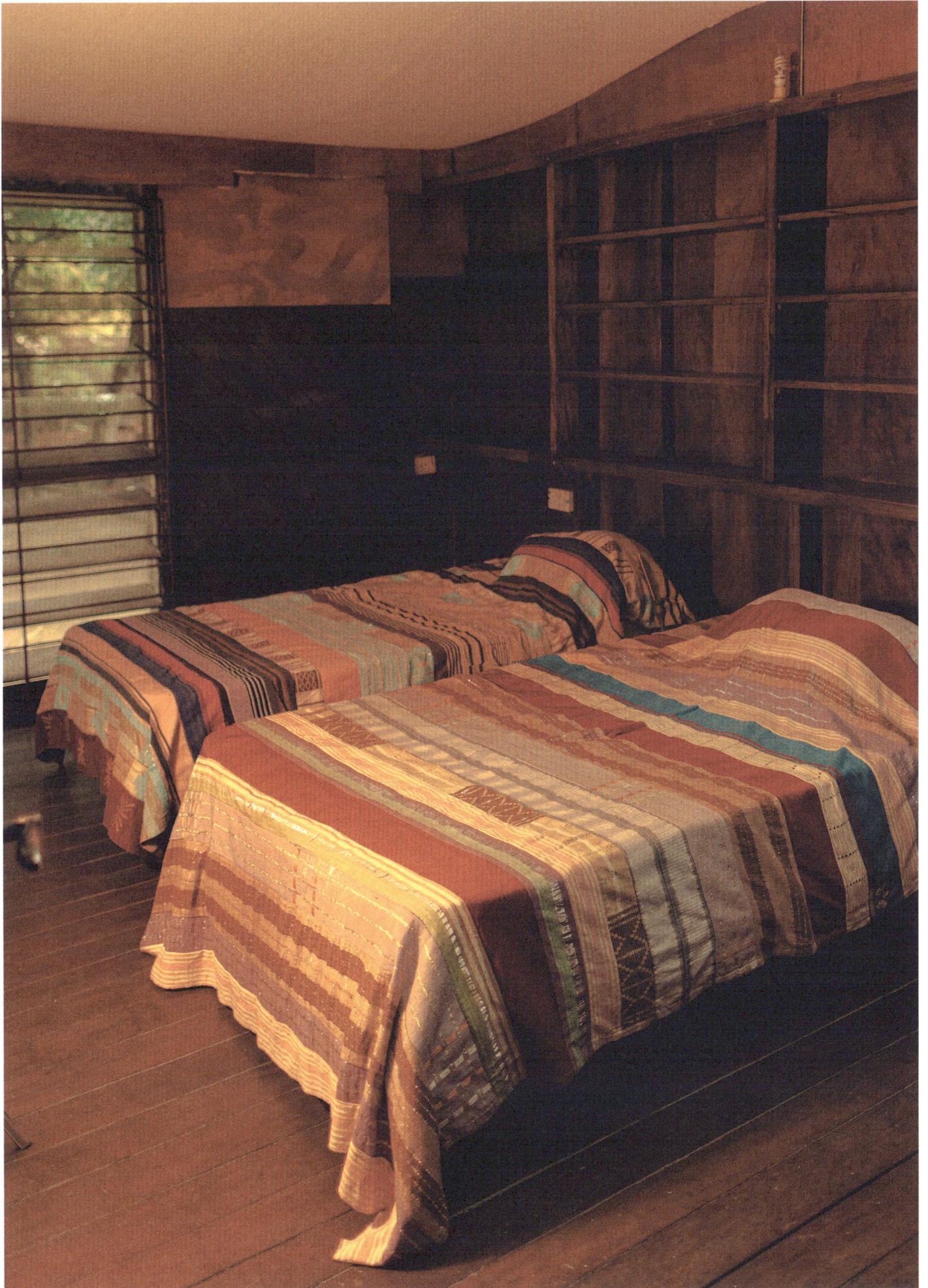

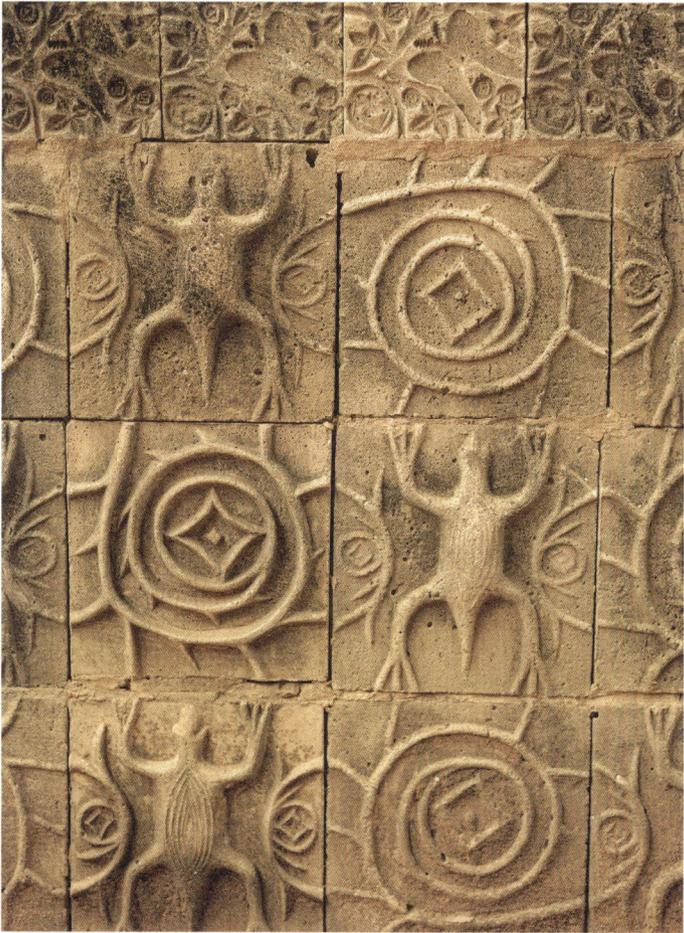

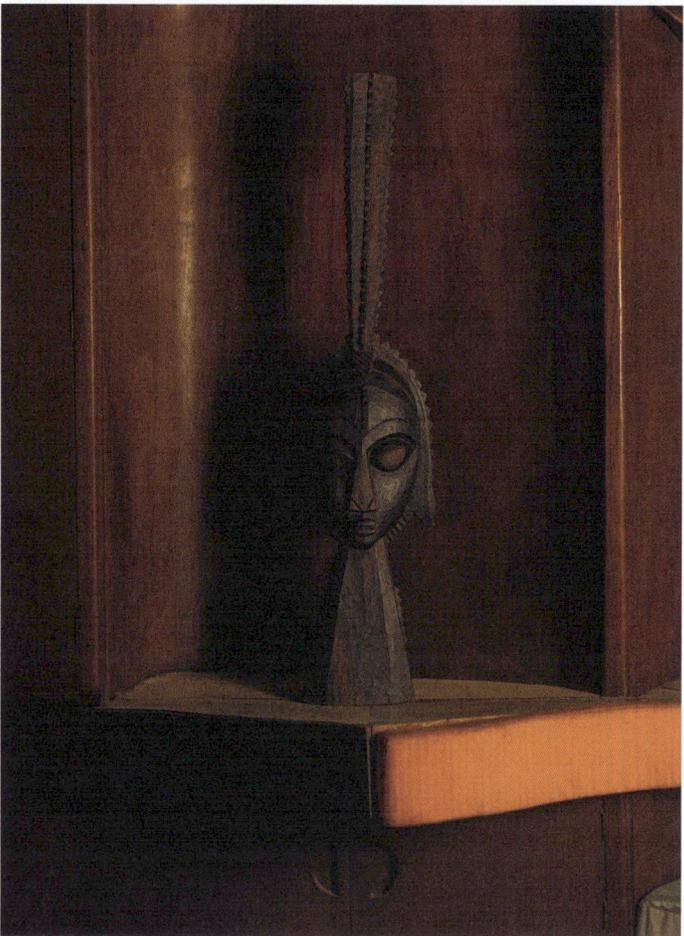

(opposite) Adjustable louvers are a hallmark of tropical modernist architecture, offering protection from sun and rain while allowing natural ventilation.

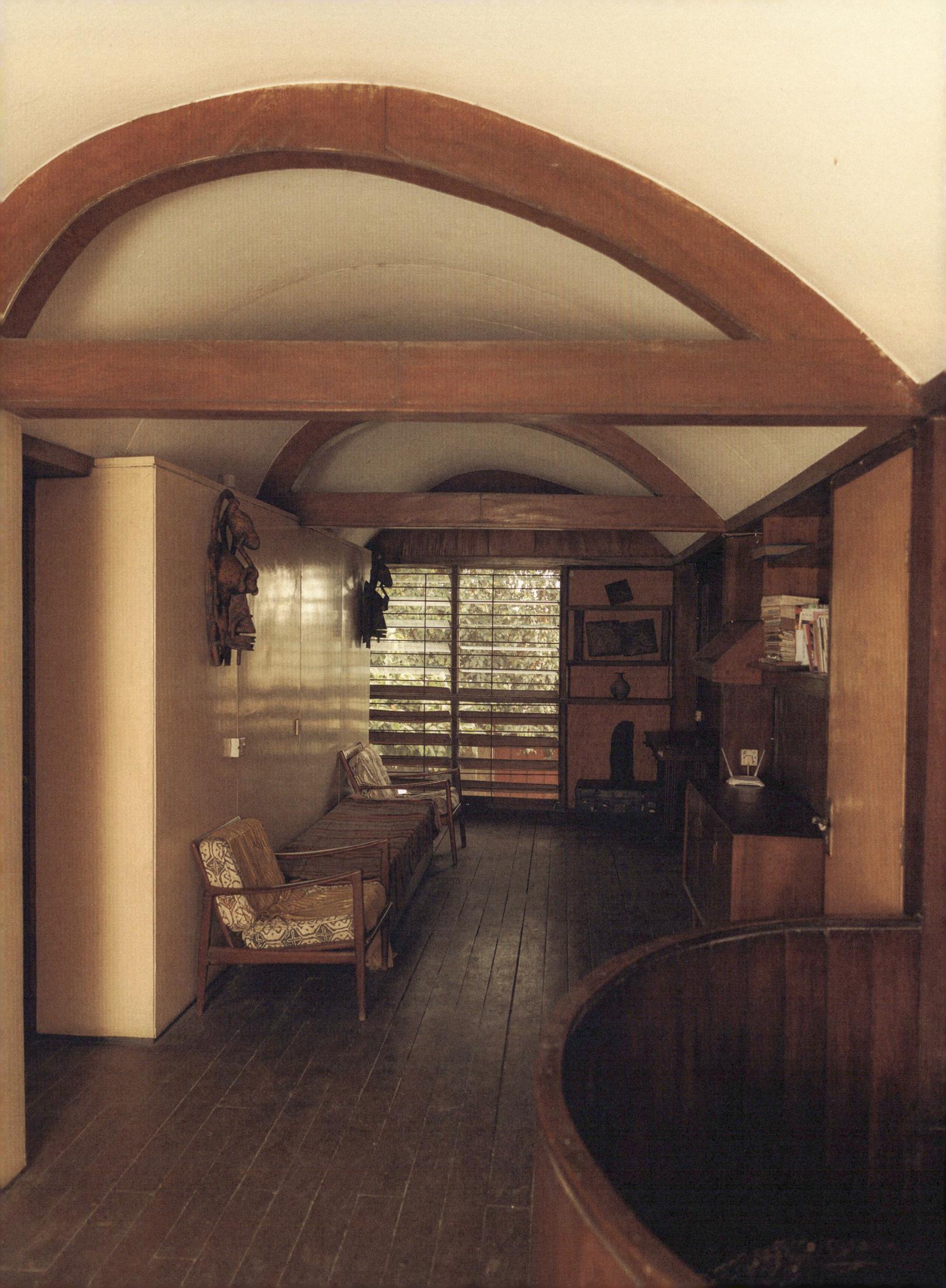

107 WAYS OF SEEING

Photography
AARON TILLEY
Styling
SANDY SUFFIELD

Photo Assistant: Lucas Aliaga-Hurt

(above) A Georgio Morandi moment during morning ablutions.
(opposite) Yayoi Kusama casts a long shadow.
(previous) The washing up creates *A Bigger Splash*.

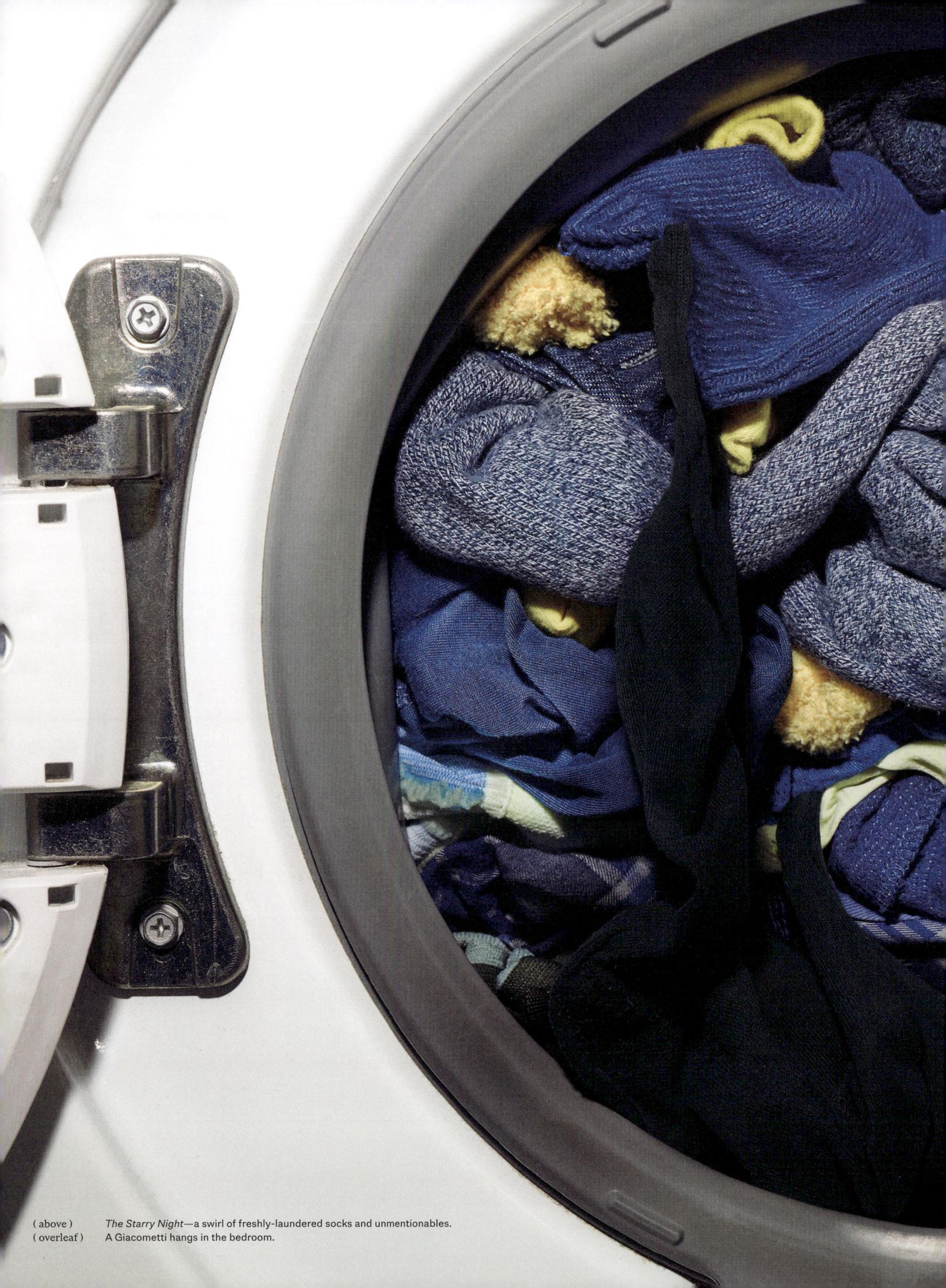

(above) *The Starry Night*—a swirl of freshly-laundered socks and unmentionables.
(overleaf) A Giacometti hangs in the bedroom.

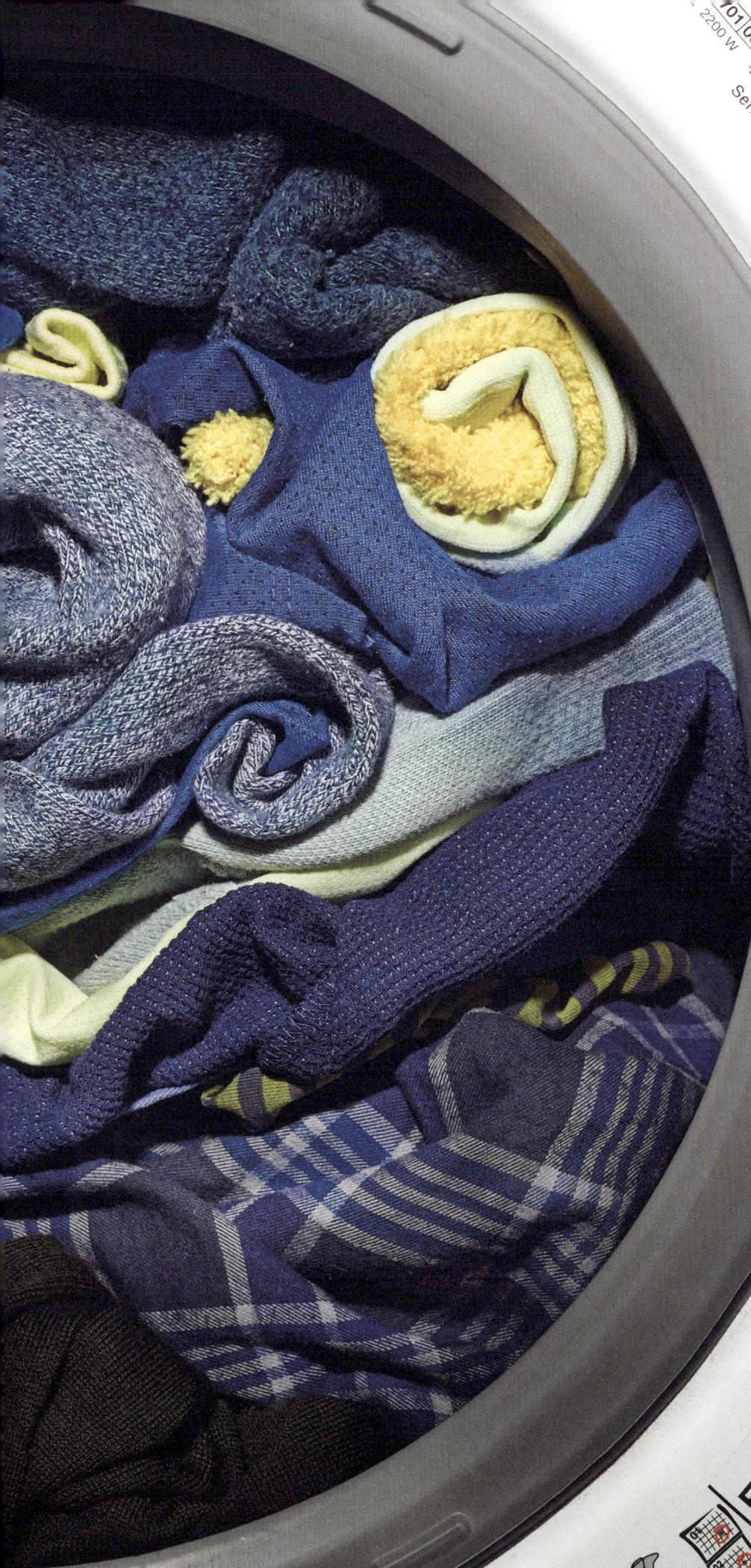

Type FLI554142

2200 W

101 00

Ser. No. 606 00016

13A IPX4 CE

132 015 071

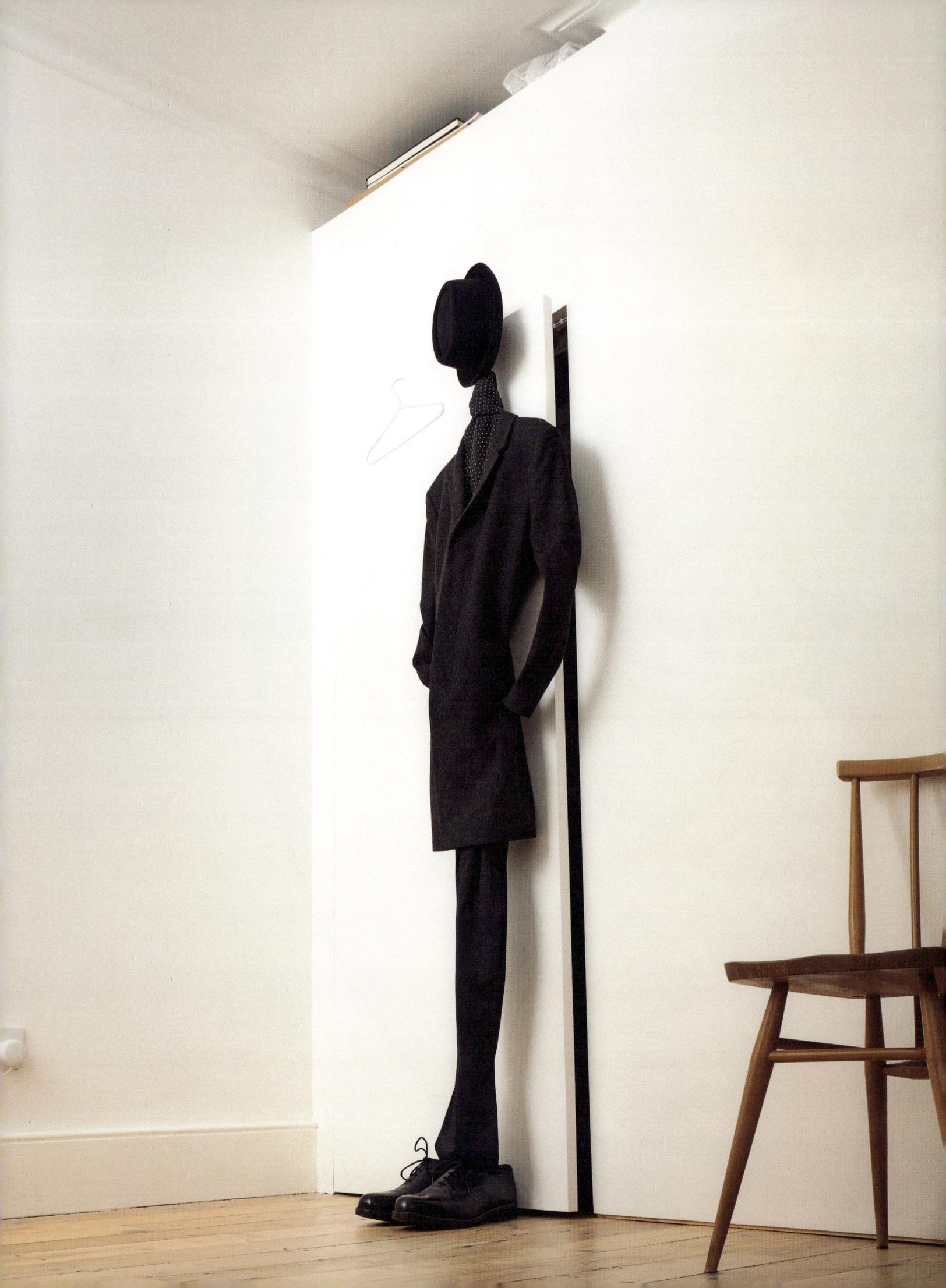

서울시티가이드
Seoul City Guide

ALSO INSIDE:

114 — 160

CONTRIBUTORS:

WRITERS
AB — Ann Babe
FB — Fiona Bae
RR — Raphael Rashid
GU — George Upton

PHOTOS
Hong Kiwoong

116
NEIGHBORHOODS:
Seoul's most exciting neighborhoods, including the concept stores of Seongsu, Seochon's traditional *hanok* houses, the side-street bars of Euljiro and Itaewon's thriving nightlife scene.

138
BEAUTY:
A pioneering skincare clinic, a restorative scalp-treatment and a viral color consultation: Seoul's booming beauty industry.

140
OBSERVATIONS:
The city through the eyes of pioneering designer Choi Byung Hoon and experimental makeup artist Oh Seongseok.

서울시티가이드

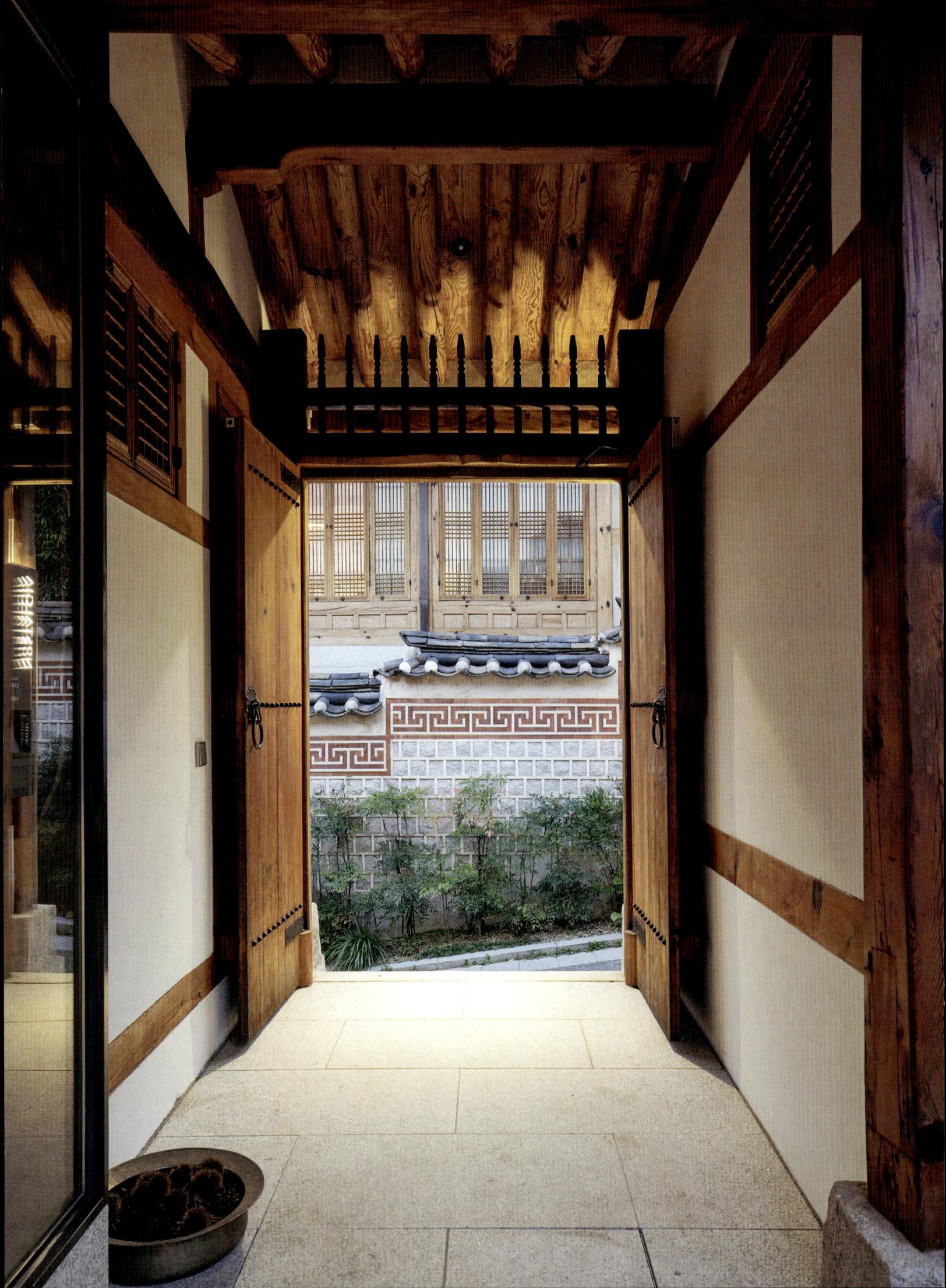

소개

Introduction

Seoul is having a moment. Over the past few decades, this sprawling city of nearly 10 million people—or, if you include its greater metropolitan area, half of South Korea's population of 52 million—has experienced a remarkable transformation. After being ravaged by the Korean War and then reshaped by rapid urbanization, the South Korean capital has emerged in the 21st century as an innovative hub for the arts; a place imbued with a creative energy that's palpable in everything from its contemporary architecture and concept stores to its thriving specialty coffee scene. Yet as Seoul continues to change, it remains mindful of its past, restoring ancient palaces and conserving its historic buildings to create a fascinating juxtaposition of old and new that's set, as it always has been, on the banks of the Han river and against a backdrop of untouched mountains.

Seoul's recent boom reflects South Korea's rise as a cultural powerhouse. For decades, the country had been in the shadow of its more influential neighbors, Japan and China. Yet the nation's newfound economic prosperity in the 1990s brought increased investment to its entertainment industry, planting the seed for what came to be known as the "Korean Wave." Having first found success in Asia for their resonant themes and storytelling, Korean dramas and pop music (K-drama and K-pop) have gained significant momentum within the last decade, transcending language barriers to bring worldwide recognition (and wildly enthusiastic fans) to bands including BTS and Blackpink, TV shows like *Squid Game* and movies such as the Oscar-winning *Parasite*.

The international success of Korean culture reflects the outward-facing optimism and creative energy of modern-day South Korea, but there is still a memory of a less prosperous time. Many people reflect on a divide between the generation who grew up during the Korean Wave and those who experienced the hardships of the previous century. The brutal occupation of the Korean Peninsula by Imperial Japan, where Korean culture was systematically oppressed, was followed by the Korean War (1950–1953), which left Korea divided in two and among the poorest places on Earth. In 1987, after decades of dictatorship and economic hardship, South Korea became a democracy again and experienced what has come to be called "the Miracle on the Han River." The rapid economic development transformed the country from being a recipient of aid to a donor nation in just a few decades. It now ranks among the world's richest countries.

All this can be read in the fabric of Seoul—in the restoration of the opulent Gyeongbokgung Palace that was destroyed by the Japanese and replaced with a since-demolished government building; in the bustling international neighborhood of Itaewon, shaped by the influence of the neighboring US military base; and in the rows of identical high-rise apartment blocks, built in response to the city's rapid growth and differentiated only by a three-digit number on their side. But these historic layers now intersect with dynamic shopping and leisure districts that are transforming former industrial areas and the experimental contemporary architecture of art galleries, luxury brands and Zaha Hadid, the late British-Iraqi architect who designed the amorphous form of the Dongdaemun Design Plaza.

The city is home to some of the most important galleries in Asia—not to mention the Asian base of many leading European and American galleries—and in 2022, the art fair Frieze launched in the capital. Equally vibrant is its gastronomy scene: The Michelin Guide published its first edition on the city in 2017, reflecting its emerging importance as a center of creative fine dining, and efforts are underway to have the traditional Korean rice wine *makgeolli*, which has been rediscovered and renewed by Seoul's bars and breweries, listed as a UNESCO Intangible Cultural Heritage. It's a spirit of innovation that's also evident in the city's café culture, characterized by high-quality coffee, playful design and increasingly eccentric pastries.

Seoul is surprisingly livable, given its size. It remains possible to eat and drink out without prohibitive prices, and the transportation system is efficient and easy to use. Nature, in this fast-paced, 24-hour city, is never far away; the mountains, a striking presence on the skyline, are easily accessible via bus or subway.

The conveniences and contradictions of life in Seoul reflect the generational shifts reshaping the city. While deeply rooted traditions and a conservative social fabric remain, the dynamic youth are challenging these norms and driving change, advocating for greater equality and diversity, and catalyzing Seoul's evolution into a metropolis with an increasingly global outlook.

The pace of change in the city—the result of decades of hard work and innovation—is showing no signs of slowing down and there are ambitious plans to grow its international renown. For now, though, Seoul offers quite enough for the curious, engaged traveler to explore.

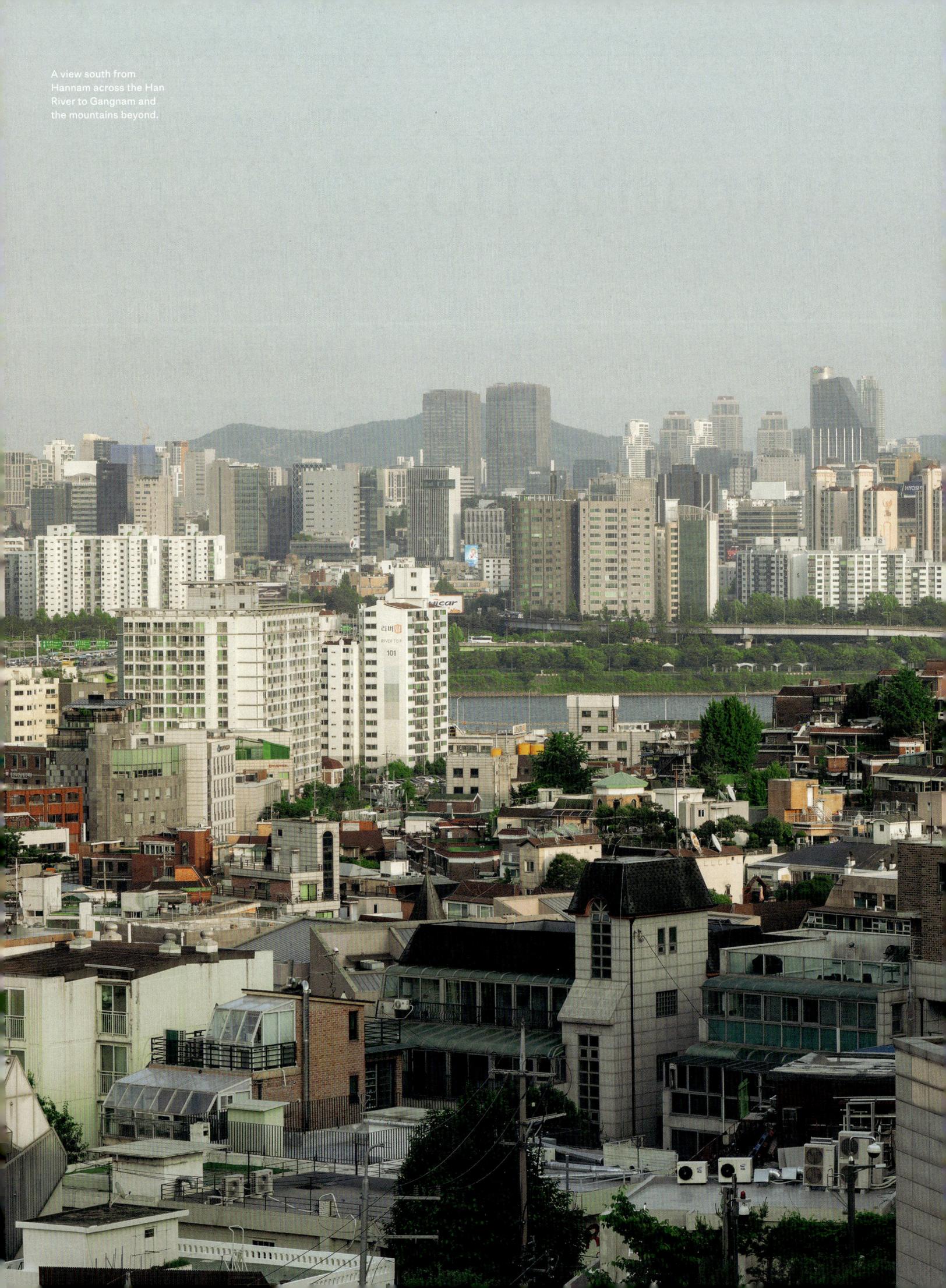

A view south from Hannam across the Han River to Gangnam and the mountains beyond.

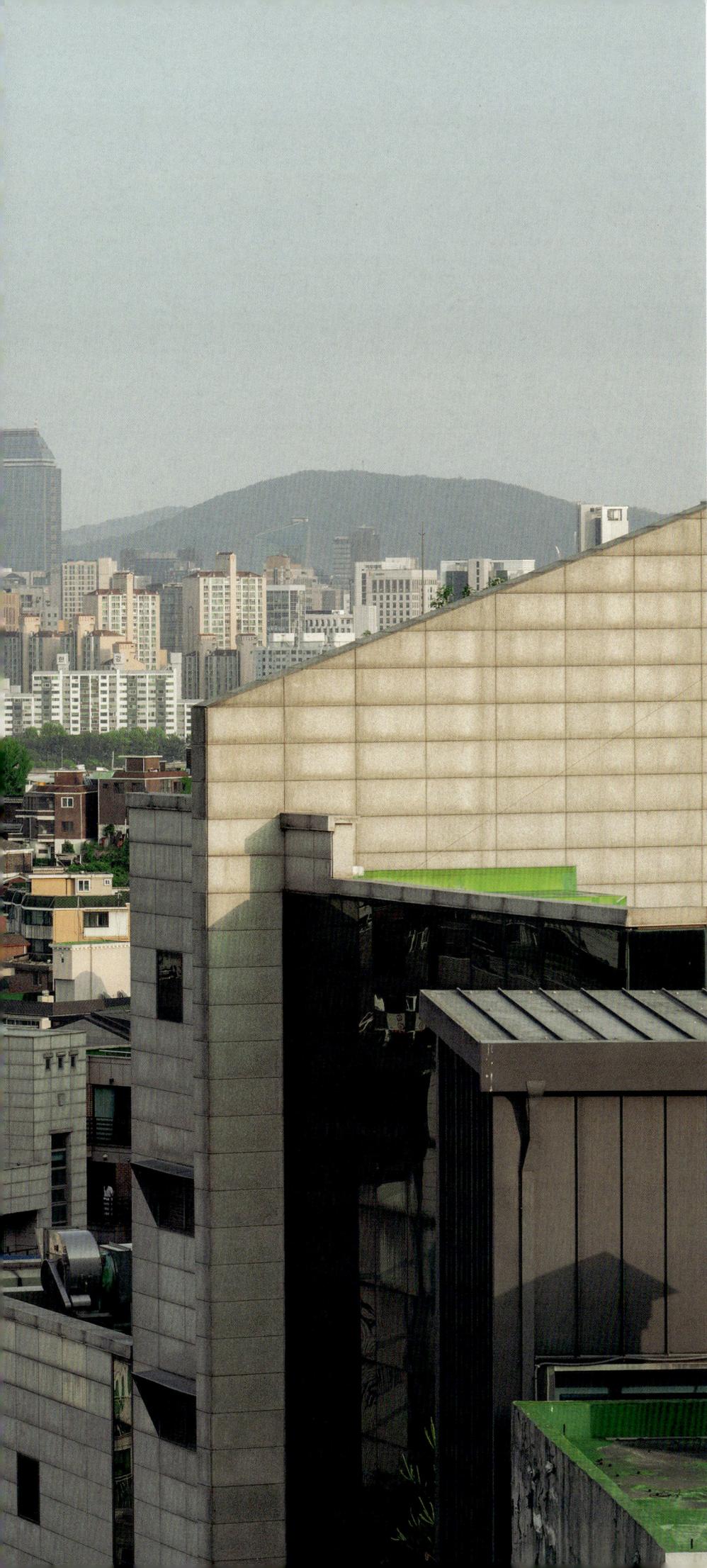

Seongsu

Located just north of the Han River in the east of the city, Seongsu is undergoing a dramatic transformation. What was once a gritty industrial area is becoming increasingly trendy. On Yeonmujang-gil, the main shopping street, mechanics and hardware stores sit alongside purpose-built, high-end concept stores, pop-up shops and specialty coffee roasters, resulting in trucks facing off with well-heeled shoppers. As Seongsu's star rises, so do concerns about gentrification and the displacement of long-term residents. The soaring rents—prime retail locations are already being booked a year in advance at weekly rates of up to $75,000—will inevitably only continue to transform the character of this traditionally hardscrabble neighborhood. (RR)

Seochon

Set against the backdrop of Inwangsan Mountain Park, the historic neighborhood of Seochon (meaning "West Village") offers a respite from the bustling city. Popular today for its traditional hanok houses that date back to the early 20th century, Seochon was threatened with redevelopment in the 2000s and designated as a preservation area in 2010. To the east is the sprawling Gyeongbokgung Palace. Systematically destroyed during Japanese colonial rule and replaced with a government building, it became a symbol of Korea's occupation and was itself torn down in the 1990s. The restored palace is not expected to be completed until 2045. Just outside the palace's walls, Seochon's quiet roads lend themselves to strolling leisurely and browsing the craft and design shops. (RR)

TIPS 조언

ADDRESSES:
Addresses in Korean are written with the largest entity first (e.g., South Korea or Seoul) and end with the street and building number. If in doubt, mapping apps will point you to the correct building—just be aware that your destination may not always be on the ground floor, or well signposted. (GU)

DINING ETIQUETTE:
Koreans will typically order dishes for the table to share. Don't be afraid to eat rice with a spoon rather than chopsticks but avoid speaking loudly and respect other people's privacy. When it's time to pay, do so at the counter and don't tip—it's considered disrespectful. (RR)

Itaewon & Hannam

Until recently, Itaewon was known as a foreign enclave as a result of being situated next to a sprawling US military base. The base closed in 2018 but the area remains a place where imported ideas, cultures, trends and cuisines come together. It's home to a small but significant LGBTQ+ scene and has a thriving nightlife, with a reputation as being somewhere people can let loose away from the conservative gaze of society. Nearby Hannam—long known for its luxury housing developments and embassies—is becoming increasingly popular with Seoul's fashionable crowd, who are drawn to the stylish boutiques, concept stores and chic cafés that have cropped up in its quiet alleyways. (RR)

Euljiro

During the day, the narrow streets of Euljiro in the center of the city are filled with the smell of ink and the clang of metalworking. But at night, those are replaced by the hubbub of people who come for the low-key restaurants and cocktail bars—their windows opened wide onto the street—or to sit in Nogari Alley to eat fried chicken and dried fish. While parts of Euljiro can feel a little dilapidated, the eclectic mix of printers, metal factories, neon-lit alleyways, art galleries and recently restored brutalist architecture make it an exciting place to be, no matter what time of day or night. (RR)

Dosan

People were still plowing fields in Dosan in the late 1970s but today, the area is known for an abundance of high-end stores, fashion brands and upscale restaurants. Dosan Park, which honors independence activist Dosan Ahn Chang Ho, forms the focal point amid the sleek shops that offer valet parking for their clients' expensive cars. The surrounding wards—Sinsa, Apgujeong and Cheongdam in the north of the affluent Gangnam district—are also known for their luxury indulgences, as well as for the "beauty belt," a stretch that includes hundreds of clinics and plastic surgery offices. (RR)

ROAMING:
Before you arrive, check whether your carrier will charge you extra to use your phone in South Korea. If it does, it's easy to find a temporary plan to use instead, which you can access by installing a physical SIM card or by downloading an eSIM. Just make sure you disable mobile data on your home service before you land. (GU)

APPS:
Restrictions on foreign companies accessing geographic data mean that Apple Maps and Google Maps have limited functionality in South Korea. Korean alternatives Naver Map and KakaoMap are free to use and are available in English, though in some cases you might need to first Google a place to find its name in Korean. (GU)

GETTING AROUND:
For such a big city, Seoul is surprisingly easy to get around. There's an extensive bus network and the metro system is clean, efficient and easy to use—pay-as-you-go transport passes can be bought at stations or convenience stores. Taxis can be hailed using apps including Kakao T and Uber, but if you're not going far, or want to explore, walking might be the best option. (GU)

A street in Itaewon—the name alludes to the former abundance of pear trees in the neighborhood.

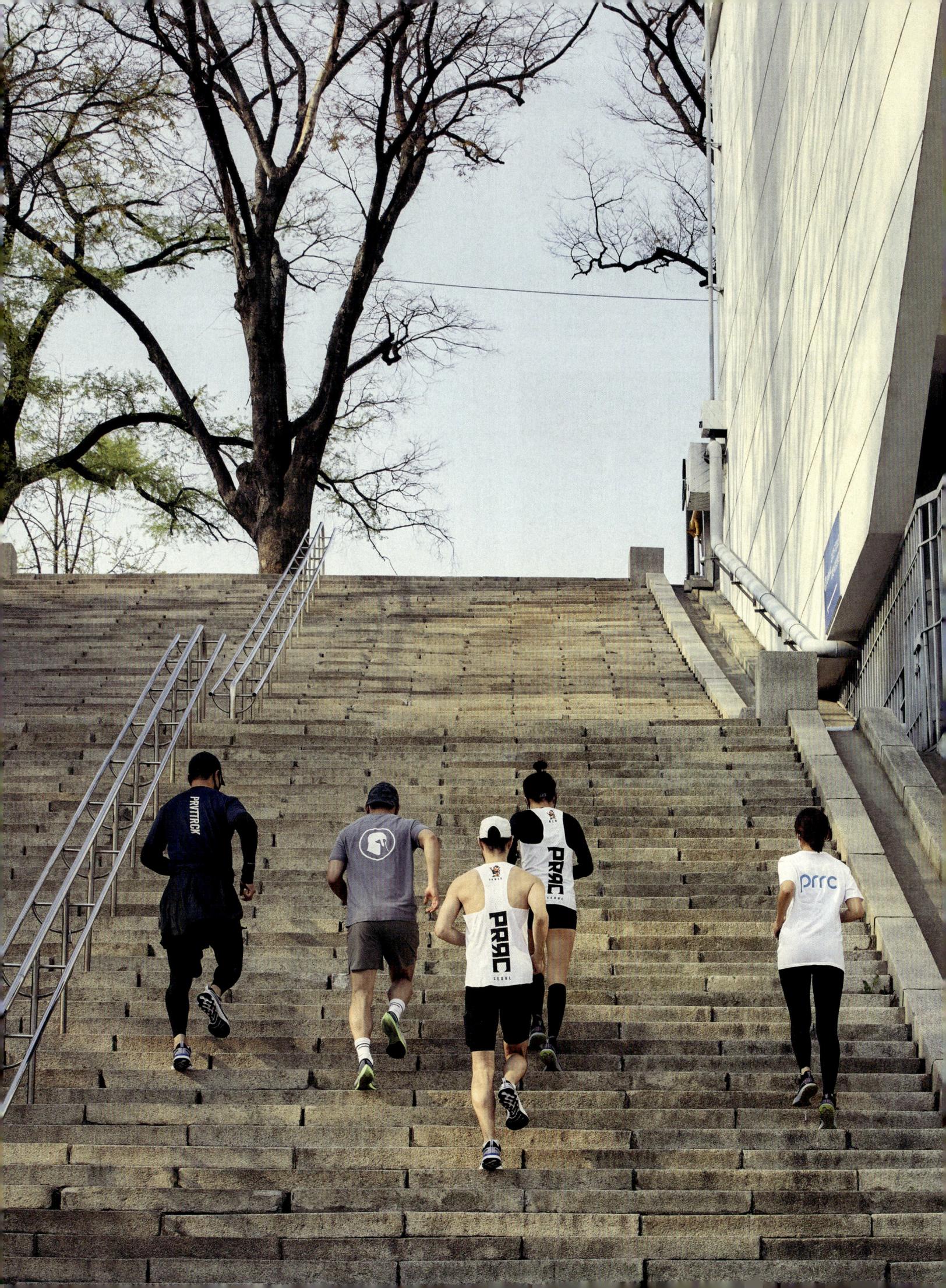

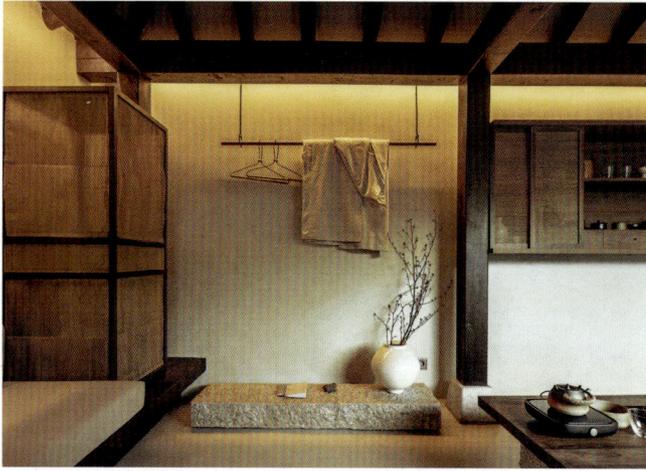

(ABOVE AND BELOW) Nuwa guesthouse in Seochon.

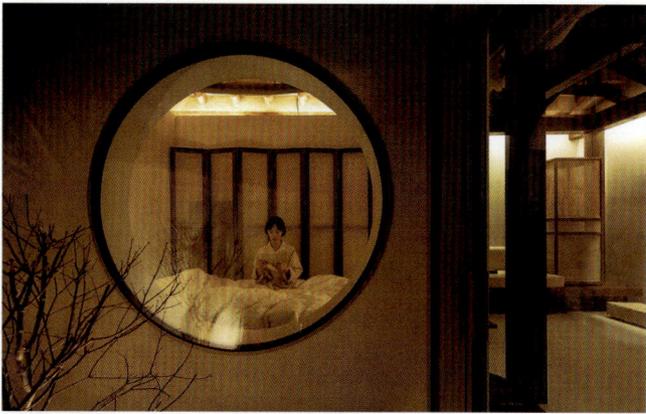

STAYS

머무를 곳

NUWA:

Designed by Seoul-based architects Z Lab, Nuwa is a single-room guesthouse in Seochon that blends traditional hanok architecture with a contemporary pared-back interior. The space has been conceived around the concept of *wayu* (literally "lying down" and "playing") and is intended as an escape from the hectic modern city. Guests are encouraged to enjoy tea ceremonies on the large walnut table, soak in the bath or simply spend time in bed—reading or taking in the small, landscaped garden from the round window in the bedroom. (RR)
3-1 Pirundae-ro 5na-gil, Jongno District

HILLO JAE:

Arranged around a tranquil courtyard in the heart of Bukchon Hanok Village, Hillo Jae combines the experience of a traditional hanok house with contemporary design, modern comforts and the works of local artists. (RR)
12 Bukchon-ro 11ra-gil, Jongno District

ANANTI AT GANGNAM:

The Ananti hotel in bustling Gangnam was conceived by SKM Architects as a place for rest and rejuvenation. All 110 rooms have double-height spaces, with the beds accessed on mezzanines, and balconies overlooking the city. The brick annex at the rear of the building—with an indoor and outdoor pool, sauna and gym—features arches that were designed to emulate a medieval monastery. (RR)
734 Nonhyeon-ro, Gangnam District

Above Top & Bottom: Texture On Texture. Middle: Park Chan Woo. Right: Jae-An Lee

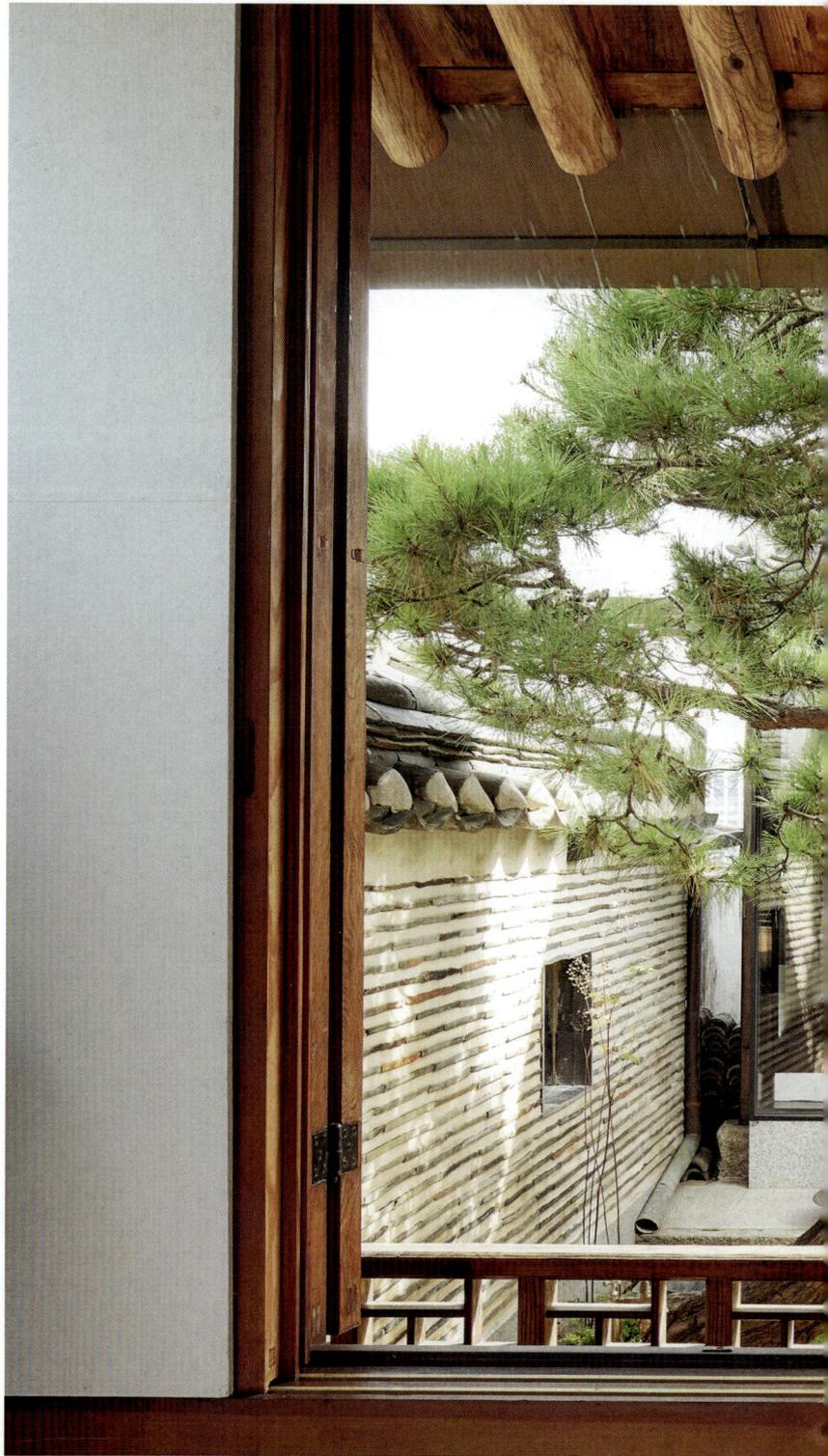

A view of the courtyard of Hillo Jae from the second-floor bedroom.

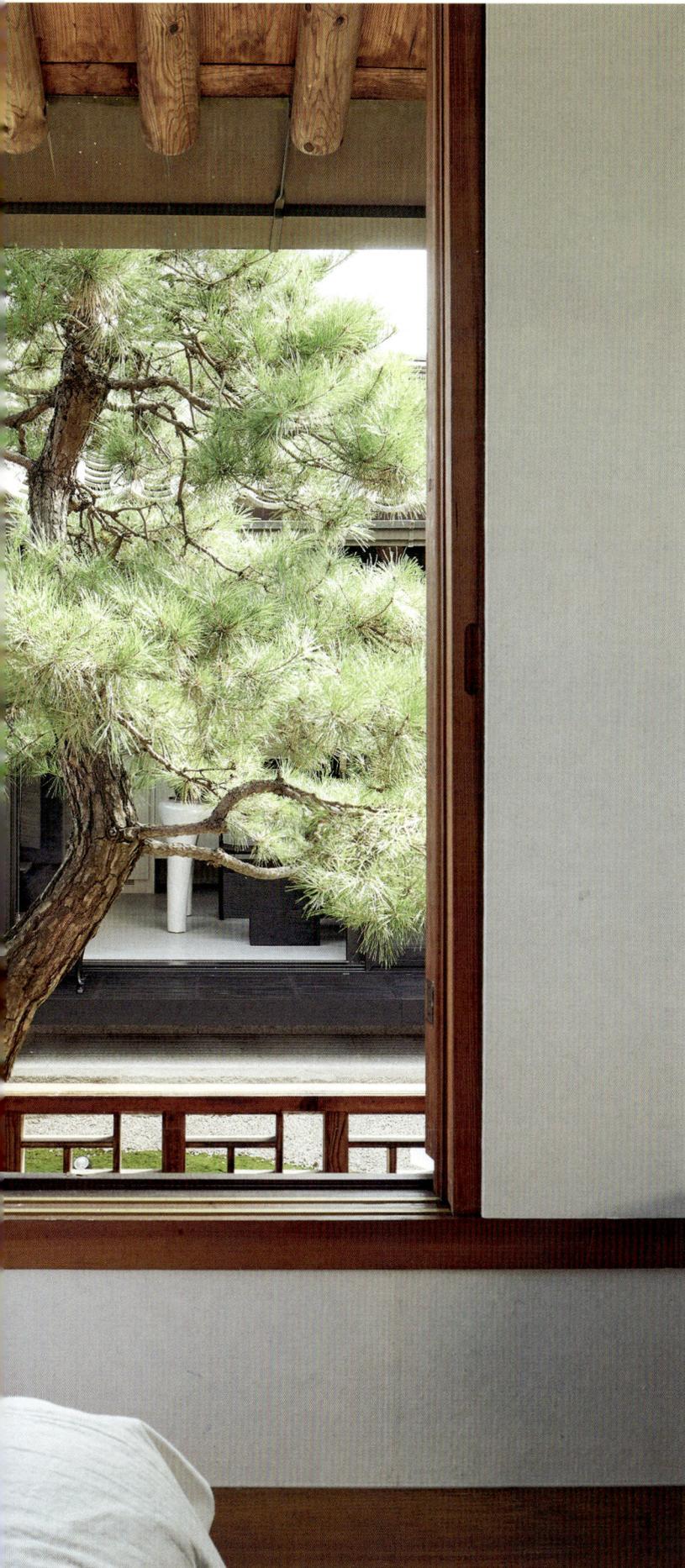

휘트니스
Running Club

Ten years ago, running wasn't the trend it is now in South Korea. The casual observer would have been hard-pressed to spot anyone partaking besides the occasional *ajeossi* (a middle-aged man), most likely wearing a pair of short shorts. Since then, however, the running scene has greatly expanded, and the culture surrounding it has too—thanks in no small part to one underground crew of DJs.

Since it was founded in 2013 by members of the 360 Sounds collective, membership at Private Road Running Club has grown to be hundreds strong, with between 30 and 50 members showing up regularly for runs. And Seoul, with its urban variety and versatility, has become a premier running city. One day, a runner could choose mountain courses and dirt trails; the next, the wide-open space of a park or the flat, even path of a track. In spring, dedication to the practice will be rewarded with the sights and scents of cherry blossoms; in autumn, the foliage falling in rich rusts and auburns.

For PRRC co-founder James Lee McQuown there is no better way to get to know the city. "There's an intimacy that develops when you traverse certain distances by foot. You get a feel for the environment, you notice the wildlife, you take in the smells, and even feel the season—all things that would be missed if locked away in a car or train." (AB)
Instagram: @prrc1936

Tartine (Hannam)

Celebrated San Francisco bakery Tartine opened its first store outside the US in Seoul in 2018 and now has six locations around the city. The original, situated in a double-height space in Hannam, offers a range of bread that can be hard to find in Seoul—such as sourdough and Danish rye that is baked fresh on-site—as well as dishes that are the result of an ongoing exchange between the Seoul and San Francisco teams, such as a sandwich version of *bulgogi*, a traditional dish made with marinated slices of beef, Jeju tangerine juice and multigrain loaf made with makgeolli. (GU)
22 Hannam-daero 18-gil, Yongsan District

Jayeondo Salt Bread

Among the many Korean baked goods that have gone viral on social media, there is one that stands out for its popularity: salt bread. The croissant-shaped pastry—a Korean version of the original invented by a bakery in Japan in 2014—is at once light and airy and intensely buttery, the brioche-like interior and harder exterior dissolving in the mouth. Salt bread can be found throughout Seoul, but specialists Jayeondo are consistently ranked as the best. Their three locations in the city regularly have long lines but they move fast as the simple kiosks sell only salt bread, which they bake throughout the day and sell in neat paper packages of four. (GU)
41 Dosan-daero 49-gil, Gangnam District

TWO MORE...

NUDAKE:
Experimental pâtissier Nudake was launched by Gentle Monster in China in 2019 and opened its first Seoul store in Dosan in 2021. It brings the eyewear brand's creative and irreverent gaze to pastries, as evident in a black brioche in the shape of a sheep or the Oniwassant, a cross between a croissant and onigiri. (GU)
50 Apgujeong-ro 46-gil, Gangnam District

BREAD OOOO:
Bread OOOO (pronounced "Bread EupEup") started as a small dessert studio called Bread Pitt in the city of Suwon in 2021 before moving to Seoul a year later. Centered around the principle that the experimental pastries and desserts are "edible ideas" that will be able to live on after they have been consumed, founder Ha Young-ji produces ephemeral confections, often in response to exhibitions at the Watermark Gallery. (GU)
1F, 8 Saechang-ro 14-gil, Yongsan District

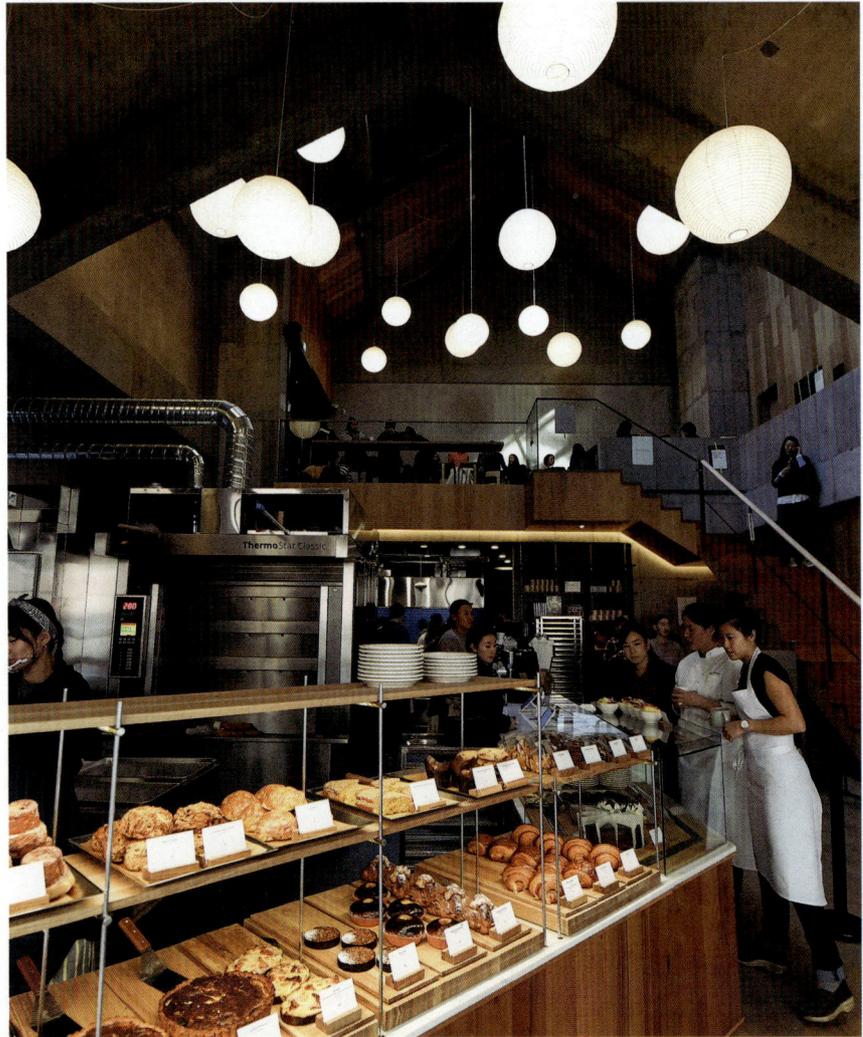

Tartine in Hannam, where Western and Korean-influenced breads and pastries are baked on-site.

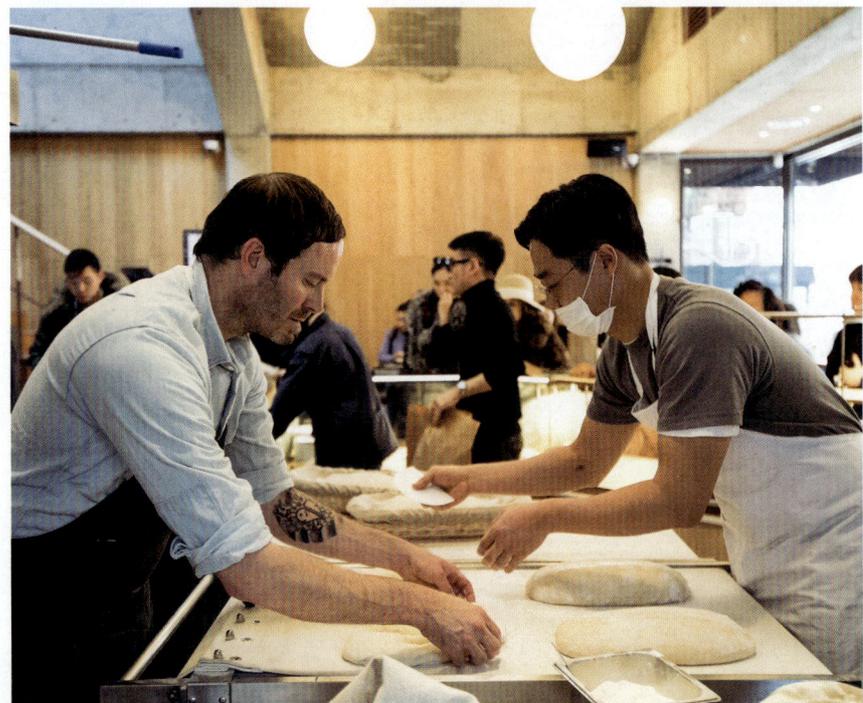

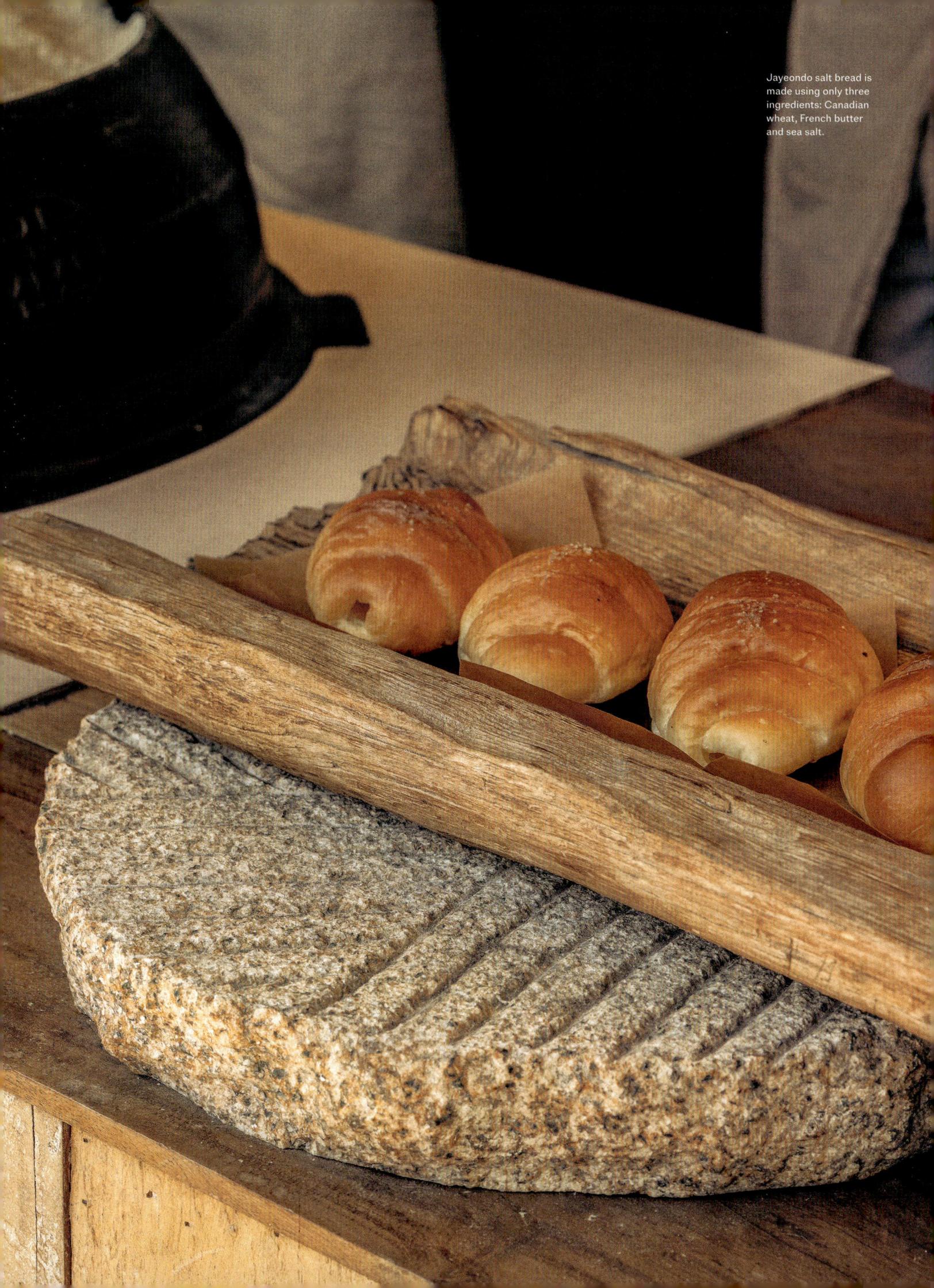

From the rooftop of T(ER)T(RE) you can see the city wall, which dates back to 1395, and Bugaksan mountain. Meaning "north mountain," it overlooks the Gyeongbokgung Palace and is the source of the Cheonggyecheon which flows through northern Seoul.

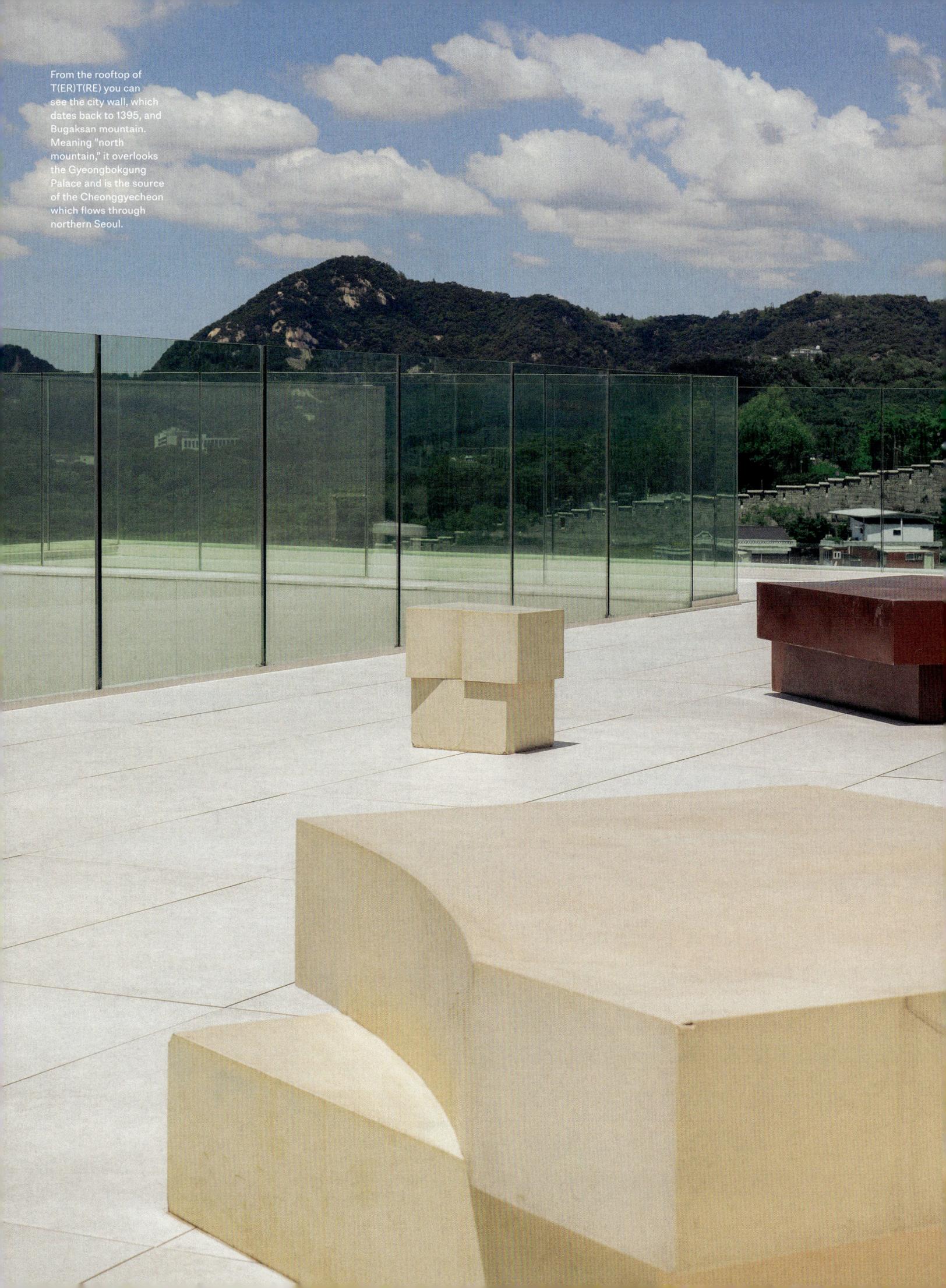

카페
T(ER)T(RE)

Coffee only began to be widely drunk in South Korea in the late 20th century but the country has quickly come to embrace it. Korea is ranked fourth in the world for the number of Starbucks branches, and the increasingly elaborate drinks and pastries sold by Seoul's coffee shops are hugely popular on Instagram, with many new cafés deliberately targeting social media with gimmicky concepts and store designs.

T(ER)T(RE) rises above this scene both literally and metaphorically, while still offering a chance to sample the discerning and playful coffee culture of Seoul. Situated on a steep residential road near Naksan mountain (*tertre* means "small hill" in French), the café—purpose-built by local architects Cho and Partners—has panoramic views that stretch from Bugaksan in the north of the city, along the city wall and past Namsan Mountain with the N Seoul Tower, to the Zaha Hadid–designed Dongdaemun Design Plaza. Against this backdrop, baristas prepare coffee as well as more creative (and Instagrammable) drinks, such as a Crème Brûlée Latte and Pink Ade, which changes color as you mix it. Stairs lead up from the bar to two additional levels with floor-to-ceiling windows and a roof terrace. (GU)

46 Naksan 5-gil, Jongno District

카페
Eert (Mangwon)

The Eert tearoom in Mangwon encourages quiet contemplation. Occupying a concrete 1974 building that once housed three separate shops and an apartment, the interior has been opened up by local architecture practice Workment, flooding the space with light from floor-to-ceiling windows that look onto the street. A table made of wood and copper runs across the full width of the building. Here, staff prepare tea against the backdrop of a warm, backlit wall, ladling boiling water into teapots. There is a seating area upstairs, where the walls have also been left raw and unfinished. In addition to several different types of tea and coffee, seasonal desserts are available. (RR)

105-1 Poeun-ro, Mapo District

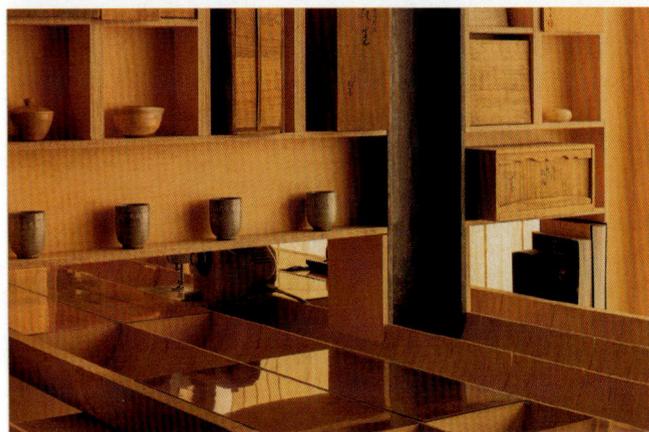

Eert's range of teas includes seasonal blends and *hōjicha*, a roasted green tea.

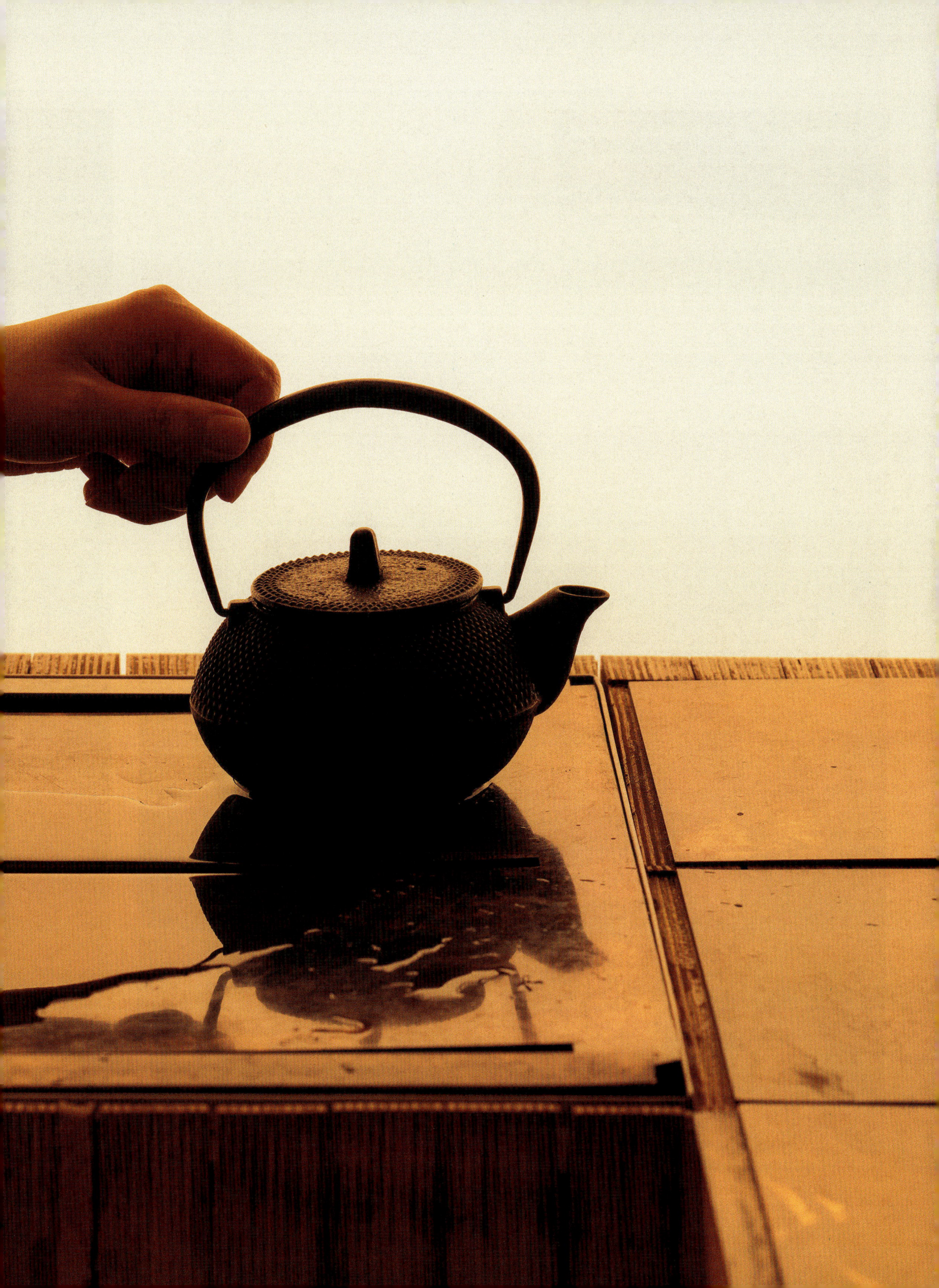

(ABOVE) Tissue bread at the Truffle Bakery. (OPPOSITE) The industrial interior of Onion in Seongsu.

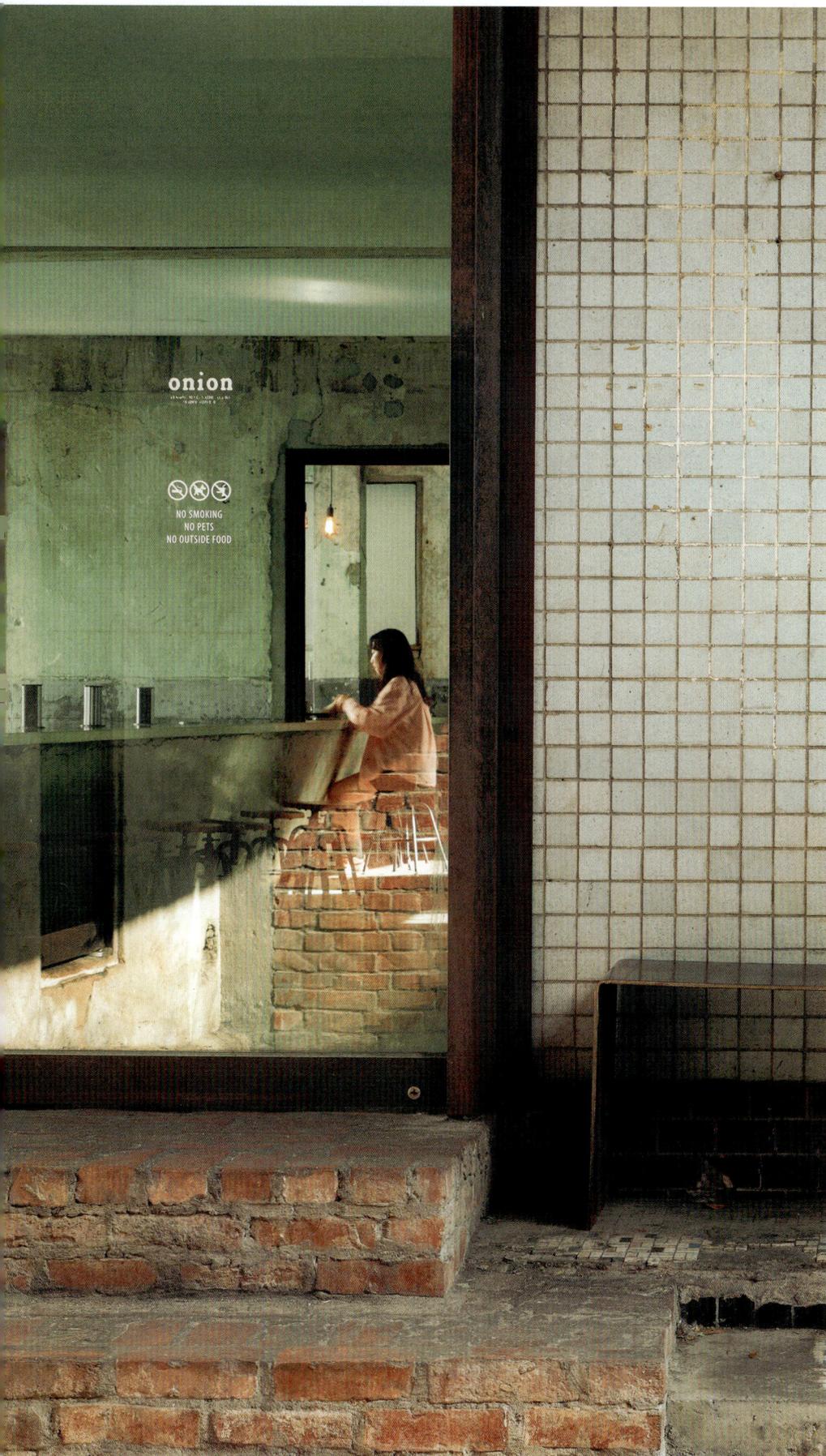

The Truffle Bakery

The sleek and stylish Truffle Bakery in Hannam was established in 2024 to offer pastries that use fresh, high-quality truffles that were previously the reserve of fine dining in Korea. It is their tissue bread, however, rather than the truffle-infused scones and salt bread, that has put the bakery on the map. A small cube of bread that can be torn into delicate, translucent layers of soft, chewy and intensely buttery pastry, tissue bread went viral shortly after the bakery opened and at one point became so popular that sales were limited to one per person. (GU)
1F&2F, 19 Daesagwan-ro 5-gil, Yongsan-gu

Onion (Seongsu)

The building that houses the first Onion café has had many lives. Built in 1970, it had been a supermarket, restaurant, mechanics and a metal factory before design studio Fabrikr encountered the dilapidated space in Seongsu. They decided to preserve as much of the building's history as possible, leaving brickwork exposed and traces of paint and tilework intact, an approach they brought to Onion's other locations—such as a traditional hanok in Anguk and half of a working post office in Mia. In the Seongsu branch, which opened in 2016, the elaborate pastries—pandoro with snowy peaks of confectioners' sugar; squid-ink "Black Crunch" brioche; avocado bread—contrast with the raw, pared-back interior, and the roof terrace has views across the still-industrial neighborhood. (GU)
8 Achasan-ro 9-gil, Seongdong District

TWO MORE...

ANTHRACITE: Anthracite has been at the forefront of both Seoul's burgeoning specialty coffee culture and—in the case of their third location, which opened in 2015—establishing Itaewon as a place for creative and experimental brands. The benches outside are the place to see and be seen in good weather. (GU)
240 Itaewon-ro, Yongsan District

TRAVERTINE: The design of specialist coffee shop Travertine in Yongsan was informed by the 1920s residential building it sits in—a surprising mix of traditional wooden hanok-style roof and raw concrete. A wraparound glass panel separates the interior from the gravel garden, and large limestone blocks at the center of the space give the café its name. (GU)
18-7 Hangang-daero 7-gil, Yongsan District

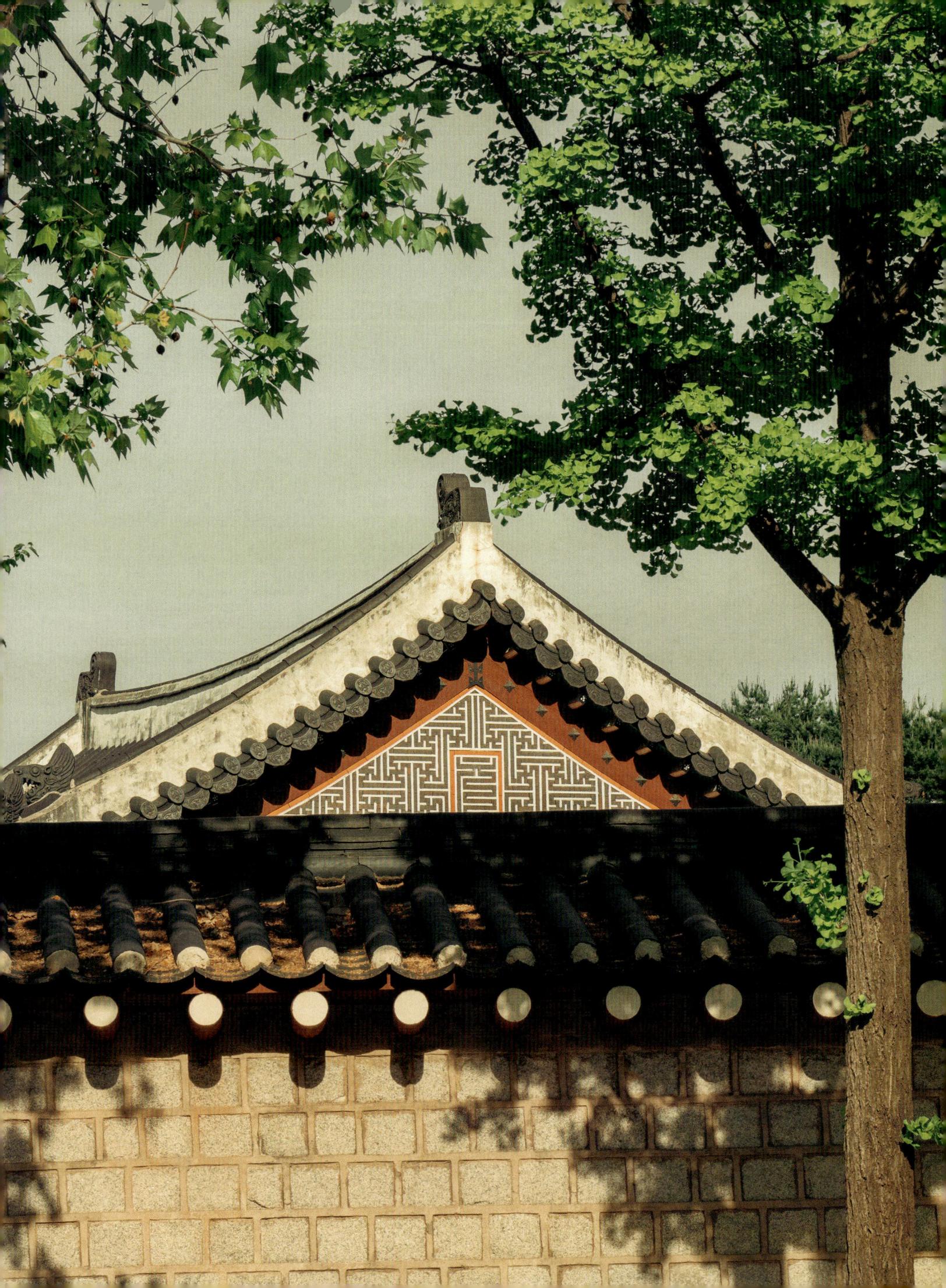

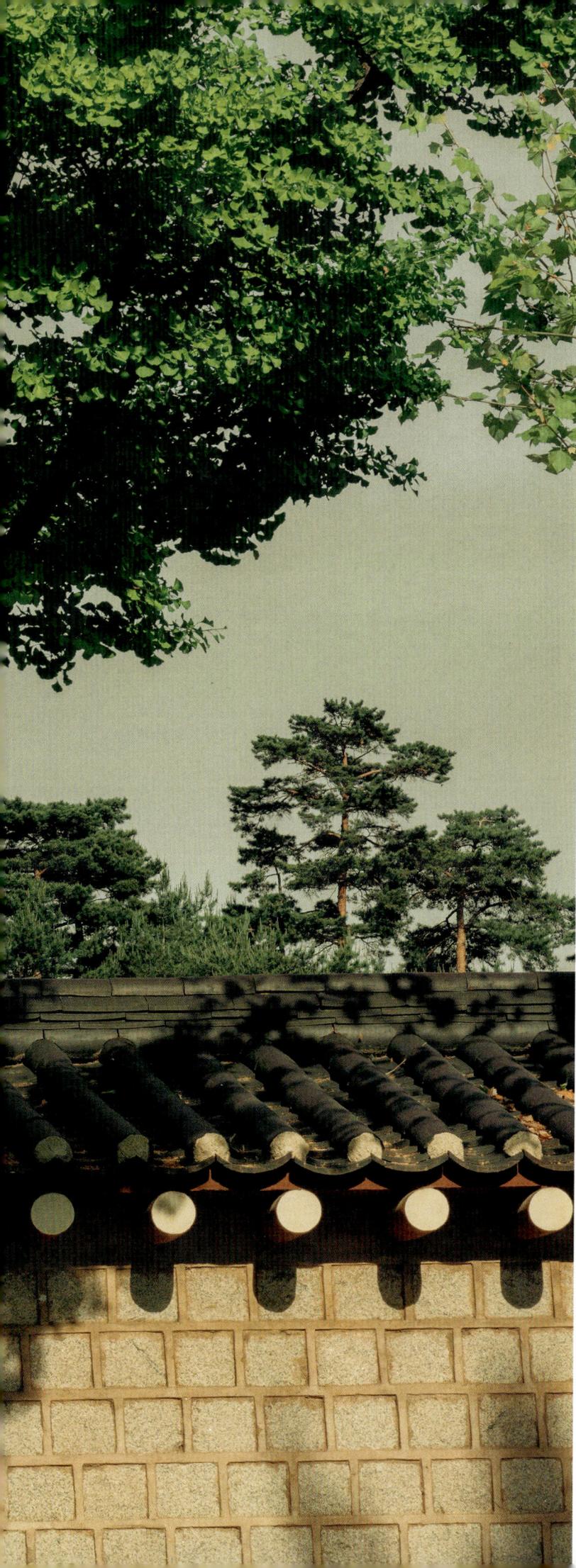

쇼핑
Gentle Monster

In 2017, Hypebeast reported that eyewear brand Gentle Monster employed just six people to design its products but 60 to design its stores. With branches now cropping up all over the world, it's a number that has likely only grown since then. Founded in 2011, Gentle Monster is one of the great retail success stories of recent years and their eclectic and immersive store designs have been central in establishing the brand's identity. Their four stores in Seoul (of the 68 worldwide) include the flagship in Hongdae, where installations change every 25 days, and the experimental HAUS in Dosan—a purpose-built building shared with sister brands Tamburins and experimental pâtissier Nudake—which frequently features installations that take advantage of the brand's recent acquisition of a robotics company. (GU)
50 Apgujeong-ro 46-gil, Gangnam District

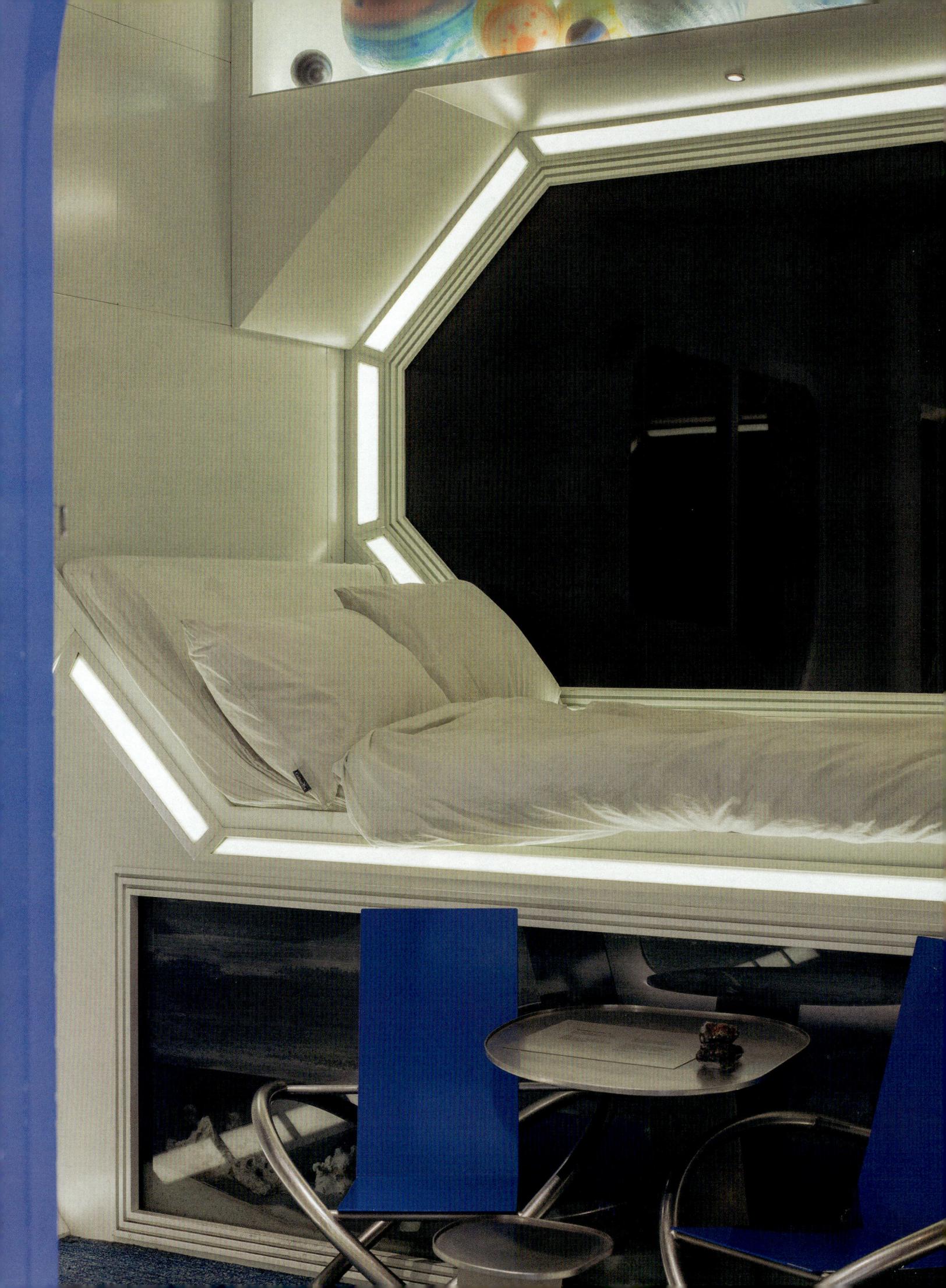

쇼핑
Ader Error

There's often a line to enter the Seongsu showroom of Ader Error, and it seems that most of the people waiting are not interested in the clothes; inside, a sequence of immersive installations—a crater left in the floor by a meteor strike, a headless spaceman floating weightless, a bubbling pool with a paddling space-craft—are primed for social media. Ader Error was established in 2014 by an anonymous team with backgrounds ranging from finance to architecture. The core team remains both anonymous and committed to the brand's founding vision: that it was never intended to only be dedicated to fashion. That's fortunate, since few visitors seem to stay to browse the oversize, unisex clothing that once led *GQ* to ask if Ader Error were the world's coolest brand, but that's beside the point. As a spokesperson for the brand told *Korea JoongAng Daily* when the Seongsu location opened in 2021, "Conveying our brand values through the online shop only goes so far." (GU) *82 Seongsui-ro, Seongdong District*

쇼핑
Jimbba

Makgeolli has been brewed in Korea for at least a thousand years. The ease of producing the cloudy white rice wine—you just need to steam rice, mix it with water and nuruk (a fermentation starter made from wheat) and leave it to ferment in a clay pot—meant that it has long been considered a working-class drink. But over the centuries, countless techniques and recipes have been developed across the Korean Peninsula and handed down through generations. It was still the most popular alcoholic drink in South Korea in the 1960s, having survived the ban on home brewing during the Japanese occupation, but from the 1970s it began to fall out of fashion and was replaced by beer.

It was in part a response to the threat of these regional recipes dying out that bar and bottle shop Jimbba was founded. Named after the bicycle couriers who would once deliver rice wine from breweries, the shop—next to Sindang Central Market—stocks makgeolli, *yakju* (filtered makgeolli) and *soju* (a distilled yakju, that's akin to sake) that the owners discover on research trips around Korea. They also document traditional recipes that they share via an online magazine. The store is part of a wave of interest in traditional Korean rice wine that has been compared to the renewed engagement with craft beer or natural wine. But the trend is unique for the way innovative and creative new breweries, bars and bottle shops are working to conserve a vital part of Korean heritage. (GU)
15-8 Toegye-ro 87-gil, Jung District

THREE MORE...

POST POETICS:
Independent bookstore Post Poetics stocks English language books on art, architecture, fashion, design and photography that are imported in collaboration with an international network of publishers. The store, which moved to its current location in Hannam in 2022, aims to offer a space for cultural exchange between Korea and artistic communities around the world. (GU)
19 Itaewon-ro 54-gil, Yongsan District

TAMBURINS:
Since it launched in 2017, Tamburins has carved a place for itself in the saturated K-beauty industry thanks to its chic, genderless cosmetics and store design. Like parent company Gentle Monster, the shops blur the distinction between art gallery and retail space— their flagship Hannam store, for example, features giant fabric pumpkins and knitted wall coverings. (GU)
238 Itaewon-ro, Yongsan District

SAYTOUCHÉ:
Saytouché is a lifestyle brand created by Lee Chan-hyuk of pop duo AKMU and photographer Jaeryn Lim. Their store showcases a variety of idiosyncratic homewares and decorative objects, including a "Liquified Persian Rug" and a mirror that makes it seem as if you are on a video call with a cat. (RR)
53 Noksapyeong-daero 32-gil, Yongsan District

There are around 350 art posters on display in Kuna Jangrong.

MMMG

Millimeter Milligram, or mmmg, was founded as a design studio in 1999 with the principle that small but carefully considered objects can enrich our lives. The original range of stationery has since expanded into a store in Itaewon in a building shared with Anthracite coffee shop. Here, mmmg products are sold alongside accessories, homewares and furniture curated by the studio, such as Arita porcelain from Japan and recycled Freitag bags. The studio also hosts collaborations and pop-ups with local producers and runs a program through its D&Department subsidiary to find uniquely Korean products that are durable and make use of traditional crafts. (GU)
240 Itaewon-ro, Yongsan District

Kuna Jangrong

Only a poster for a 1965 Alexander Calder exhibition at the Los Angeles County Museum of Art, displayed in the second floor window of a brick building in Seongsu, gives any indication that you have arrived at cult art-poster store Kuna Jangrong. There—providing you have made an appointment online—you can browse a range of exhibition posters collected from around the world by founder Kim Kuna. As well as rare and limited edition runs, there is an exclusive range of posters designed inhouse and a rotating exhibition dedicated to a different artist each month. (GU)
2F, 7 Yeonmujang 7ga-gil, Seongdong District

Point of View

Stationery store Point of View moved to its current site in Seongsu in 2022. Conceived by design studio Atelier Écriture, the shop is split across three levels. The first floor is dedicated to everyday stationery and can get busy—a reflection of its renown online—but the second, which has a more refined selection of notebooks, accessories and wrapping paper, and the third, where there is luxury stationery, artwork and homewares in a wood-paneled, domestic setting, are quieter and lend themselves better to slow, peaceful browsing. (GU)
18 Yeonmujang-gil, Seongdong District

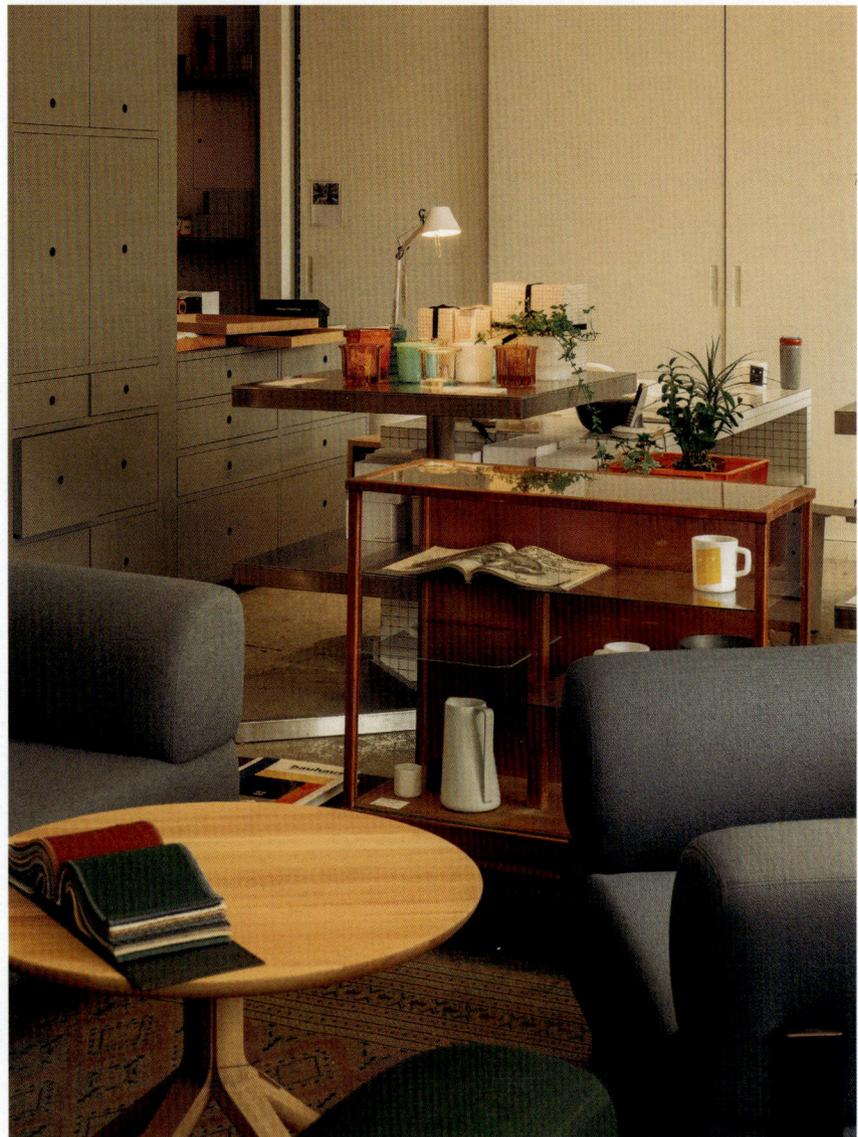

The D&Department concession in the Millimeter Milligram store in Itaewon.

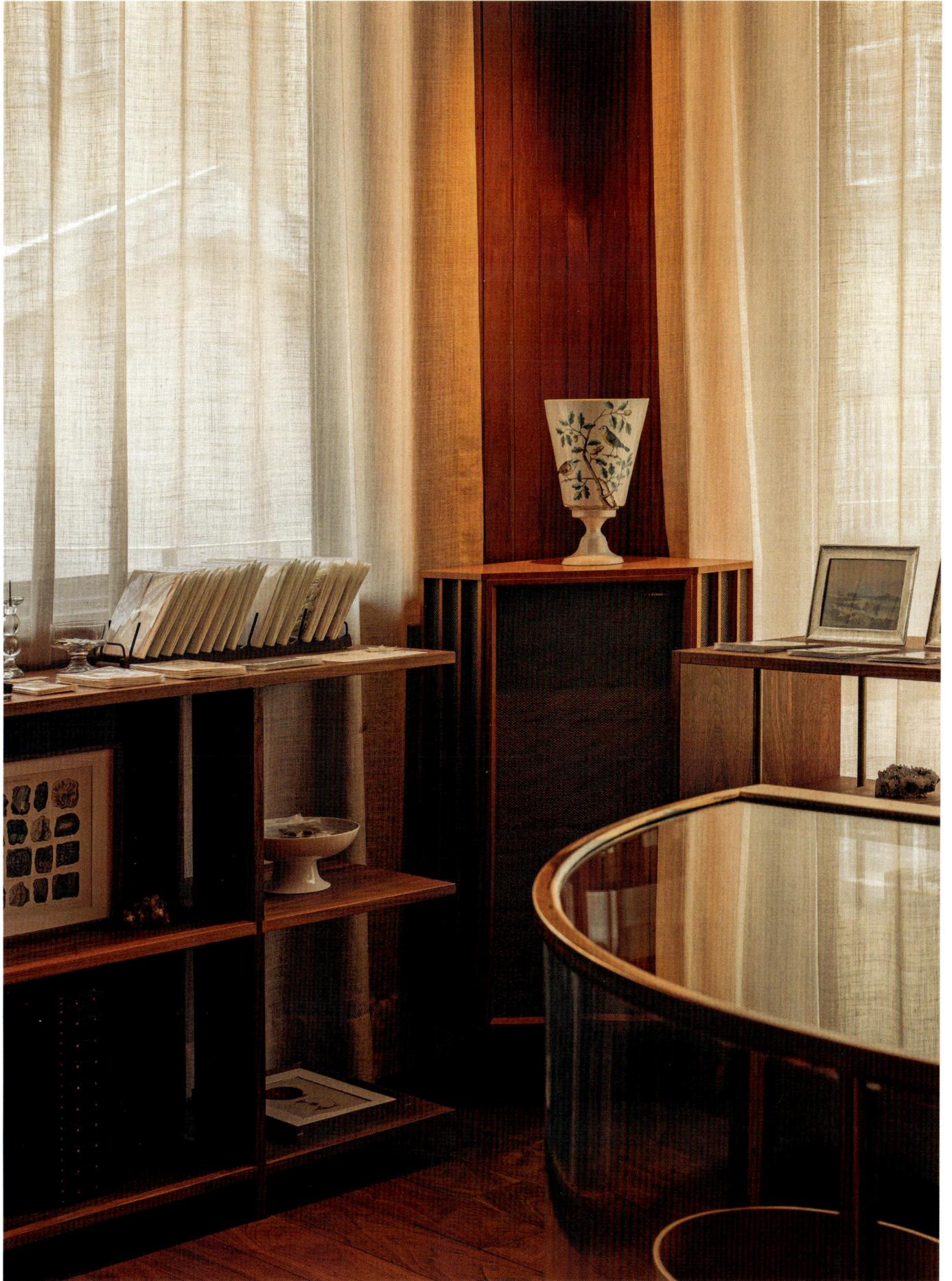

The third floor of Point of View was originally an apartment. Its interior has been preserved.

Facial Treatments

The Korean beauty industry has come to be recognized for its focus on innovation and skin health. Korean skincare products are increasingly sought after in the West and many of those in search of "glass skin"—the glowing and flawless skin coveted in Korea—are now traveling to the country for specialized treatments. The Lamiche Dermatology Clinic in Jamsil is popular with influencers and Korean celebrities alike. Following a 3D skin analysis, patients are treated with lasers that target pigmentation and acne scars, encourage skin rejuvenation and clean pores. The results might take weeks to show but instructions for aftercare and prescriptions are provided. (RR)
14 Baekjegobun-ro 7-gil, Songpa District

15-Step Scalp Treatment

Eco Jardin's viral 15-step 90-minute scalp treatment starts with a microscopic scalp consultation to identify issues such as dryness and oiliness. Practitioners will then perform a variety of treatments and massages to open up follicles and relieve tension. A "galvanic sealing brush," which emits a low-level electric current to soften the hair follicle, and has red and blue LED lights, is used to encourage growth and remove bacteria. The hair is gently rinsed, followed by a "mist tonic," shampooing and styling, leaving hair soft, voluminous and Instagrammable. (RR)
2F, Hyosung Harrington Square Building B, 92 Mapo-daero, Mapo District

Color Analysis

Color consultations have been around for decades but the practice, which identifies which colors best suit your skin tone, has grown in popularity on social media in recent years. The Cocory Personal Color Research Institute has three branches in Seoul and offers consultations in English. The experience begins with a crash course in color theory followed by an assessment of your skin tone with a spectrometer. You are then draped in a rainbow of fabrics corresponding to the four-season color theory before being given your results—summer pale or dark autumn, for example—as well as recommendations for everything from makeup and jewelry to hair and nail color and even perfume. (RR)
193-3 Yeonhui-ro, Seodaemun District

커뮤니티
Kinfolk Seongsu

In 2022, Kinfolk launched Kinfolk Notes—a beauty brand that marries Danish design, Korean beauty know-how and French fragrances—and opened a series of pop-ups across Seoul for people to try the products for themselves. The Seongsu space opened in April 2024 as a flagship home for the Kinfolk Notes line and includes a design store, flower shop and garden café. (GU)
17-1 Yeonmujang-gil, Seongdong District

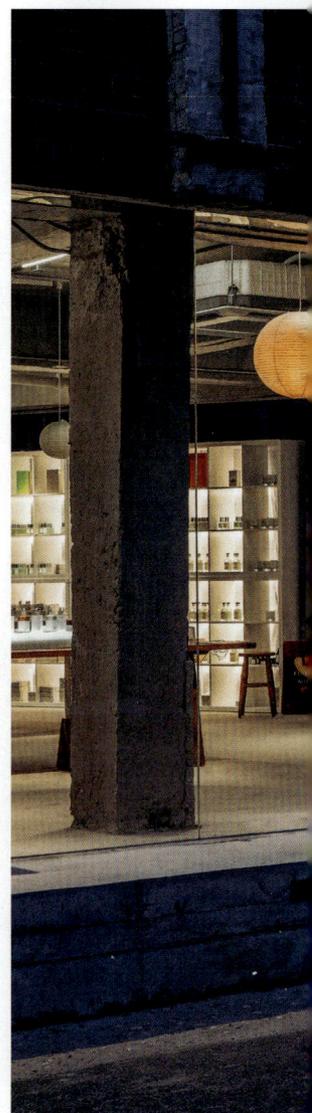

ITAEWON POP-UP:
Kinfolk's skincare line,
a range of aromatic
hand soaps, lotions and
creams, launched in
2022 and was followed
by a fragrance collection
that is available as eau
de parfum, diffusers
and candles, including
Fleur de Monet, which
has top notes of fresh
orange blossom and
base notes of amber,
musk and vetiver. These
are also available to
sample at Kinfolk's pop-
up stores, including the
latest addition in busy
Itaewon. (GU)
*256 Itaewon-ro,
Yongsan District*

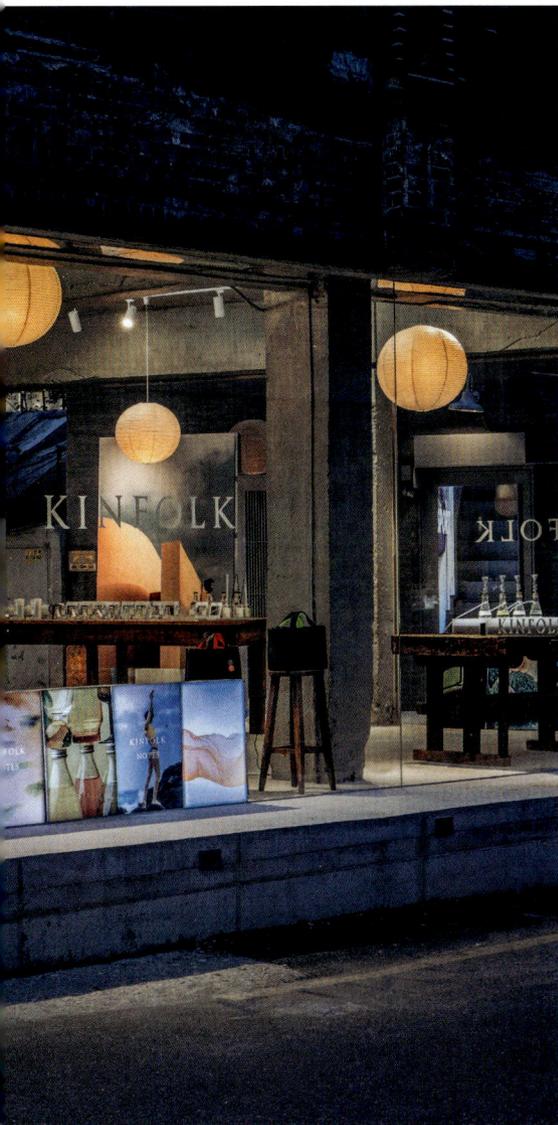

커뮤니티
Kinfolk Dosan

Kinfolk's lifestyle and community space in Seoul opened in 2019. Situated amongst the concept stores and luxury brands of Dosan in Gangnam, the space hosts a store, selling Kinfolk Notes, a range of interior products, stationery, homewares, posters and art books and, of course, the latest issues and books from *Kinfolk*. There is also an outpost of celebrated San Francisco bakery Tartine and space for events and exhibitions, such as "At Home with Kinfolk," a collection of furniture by pioneering modernist designers Pierre Jeanneret, Charlotte Perriand, Le Corbusier and Jean Prouvé, that was hosted in partnership with Vint Gallery, Teo Yang Studio, Creative Lab, Vitra and Cassina in 2020. (GU)
24 Eonju-ro 168-gil, Apgujeong-dong, Gangnam District

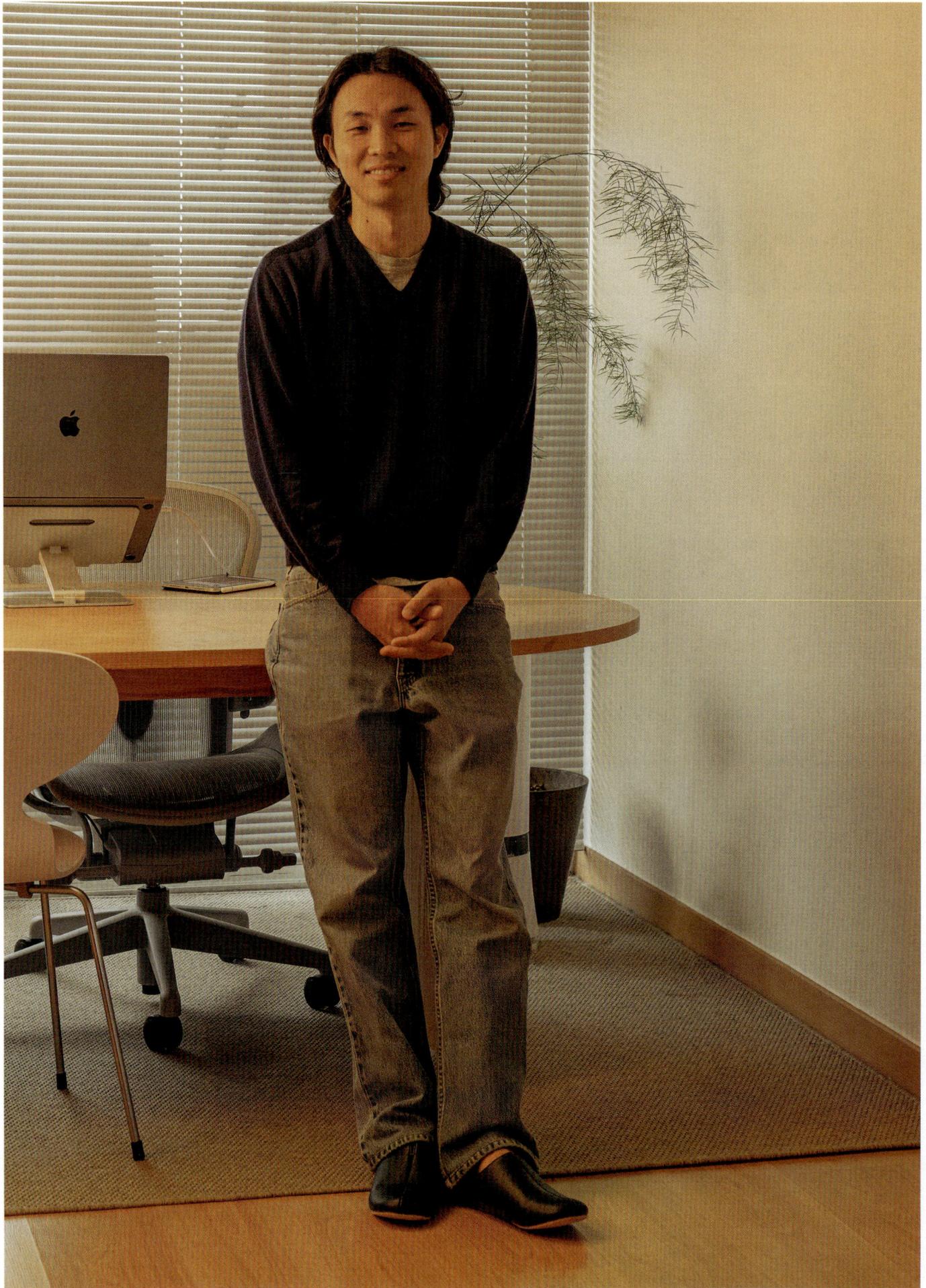

의견
Oh Seongseok

MAKEUP ARTIST

Oh Seongseok set out to become a makeup artist at 16 and has since become one of the most sought-after in Korea for what he describes as his "rough and tough" portfolio. While the person I sit down to interview has a gentle demeanor and exudes a boyish shyness, he takes a daring approach to his medium.

Best known for his long-term collaboration with photographer Cho Gi-Seok and his use of dramatic forms, intense colors and elaborate prosthetics, his work stands out in a country that prefers a natural-looking style and has led to his work appearing in global magazines and celebrated campaigns for international brands.

FIONA BAE: What's your creative process?

OH SEONGSEOK: I'm always sketching on my iPad and I'll often talk with [Cho] Gi-Seok when we work together. It's a back-and-forth: "It looks good." "How about changing this?" "Yeah, I think it looks better." I mostly work with Gi-Seok, but recently I've started to work by myself. I've been improvising, without having a particular theme or series in mind. At the moment it's just for fun, but then it's important for me to have fun through my work. It's okay if what comes out isn't great.

FB: How did you get started in the industry?

OS: Rather than working for a company and climbing up the ladder from the bottom, I longed to become a freelancer. Since I didn't know people in fashion, I read lots of magazines and asked around for my first commissions. I didn't like the standardized aesthetics that I was asked to follow as a makeup artist. I didn't think it was beautiful. On the other hand, people said that my work, which I felt was beautiful, was coarse and scary. And now people find it difficult to ask me for a natural look!

FB: What's your view on the Korean makeup scene?

OS: [Successful] artists overseas have distinctive styles. In Korea, everyone feels the same; they don't take any clear stance. But I don't know if I can argue against that since the Korean way has had such a global success. And the techniques to make the look super natural and real are amazing.

FB: You moved to Seoul from Jeju Island when you were a child. How do you find working and living in Seoul?

OS: I like Yeonhui, where I live—it's quiet, and the buildings are low. And I'm fine with eating the same food and going to the same places. When photographers visit Seoul, I learn a lot working with them and it makes me wonder if I should live abroad. But I don't want to change things up too quickly. I want to make sure I can continue doing what I'm doing for a long time. (FB)

의견
Choi Byung Hoon

DESIGNER

According to the prominent New York design gallery Friedman Benda, Choi Byung Hoon is "a pioneer who synthesizes traditional Korean craft and contemporary design." After graduating from Hongik University in Seoul in 1974, Choi became a leading figure of contemporary Korean design, both in his own practice—producing sculptural works that blur the distinction between artist and designer—and through teaching positions that he has held at his alma mater since 1990. His work is found in numerous collections throughout the world, including Hong Kong's M+ Museum, the Metropolitan Museum of Art and Vitra Design Museum in Germany.

FIONA BAE: How would you describe your work?

CHOI BYUNG HOON: It's an encounter between primitive nature and modernity that, through the touch of my hands, gains a specific value. I like to use rocks, for example; when I'm asked how long it takes to complete a work, I answer that it took eternity. There is also something typically Korean in my work—just as with the humble moon jar, I like to make work that has subtle charm and inner depth, and which can revive Korean traditions while introducing something modern.

FB: What does identity mean to you?

CBH: My work is a continuous process of figuring out my identity. On the morning of the opening of my first overseas show in Paris with François Laffanour at Galerie Downtown in 2010, I walked through the streets of Saint-Germain-des-Prés, which are lined with dozens of design galleries. Looking through the windows, I instantly felt that my works are different. I knew I should not try to mimic French furniture and wanted instead to do something simple and light, like moon jars. People at the opening told me my works felt like Oriental paintings.

FB: What's your creative process?

CBH: With every object and experience, I think about where I am going next with my work. Everything can be an inspiration and having worked now for 30 years, I have come to trust my eyes and intuition.

FB: What do you think about the approach of young Korean designers toward tradition?

CBH: There are many young talented designers but I feel they lack the depth needed to find their own language; they need to melt tradition into their work in order to create something of their own.

FB: You have lived in Paju, to the north of Seoul, since 2000. Do you still feel connected to the city when you visit?

CBH: I am often in Seoul for meetings and to experience the dynamic cultural scene. Living outside of the city can be somewhat stagnating at times and going back to Seoul recharges my batteries. It's extremely lively, but sometimes it can be hard to breathe. (FB)

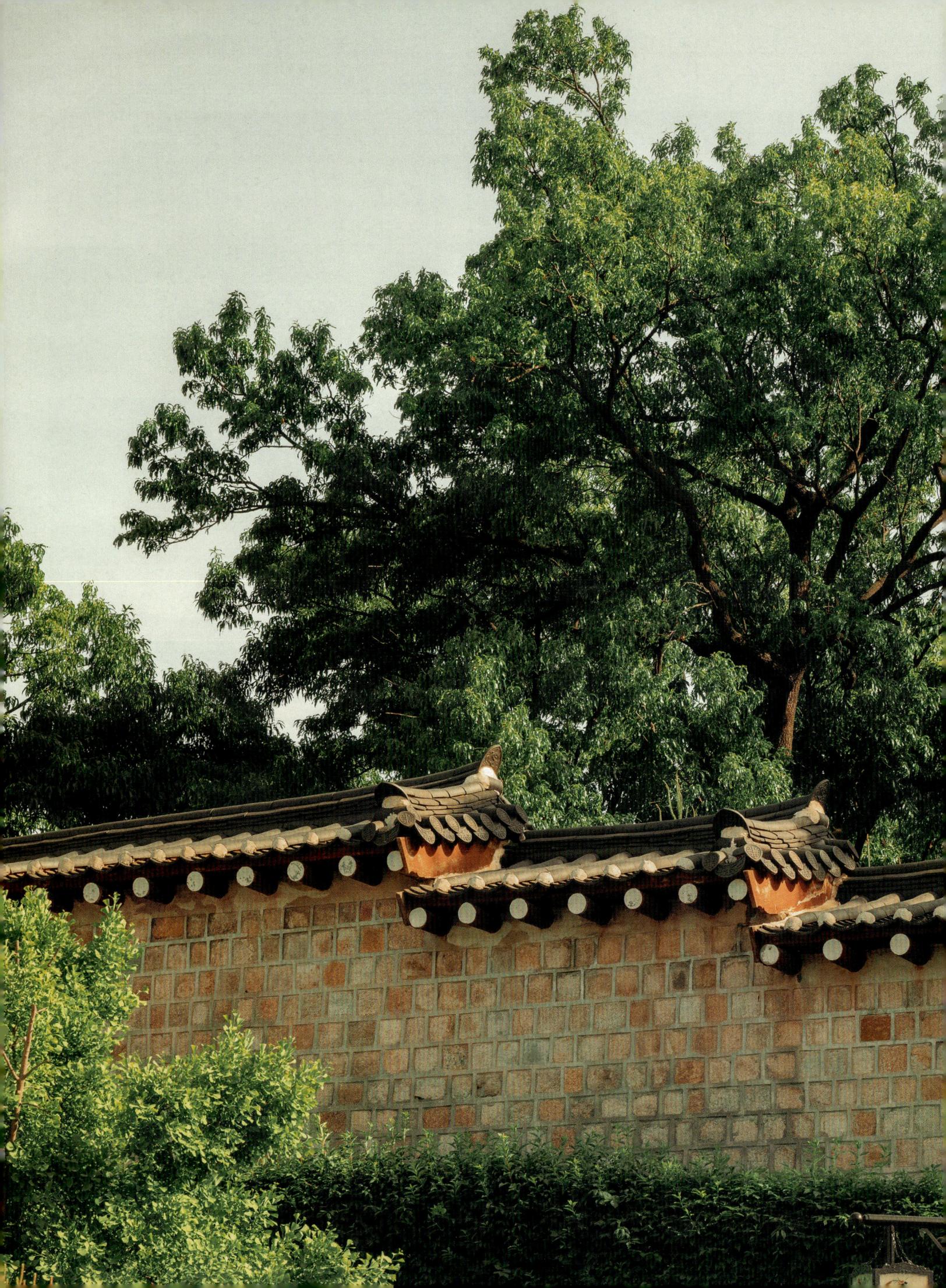

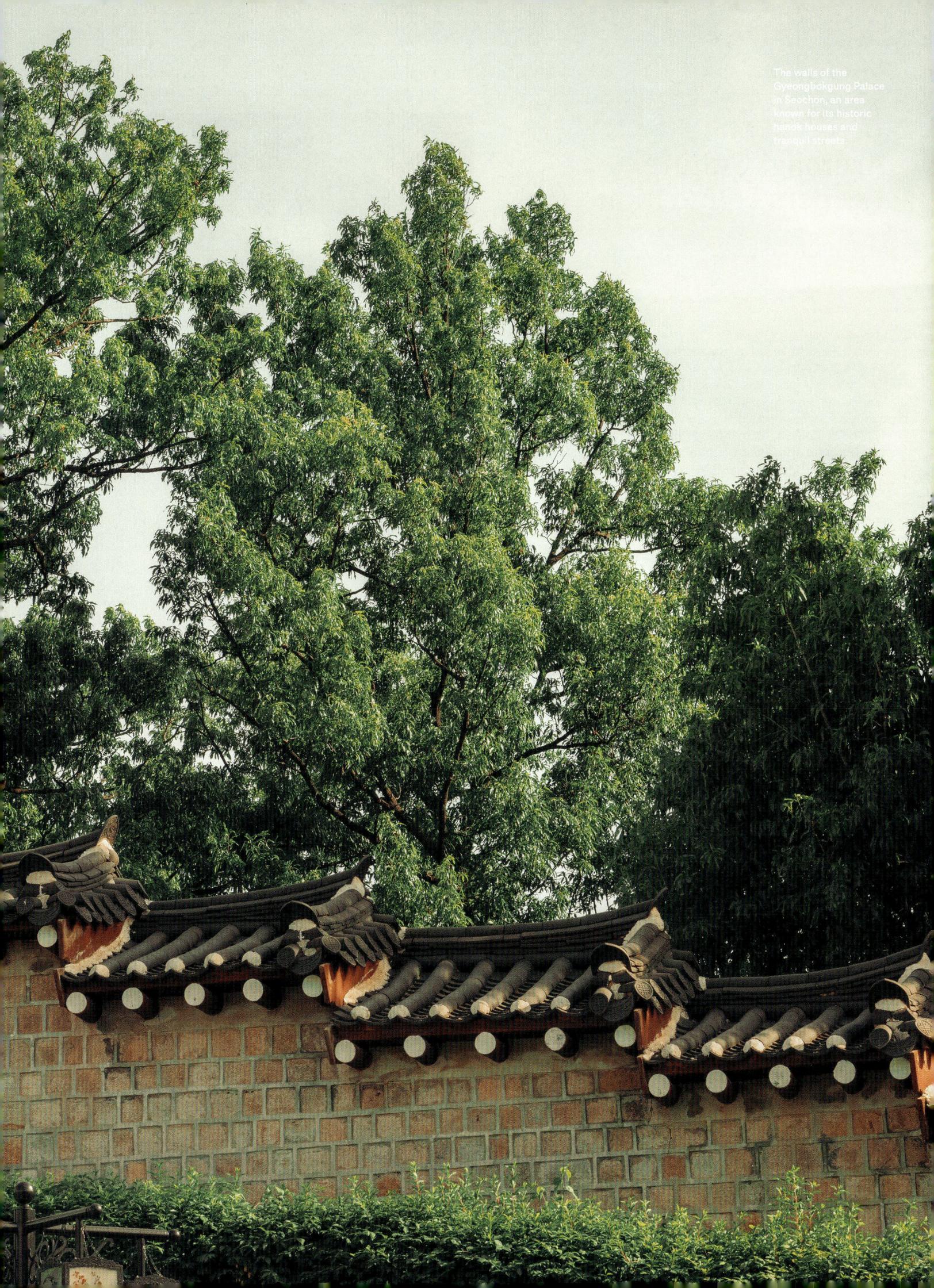

문화와 예술
Arumjigi Culture Keepers Foundation

The Arumjigi Culture Keepers Foundation began in 2001 as a group of volunteers who came together to weed the grounds of palaces. Since then, it has grown into a nonprofit organization that works to preserve and promote traditional Korean culture through research, education and restoration programs. Their headquarters in Seochon, designed in 2013 by architecture practice M.A.R.U., sits opposite the west wall of Gyeongbokgung Palace and combines a contemporary structure in wood, glass and concrete with a hanok house, built using traditional techniques. A space on the ground floor hosts a program of exhibitions that showcases both traditional Korean crafts and the contemporary artists and makers who draw inspiration from them, reflecting the foundation's mission of bringing traditional Korean culture into conversation with the 21st century. There is also a coffee shop and reading room and a store that sells a range of homewares produced by artisans.

Arumjigi continues to preserve cultural heritage beyond its walls, and the foundation is involved in projects such as restoring the Jeukjodang Hall (the king's executive office in Deoksugung Palace), improving the lighting of Changdeokgung Palace's main halls and preserving the historic zelkova tree in Wonjeong-ri village. (RR)

35-32 Tongui-dong, Jongno District

Photos: Jonas Bjerre-Poulsen

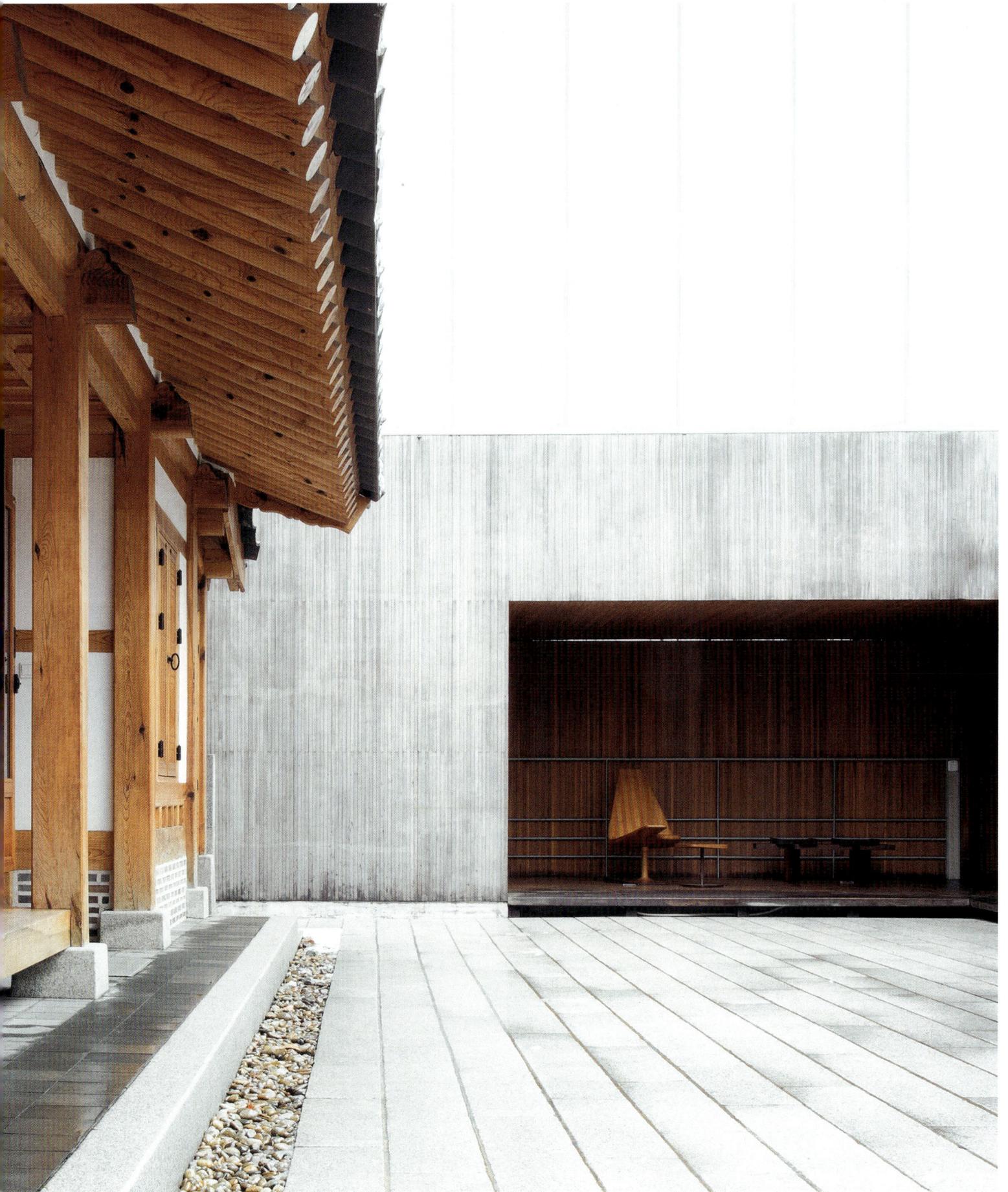

(ABOVE) The first building of the Kukje Gallery complex in Samcheong, K1, features a sculpture—*Walking Woman on the Roof*—by Jonathan Borofsky.

Kukje Gallery

A short walk from the National Museum of Modern and Contemporary Art, the commercial art gallery Kukje has been gradually expanding on its site in Samcheong since it moved there in 1987. Three contemporary spaces, as well as a restored hanok viewing room, showcase contemporary paintings and sculptures by acclaimed Korean and international artists including Haegue Yang, Kimsooja, Elmgreen & Dragset and Louise Bourgeois (*kukje* means "international" in Korean). The architecture of Kukje is notable in its own right: The third addition to the complex, built in 2012, has a facade formed from a mesh blanket of more than 500,000 hand-welded stainless-steel rings. (RR)
54 Samcheong-ro, Jongno District

Leeum

Leeum, Samsung Museum of Art is operated by the Samsung Foundation of Culture, which was established in 1965. The museum opened in Hannam in 2004 and houses the foundation's collection of traditional Korean and modern and contemporary art. Museum 1, designed by Mario Botta, is dedicated to works that span Korea's ancient history through to the end of the Joseon dynasty in 1910; the collection includes 36 officially designated national treasures. Museum 2, designed by Jean Nouvel and Rem Koolhaas, features modern and contemporary artists including Nam June Paik, Mark Rothko and Damien Hirst. There is also a sculpture garden with works by Anish Kapoor and Alexander Calder. (RR)
60-16 Itaewon-ro 55-gil, Yongsan District

CULTURAL LANDMARKS...

GYEONGBOKGUNG PALACE:
The Gyeongbokgung Palace is the largest of the "Five Grand Palaces" built during the 505-year-rule of the Joseon dynasty. Established in 1395, three years after the dynasty was founded, the palace was demolished during the Japanese occupation of Korea and, since 1990, rebuilt by the Korean government. (GU)

DONGDAEMUN DESIGN PLAZA:
Designed by British-Iraqi architect Zaha Hadid, the striking Dongdaemun Design Plaza opened in 2014 as a cultural hub, with a convention center, library, education facilities, galleries and landscaped rooftop gardens. The amorphous structure replaced the dilapidated Dongdaemun Stadium. (GU)

Photo: Inigo Bujedo Aguirre / Getty Images

(ABOVE) The facade of the Dongdaemun Design Plaza is formed from 45,000 aluminum panels.

문화와 예술
SongEun Art and Cultural Foundation

The SongEun Art and Cultural Foundation has played an important role in promoting contemporary art in Korea and in supporting young local artists since it was established in 1989. In 2021, the nonprofit foundation opened a new space in Chungdam designed by Herzog & de Meuron. The building has a striking triangular profile, presenting to the street as a 193-foot-tall concrete monolith while reducing to the level of the adjacent low-rise buildings at its rear. Inside, there are artist studios and exhibition spaces that show a mix of established international and emerging Korean artists. (RR)

441 Dosan-daero, Gangnam District

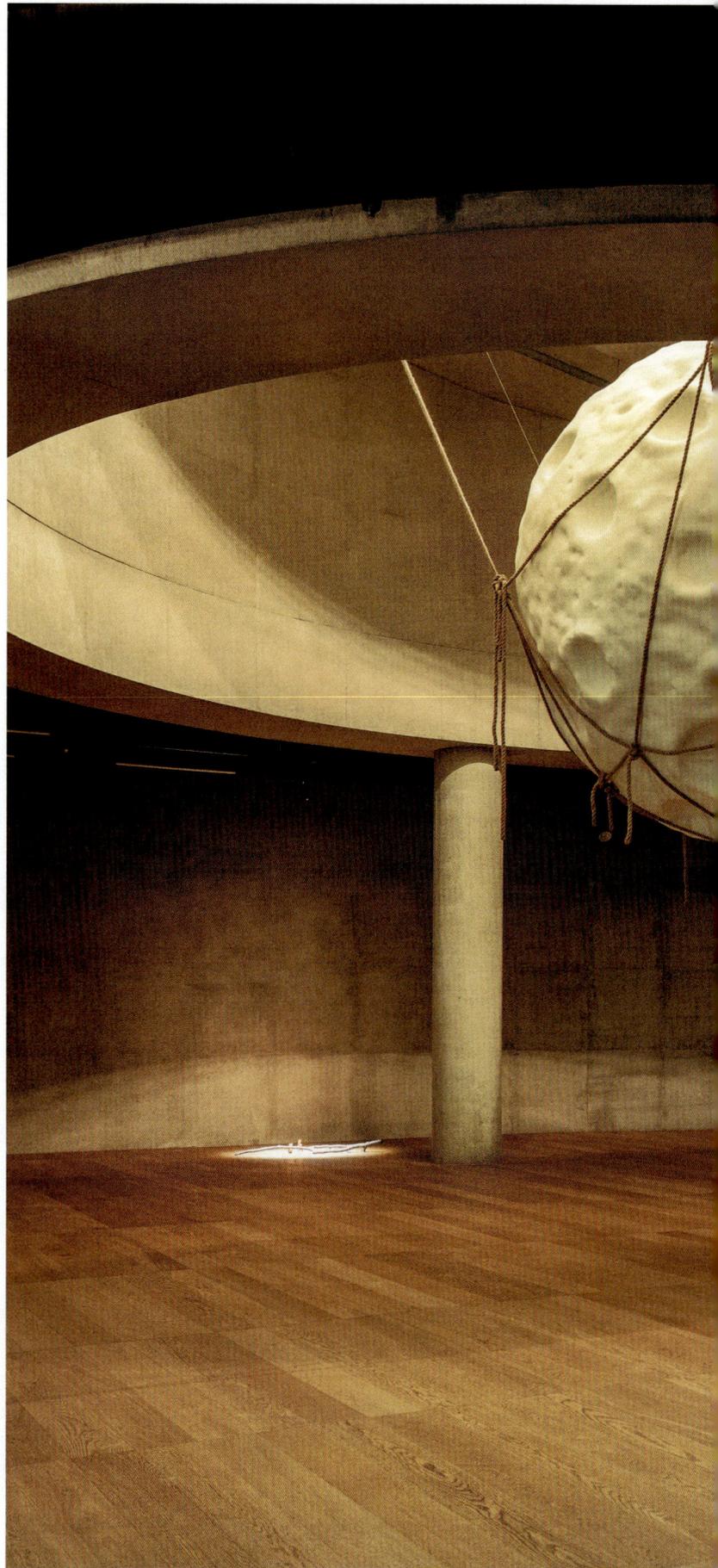

문화와 예술

문화와 예술
Korean Furniture Museum

The Korea Furniture Museum is located in the affluent neighborhood of Seongbuk, an area in the north of Seoul that is known for ambassadors' residences and the remnants of the Seoul Fortress Wall. Established in 1993 by owner and director Chyung Mi-sook, the museum is dedicated to traditional Korean furniture. The museum is housed in several hanok structures, brought together from across Korea and arranged as a village, to offer a window into the experience of the Korean nobility during the Joseon dynasty. It includes fragments salvaged from Changgyeonggung Palace in Seoul following its demolition in the 1970s. Rooms—which have been arranged to emulate the interiors of aristocratic homes—demonstrate the elaborate rules around decoration and social status in Korea, as well as the principle of *chagyeong*, or "borrowed scenery," which incorporates the landscape into the architecture by, for example, framing it in a window. Of the 2,500 pieces that Chyung has been collecting since the 1960s, about 550 are on display at any given time. Visits to the Korea Furniture Museum are only possible as part of a guided tour and should be booked well in advance. Access can be difficult as there are no sidewalks—the museum recommends taking a five-minute taxi from Hansung University Station. (RR)
121 Daesagwan-ro, Seongbuk District

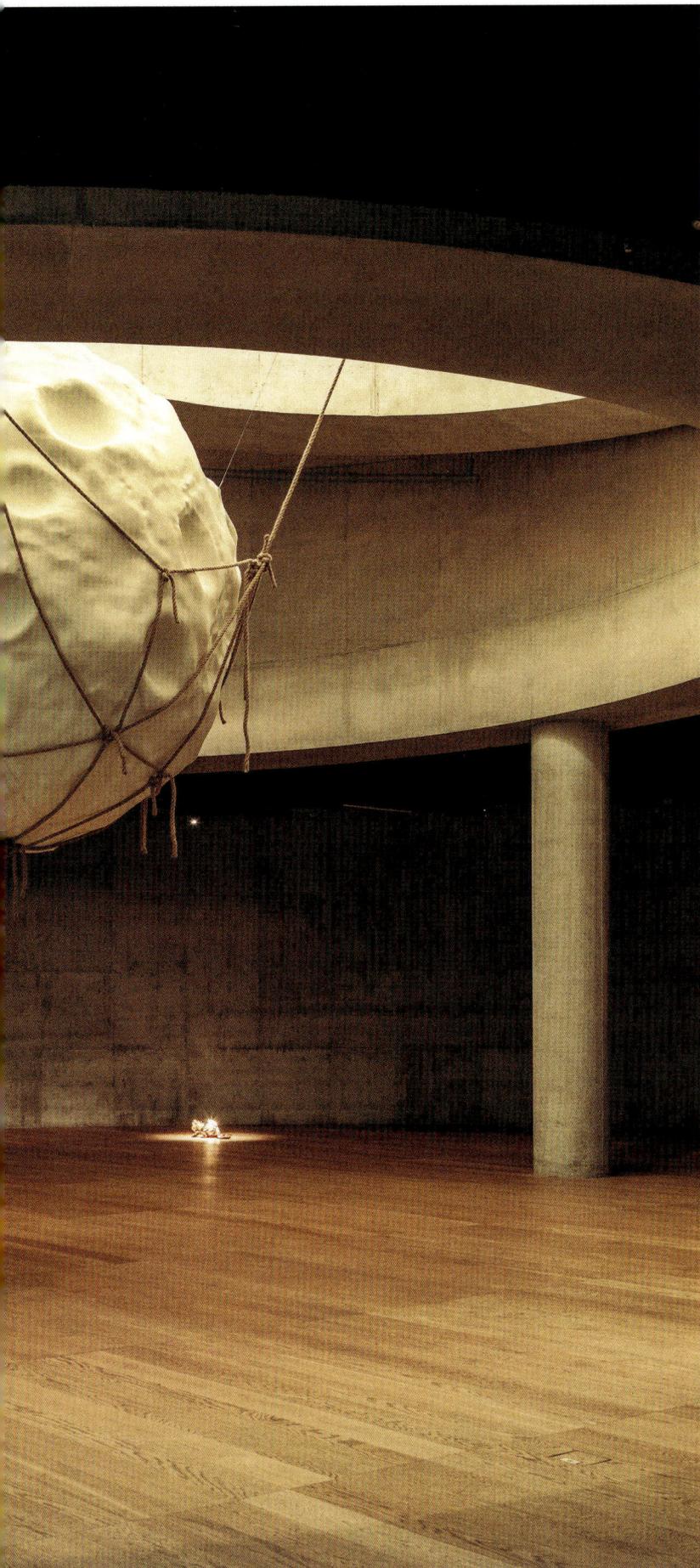

Photo: Daniele Venturelli / Getty Images

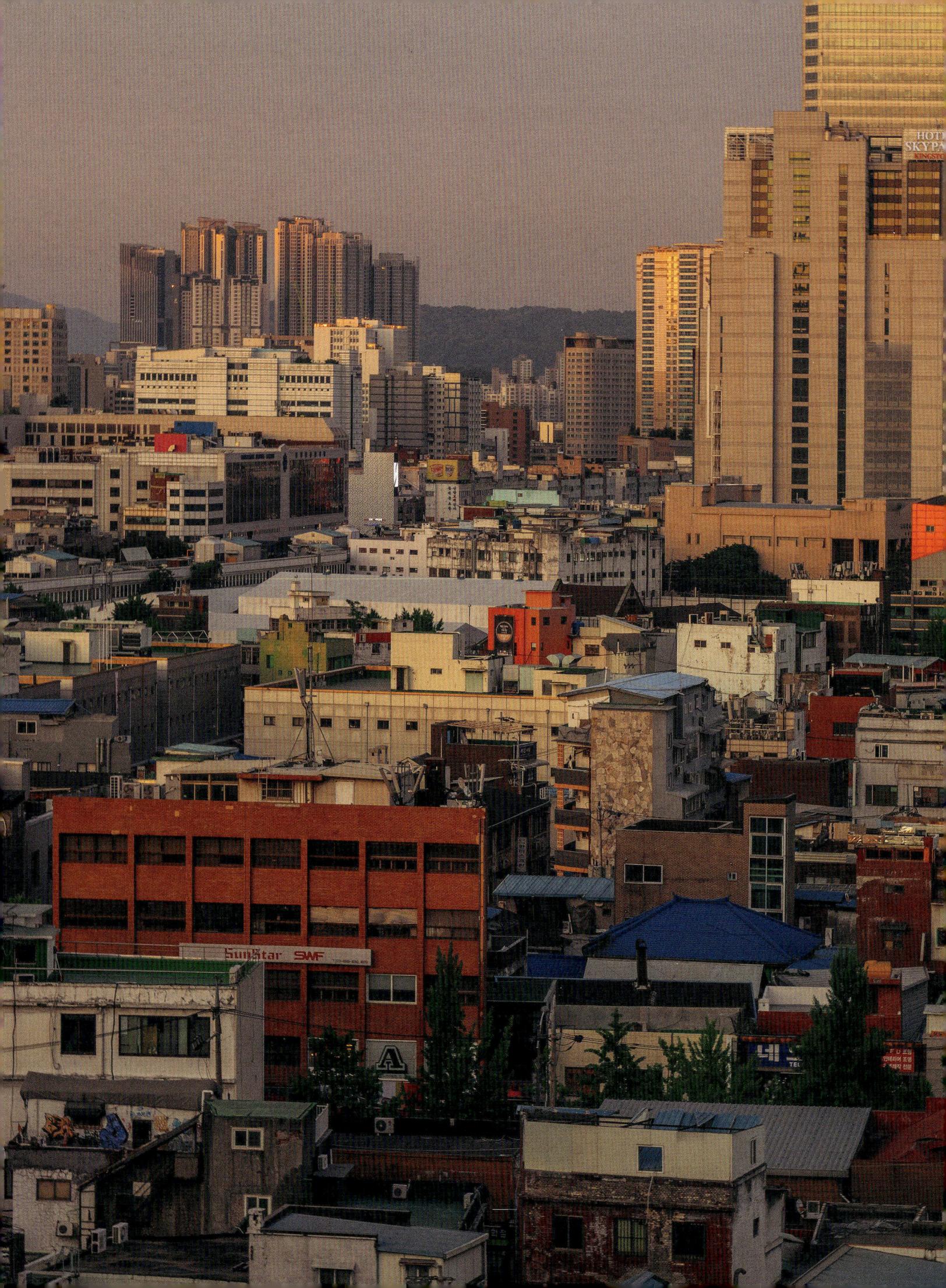

AFF Seoul

Located on the upper two floors of an unassuming building in Euljiro, AFF Seoul (standing for "Asian Funky Flavor") draws inspiration from the head chef's travels in Hong Kong and Southeast Asia. Dishes like halibut ceviche, Thai oyster soup and grilled sablefish are paired with natural wine in candlelit dining rooms. In good weather, diners are seated on the balcony of the double-height rooftop room, where there are views over a cityscape of narrow alleys and high-rise buildings. There's also the option to have a drink downstairs at the bar-cum-aquarium. (GU)
4F/5F, 42-21 Supyo-ro, Jung District

Hanchu

The Korean word *anju* refers to food that's eaten with alcohol, such as tofu and stir-fried kimchi with makgeolli, fish dishes with soju, and *chimaek*, a portmanteau of the Korean word for fried chicken, *chikin*, and *maekju*, beer. Fried chicken became popular in Korea in the 1970s and has since developed its own variations. Hanchu in Apgujeong serves huraideu-chikin—crispy and lightly spiced fried chicken—with pickled radishes and draft beer in an unpretentious setting that's open until 3 a.m. The restaurant also offers fried chili peppers, chicken gizzard and squid, and fish cake soup. (GU)
68 Nonhyeon-ro 175-gil, Gangnam District

TWO MORE...

KYOJA:
There are just four items on the menu at Kyoja and one of them, *kong-guksu*, a cold soybean noodle soup, is only available between late spring and early autumn. Despite this, the restaurant, which was established in Myeongdong in 1966 and is still owned by the same family, has long been a local staple for its dumplings and noodles. (GU)
29 Myeongdong 10-gil, Jung District

ONJIUM:
Onjium, which means "creating in the right way," is a Michelin-starred restaurant and research institution dedicated to renewing traditional Korean cuisine. Housed in a minimalist, contemporary building, and overlooking the Gyeongbokgung Palace, the restaurant offers a fitting setting to discover modern versions of dishes inspired by royal Joseon recipes, like abalone dumplings, clam pancakes and steamed *gueomdak*. (GU)
49 Hyoja-ro, Jongno District

음식과 음료
Millennial Dining

Meat wasn't widely consumed in South Korea until the economic boom of the 1970s and it continues to be associated with wealth and social status. While Koreans regularly cook meat-free meals at home, it's less easy to find vegan or vegetarian dishes when eating out; even apparently vegetable-based dishes like kimchi will often contain fish or be cooked in a meat broth.

Millennial Dining in Seocho is one of the few vegan restaurants in Seoul. Founded by chef Lynn Ahn in 2020, it brings together recipes Ahn learned from her grandmother, traditional fermentation techniques and research into plant-based food with the overall aim of demonstrating that vegan food can be accessible and enjoyable—regardless of whether you eat meat or not. Dishes like pasta with apple jam and Beyond Meat bacon, carrots slow cooked for five hours and roasted with a soybean paste, and a truffle and mushroom pizza with handmade vegan mozzarella are typical of Ahn's approach, which views vegan cooking as an opportunity to create something new, rather than being a dietary requirement that has to be accommodated. The restaurant is zero-waste and has its own herb garden, reflecting its wider goal to "promote a lifestyle that respects both personal well-being and global environmental sustainability." (GU)
3F, 316-1 Hyoryeong-ro, Seocho District

Head to page 23 for Millennial Dining's recipe for beet sashimi.

음식과 음료
SookHee (Myeongdong)

The entrance to speakeasy bar SookHee is hidden behind a secret door on the fourth floor of a nondescript building in the middle of busy Myeongdong—a setting that makes a striking contrast with the opulent decoration inside. Drawing inspiration from the Geunjeongjeon Hall at the Gyeongbokgung Palace, the bar has been decorated in traditional Korean style: wooden beams embellished with colorful dancheong paintings, munsal lattice-work, mother-of-pearl panels and antique cabinets. The cocktails showcase seasonal fruits and local flavors like jujube and scorched rice, and there is a small food menu for snacking. (RR)
4F, 7-9 Myeongdong 10-gil, Jung District

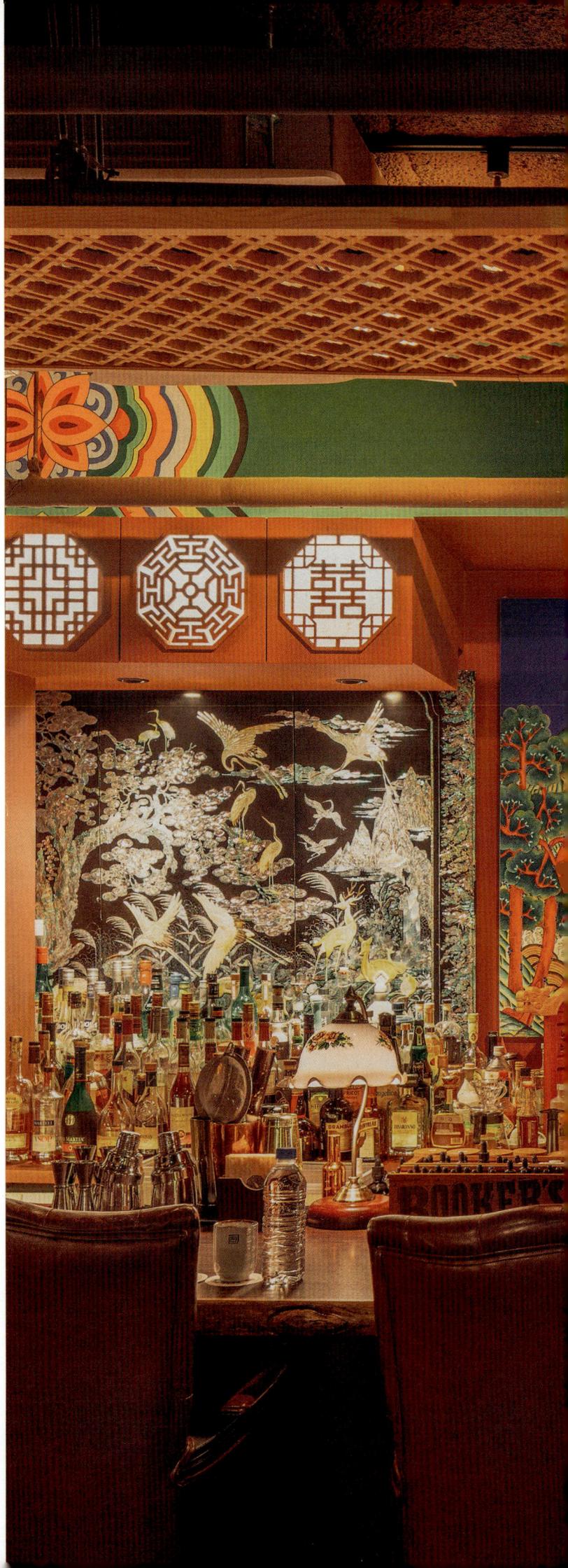

음식과 음료

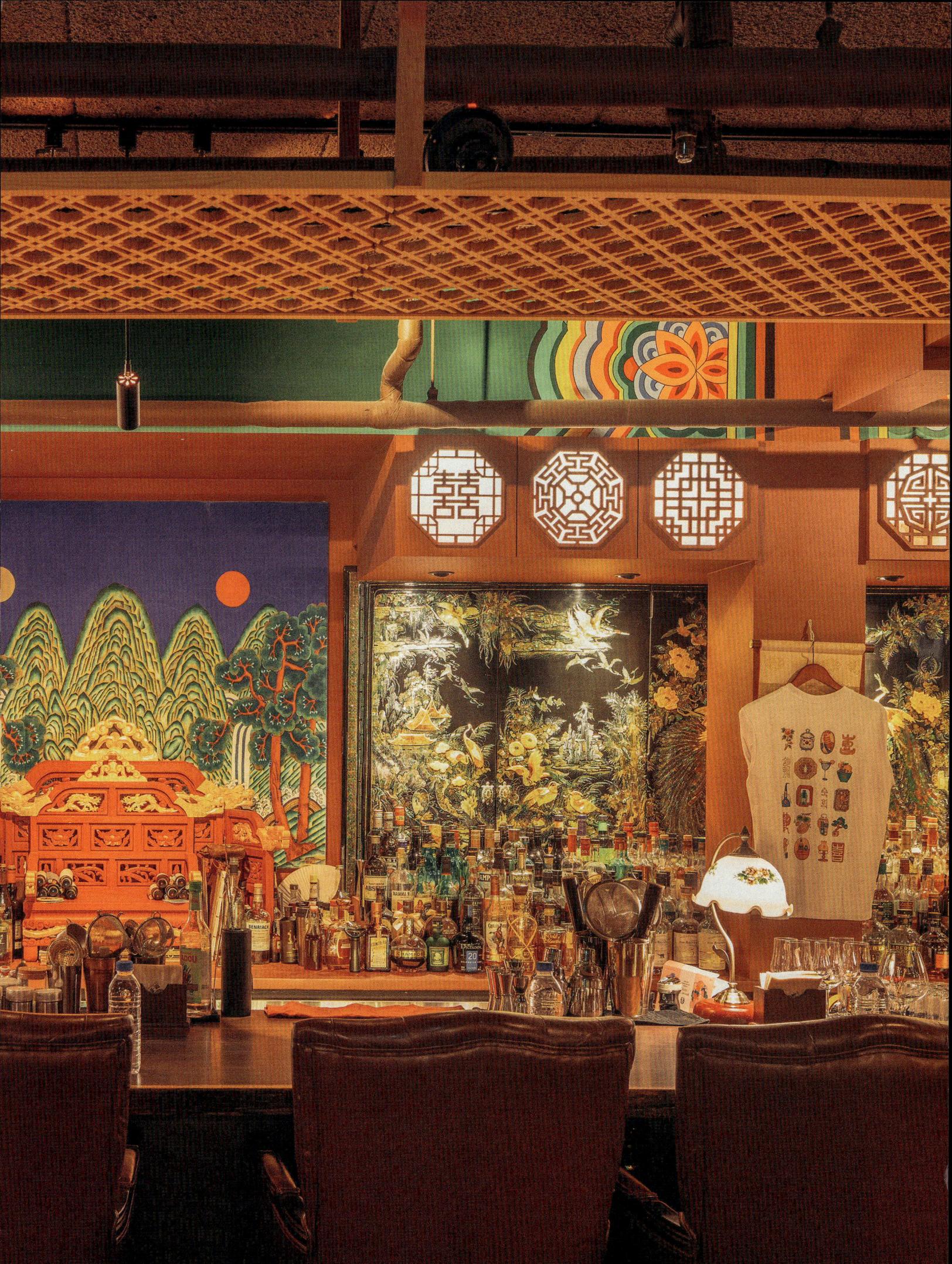

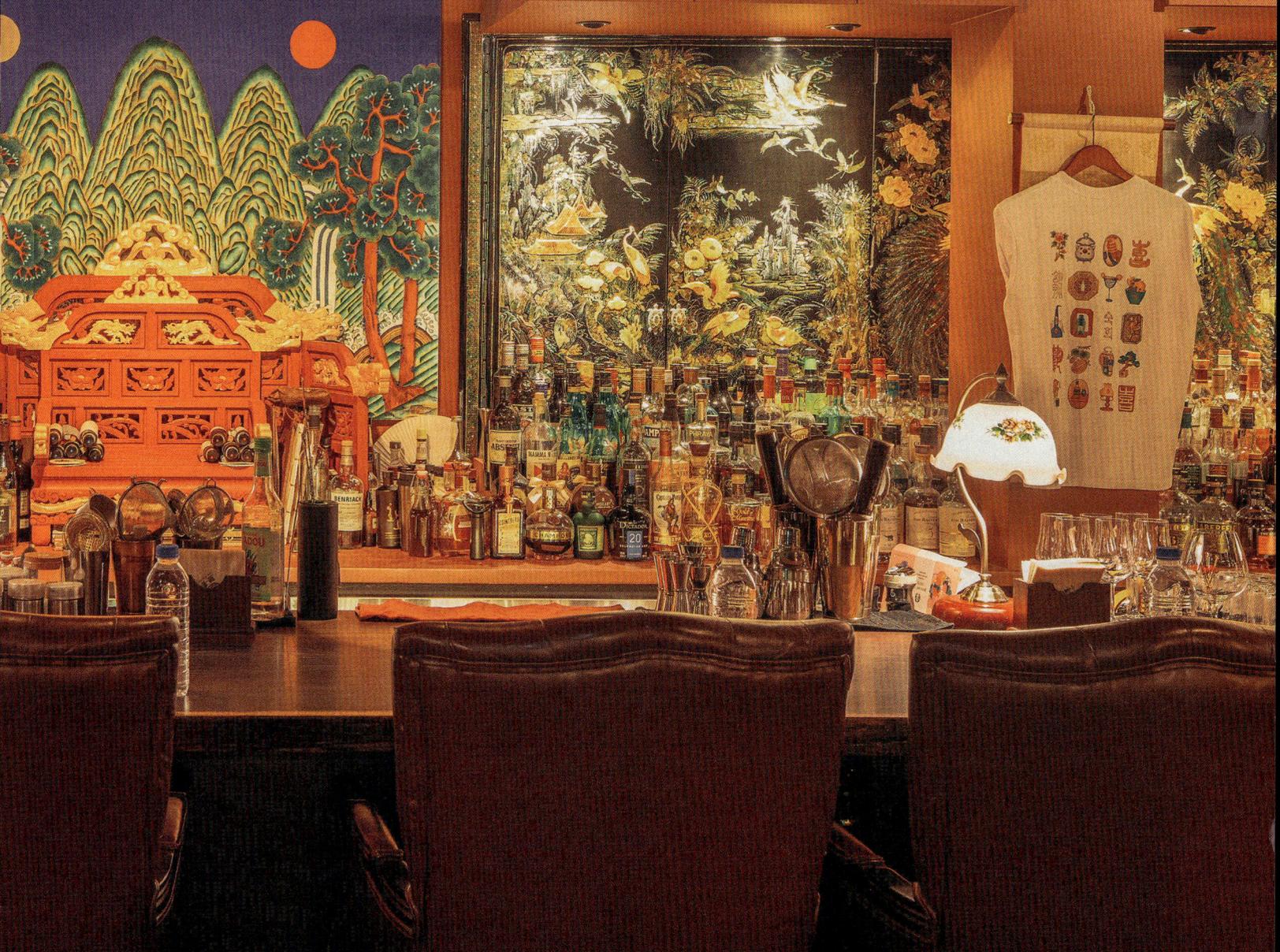

Sigol Bapsang

While much of bustling Itaewon has transformed dramatically in recent years, Sigol Bapsang offers a reminder of how things once were. Located just off the main stretch of Itaewon-ro, this small, traditional Korean restaurant (there are just five tables) has remained largely unchanged through the decades. Here you can order *bapsang*, a traditional meal that consists of rice, soup and *banchan*—20 or so small vegetable side dishes that can be supplemented with a seafood omelet or bulgogi (thin slices of meat that have been marinated and grilled). The restaurant is open 24 hours a day. (GU) *235 Itaewon-ro, Yongsan District*

Tarsty

Natural wines have grown in popularity in Seoul, with several bars opening in recent years to cater to the trend. Tarsty is one of the latest additions to the scene and provides a chance to escape to a quieter part of the city. Situated in a contemporary hanok in Samcheong, just east of Gyeongbokgung Palace, there are five tables, a small courtyard and a rotating list of imported orange wines that are paired with Korean small plates. The seats in the window—which have views across the hanok rooftops to the gardens surrounding the Blue House, the residence of the South Korean president until 2022, and Ingwangsan Mountain—are particularly popular at sunset. (RR) *102-15 Samcheong-ro, Jongno District*

Kompakt Record Bar

Seoul's record bar scene was likely inspired by mid-century Japanese listening bars, which gave music lovers access to sound systems and a collection of imported records that they wouldn't have had at home. The current trend in Seoul might be motivated as much by nostalgia, or anemoia, as by the high-end speakers, but "LP bars" have been cropping up in the city since the 1990s and have a broad appeal: There are bars dedicated to '60s psychedelia and '70s Korean folk, for example. Kompakt Record Bar opened in 2018 and now has four locations around Seoul. At the original, and most compact, in Apgujeong, waiters double as DJs when not serving cocktails and guest DJs visit on weekends. (GU) *46 Dosan-daero 25-gil, Gangnam District*

THREE MORE...

MINGLES: Chef Mingoo Kang trained under Spanish chef Martin Berasategui and worked at fusion restaurant Nobu in Miami and the Bahamas before returning home to study Korean cuisine. His two Michelin-starred restaurant, Mingles, in Cheongdam offers a seasonal, 10-course tasting menu that specializes in local fish and vegetables, like bellflower root and acorn jelly. (GU) *2F, 19 Dosan-daero 67-gil, Gangnam District*

SAMWON GARDEN: Samwon Garden elevates Korean barbeque—where grills are built into the table and diners cook the meat themselves—to the level of fine dining. Situated in a high-ceilinged space in Dosan with large windows that look out onto a landscaped garden, the restaurant serves a range of beef and pork, cooked at your table over coals, as well as other traditional dishes. (GU) *835 Eonju-ro, Gangnam District*

THE EDGE: The Edge is part bar, part record shop and part nightclub. Tucked down an alleyway in bustling Euljiro and sharing a third-floor space with vinyl shop Clique Records, the Edge serves coffee during the day and natural wine at night to the backdrop of visiting and resident DJs. (GU) *3F, 8 Eulji-ro 12-gil, Jung District*

Tarsty occupies a traditional hanok house in Samcheong.

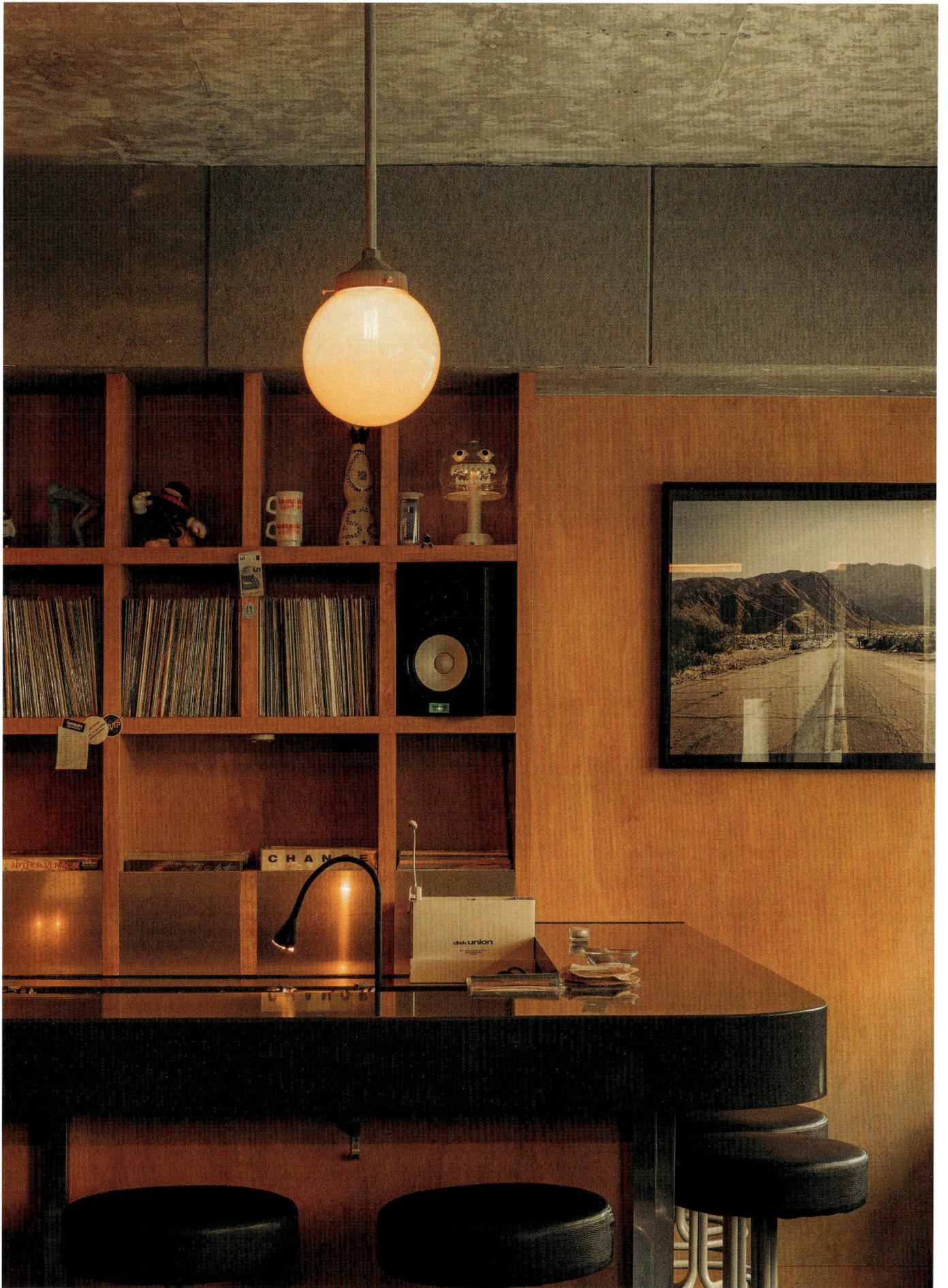

Kompakt Record Bar's second location at 28 Nonhyeon-ro 157-gil

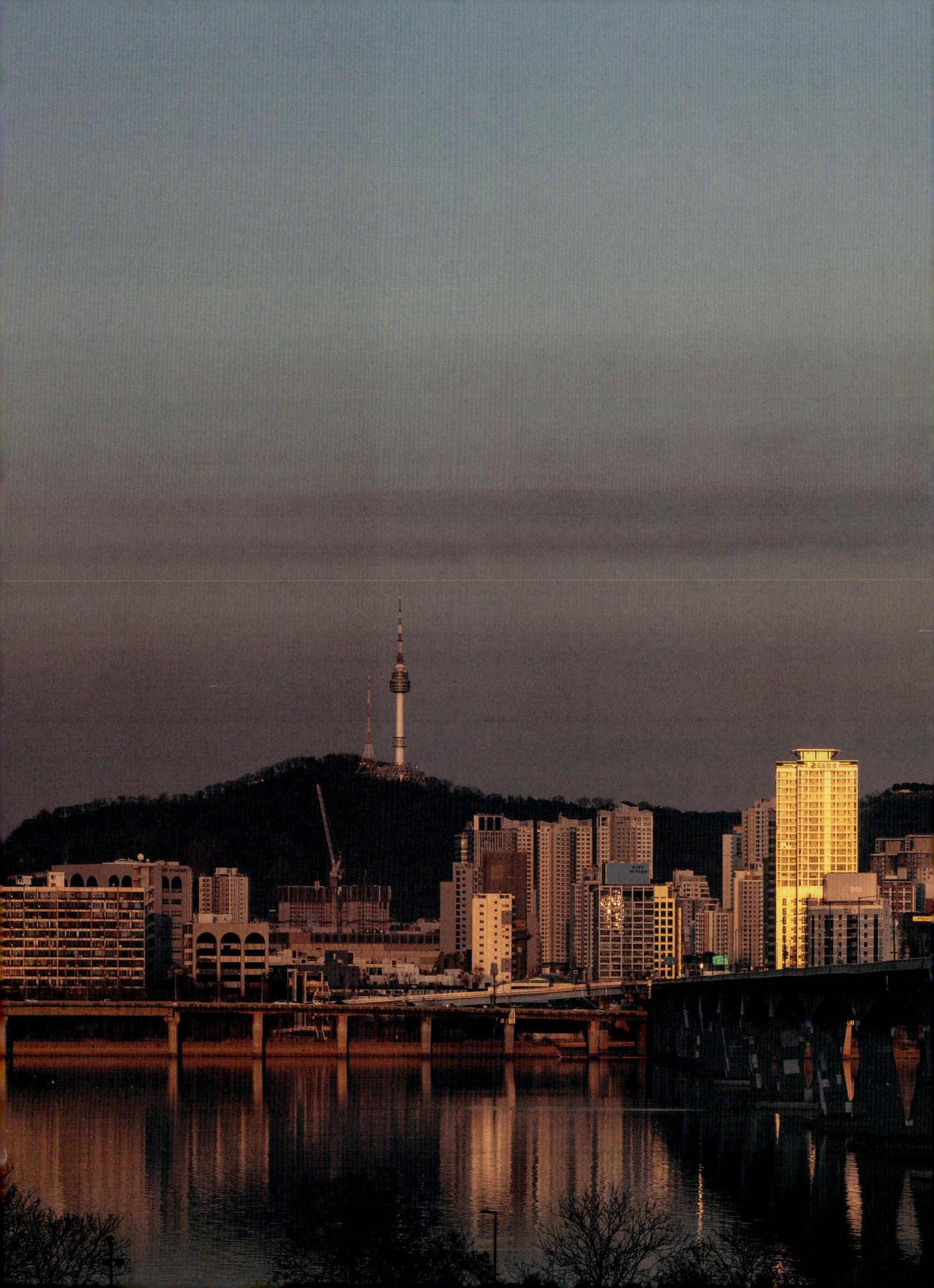

Directory.

Words:
Jessica J. Lee

Getting a feel for fungi.

Amidst the leaves that speckle the forest floor, a little orange cup extends toward the sky. Semicircles of white grow from a fallen log; frilly yellow saucers encircle the base of a tree. These are fall fungi—there all year, growing quietly, unseen until suddenly they emerge in full flush.

Fungi are sometimes described as "the hidden kingdom." Ranging in size from the microscopic to the enormous, they can be found almost anywhere in the world—from the yeast that leavens your bread to the pale green fungal blankets that grow on Antarctic snow. But for most of the year, they are invisible to us, existing as webs of mycelium that can extend for miles underground: One honey fungus network in Oregon is considered to be the largest single organism on Earth.

When the cooler, damp weather of fall and spring arrives, the mycelia send out fruiting bodies that you may more readily recognize as mushrooms. These seasons provide the perfect opportunity for learning to spot fungi. It's an act that requires slowing down to search the leaves, soil and grass and recalls what anthropologist Anna Tsing has described as "the art of noticing," a practice that can encourage us to be more mindful and aware of the natural world.

In the temperate zones of North America and Europe, you may spot orange-gilled toxic jack-o'-lantern mushrooms at the bases of old oaks (bioluminescent at night!), or conical shaggy inkcaps on the lawns in local parks. Penny buns (also known as porcinis) have stout brown caps and grow especially well on the edges of woodlands, while common field mushrooms and puffballs (which look exactly like their name) can pop up in rings that dapple open fields. And not all fungi are found on the ground: Look up as you walk through a forest and you may spot flame-orange chicken of the woods mushrooms growing from the sides of tree trunks.

As with all things in nature, safety is key. If you plan to forage, do so with an expert and never eat a fungus that has not first been identified by a mycologist. You can also make "spore prints": When these tiny dust-like particles fall onto a piece of paper, they leave a trace of a mushroom's intricate form. It's just one of the many ways fungi can inspire a slower pace of life—the perfect antidote to the busyness of fall.

WILD LIFE

Words:
Alice Vincent

A fall gardening guide.

For gardeners, fall has traditionally been a time to clear away the last of the summer growth, plant bulbs for the spring and tuck the garden in under a thick layer of mulch to wait out the winter.[1] It's as much a part of the season as falling leaves, bonfires and golden sunsets.

Not everyone adheres to this way of thinking, however. Some gardeners are against the idea of tidying, seeing the garden as a space where wilderness and human creativity should be left to express themselves freely. Others make the argument that putting the garden to bed ignores its role in broader ecological cycles that surround it: Certain plants in the garden may be dormant, but there's still crucial living going on.

However you look at it, there are certain tasks at this time of year that are essential to giving your plants the best chance come the spring. If you live somewhere that is susceptible to hard frost—where the weather drops below freezing or you get snow—then your tender and frost-intolerant plants, such as pelargoniums, will need to either be brought inside or sheltered with fleece or cloches (glass or plastic domes). This is also a good opportunity to trim back any unruly or damaged growth to encourage a more fulsome shape next year. In most cases, this will result in an abundance of cuttings; there are few better holiday gifts than a plant that you have grown yourself, bringing with it a promise of warmer days to come.

Hardy or frost-tolerant plants are able to survive the cold weather and it can be a good idea to wait until the spring to cut them back, leaving their bare skeletons to play with light and shadow and provide crucial winter habitats for hibernating insects. Autumn is, however, a good time to lift and divide perennials that have grown over the summer—be sure to replant them to bulk out your flower beds. In the garden, the new year starts now.

(1) Most leaves can be raked up and turned into mulch: Punch a few holes in the side and bottom of a trash bag and fill with any leaves; sprinkle with water, shake and tie. Store the bag in a shady spot and leave it to compost for one year.

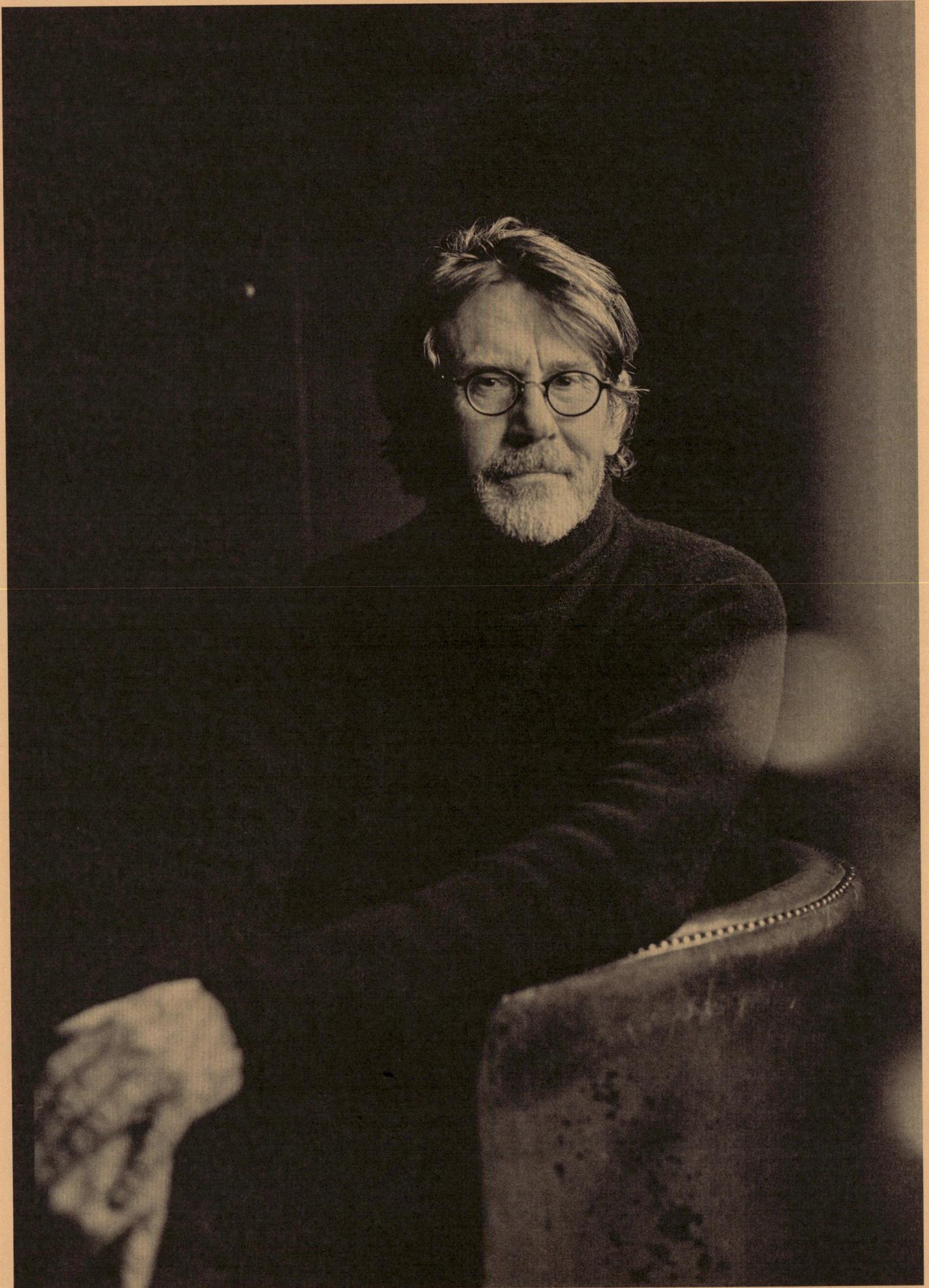

Photo: Jenny Zarins

NIGEL SLATER on life's small pleasures.

Ardent followers of Nigel Slater don't just pepper their cookbook collections with the British food writer's works; they have a dedicated "Nigel Shelf." From his less-than-epicurean beginnings, chronicled in his 2010 memoir, *Toast*, Slater emerged as the unlikely hero of everyday cooks in the 1990s through a recipe column he has now written for *The Observer* newspaper for over 30 years. He's a champion of real food cooked without fuss, but it's a lot of what Slater *isn't* that has defined his appeal: He's not a chef, he doesn't intellectualize food, and while he is culturally curious, a collector of ceramics and a keen gardener, he's not at all preachy. He simply enjoys food, and sharing that joy through his writing.

EMMA MOORE: How do you approach writing about food?

NIGEL SLATER: From a very personal level—a diary, if you like. From the beginning, I've always added a sense of place to the recipe. I didn't want to go into, you know, "This is my granny's way of making Victoria sponge." But at the same time, I wanted to tell a story so that the recipe had a home, so to speak.

EM: Have you always journaled?

NS: I kept a diary right up until my 20s and then I had a house fire. Every single one went, which at the time was a bit of a relief because I always worried about people looking at them. Now I wish I knew what I was doing when I was 15. But that's all gone. What I have are very scrappy notes from those days. There will be one line about when I was in India eating something, but I can often remember that more clearly than what I did yesterday.

EM: Is there a comparison to be made between your style of cooking and your style of writing?

NS: I suppose I don't always follow the rules. I want a recipe to work, but what's more important to me is that it's just delicious. And it's a little bit like that with writing: I know that I shouldn't start a sentence with "and" or "so," but I still do because it feels right. I know that there are certain things that you should fuss about in cookery—making sure that you get the tiniest bit of pith off that orange—but I often don't. I have that "life's too short" thing. I don't go over my writing again and again.

EM: Your new book, *A Thousand Feasts*, has no recipes. Is it another memoir?

NS: *Toast* set out to be a collection of 1960s and '70s food, but I wrote it so personally it ended up being a memoir. *A Thousand Feasts* was really just bits from my notebooks over the years, but it has ended up a bit of a memoir too. There's cookery in there; I will talk about stirring, for instance, that lovely thing when you've had a busy day, and you're just stirring risotto, round and round, slightly mindlessly. Then there's the joys of eating—things I've eaten all over the world that I can remember with huge clarity.

EM: Do you have confidence that these little joys will resonate with others?

NS: I don't live in a bubble—I know what's going on—but I do feel the time is right for some celebration of everyday things that actually enrich our lives. I need it. Tiny things mean a lot to me. If I brought in negative moments, it felt like I was going against what I was trying to do, which is this collection of joy. So people will sit in bed and read a lovely piece about doing the ironing or about unwrapping a gift. I want someone to read about that before they go to sleep at night rather than looking at the news. I don't think you sleep as well.

EM: Is it liberating to write without recipes?

NS: It's totally liberating. I've always been tied to what's on a plate. I have something I can witter about where I don't have to be purely accurate and practical. But also there are things that I feel strongly about and I suppose there is a little bit of whimsy in there. I'm waiting for some people to absolutely hate it. And that's fine. It is very personal.

SQUID GAME

Crossword: Mark Halpin

ACROSS

1. Confidently claim
5. Unruly crowds
9. Text back and forth, perhaps
13. Hogwash
14. Blind as _____
15. Swear word
16. Group containing Thor, Odin, etc.
17. Atlantic City locale
19. Game in which large-billed birds traverse the Lollipop Woods?
21. In the style of
22. Barbie and Ken, e.g.
23. The Louvre, for example
27. Poet Ginsberg
29. Always, poetically
30. That woman
31. Game in which manatees conceal themselves?
35. Grad, for short
37. Fix, perhaps unfairly
38. Cheers in a stadium
39. Game in which marsupials try to sink each other?
44. Throne room in Buckingham Palace, say?
45. Retiring
46. Made lighter
48. Success in pitching or bowling
50. When doubled, a vitamin B deficiency
52. Big coal-mining state, briefly
54. Game in which tusked beasts struggle back and forth?
57. Famed Harlem theater
60. Big name in tractors
61. Noble figure
62. Something used to hunt and peck
63. Mountain nymph
64. Like quiche or custard
65. Believers
66. Epitome of smoothness

RECEIVED WISDOM

Words:
Benjamin Dane

Creative director and graphic designer VERONICA DITTING on collaboration, Joan Didion and learning not to "feed the crazy."

I stay creative through collaboration. When you work in graphic design, you can become a lone wolf, taking on projects that you both start and finish on your own, but as a creative director, you must constantly interact with other like-minded talents—that dialogue really sparks my creativity. On a photo shoot, for example, if you find the right collaborators and establish a common language, you can reach a kind of higher state where everything just clicks, and ideas are generated that you could never have gotten on your own.

I used to share an office with Bart de Baets, another graphic designer. He would often laugh at the fact that, while my work is very particular, precise and in some ways quite rigorous, my home is the complete opposite. I live in the brutalist Barbican Estate in London, but my apartment doesn't have a minimalist John Pawson interior. The floor is bright green and made of Pirelli rubber, and the decoration is quite eclectic; it's filled with ceramics, glassware and books that I've collected—I think it would probably surprise a lot of people who only know my work.

It fills me with a sense of pride when people collect what I make. I've created quite a few print publications for Hermès along with invitations for their runway shows, and I'll often hear from people who collect them. Sometimes, I'll receive a picture on Instagram from someone showing me their bookshelf filled with *Le Monde d'Hermès* magazines or every issue from my 12 years at *The Gentlewoman*.[1] I really care about everything I do and it's the biggest possible compliment when people value my work to such an extent.

Two summers ago, I was reading *Play It as It Lays* by Joan Didion. I think it's quite a good motto to live by. In life, you often try to steer things in a certain direction, but you can't control everything. Sometimes you have to act, and sometimes you have to react to what's in front of you.

When I was around 30, I went to therapy for the first time. In one of my sessions, I was describing a situation to my therapist where I repeatedly explained myself to get a point across, and she simply said: "Don't feed the crazy." It kind of applies to any situation—in life or in work. If someone is angry, hysterical or just doesn't seem to understand you, sometimes you just need to let it go instead of trying to set everything straight.

I go to a Pilates class every Saturday morning and I practice yoga nidra, which is good for calming the nervous system and improving your sleep. When I need to unwind, I either do that or go to a pottery class. It forces me to be present in the moment, and I'm also terrible at pottery, which I think is a positive thing. Sometimes, it's healthy to do something where the objective isn't to be good—I'm definitely not going to send you a mug that I've made.

(1) *The Gentlewoman* is a biannual British fashion magazine for women, edited by Penny Martin. Since launching in 2010, it has been applauded for its timeless design that features crisp typography and stripped-back layouts—the work of Ditting.

TOP TIP

As Told To:
Elle Hunt

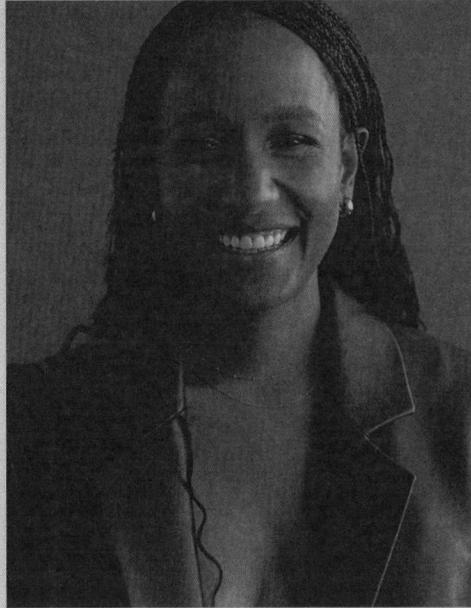

Interior designer SHANE V. CHARLES on "de-influencing" your home.

To "de-influence" your home, you first have to understand how our interior design decisions are being influenced. The internet is working overtime to tell us what we *should* like or need, and has considerable impact on our sense of aesthetics. Take those heinous sheets of adhesive that are meant to look like tile or marble countertops that were everywhere in 2020 and 2021. I get it: People were stuck at home, wanting to express themselves creatively and update their spaces, but in my opinion, those types of choices only lead to future headaches. Often, there's no going back on those purchases and you can quickly live to regret them.

It's important that we instead pull inspiration from what we see around us: the detail of that historic building on your corner, the woodwork in your neighborhood coffee shop, the staircase at your local library. Looking up from your phone and taking note of the beauty around you will help enhance your thoughts about your style, which you can then take to your Pinterest board.

The next step is to focus on the space you're designing so that you can make choices that are true to that environment. Natural materials like wood, rattan or stone are always better, but identifying what's natural for you, and your space, will get you the best results. There are so many layers you can consider: the climate, the lighting, what direction the windows are facing. Alternatively, you could grow your understanding of the aesthetic or style you're going for.

All this takes time: Don't feel like you have to rush to achieve an aesthetic or deliver on an overall design, as that's often when you'll make decisions that you won't be happy with a year from now. Shopping for vintage or secondhand furniture, for example, can be a great way to find well-made pieces. Ultimately, you've got to be willing to take your time to find the exact piece that you have in mind.

—

Words:
Emily Nathan

Strategic consultant EMILY SEGAL on the art of trend forecasting.

Emily Segal is a decidedly multifaceted professional. Known for her work as an author, artist and strategic consultant, Segal gained prominence as a co-founder of the pioneering trend forecasting group K-HOLE—responsible for coining the term "normcore" during the 2010s—and went on to write a book, *Mercury Retrograde*, which explores the impact of contemporary culture and technology on modern society.[1] Speaking from her home in Los Angeles, Segal describes how trend forecasting has enabled her to draw a varied set of interests, talents and experiences into productive harmony.

EMILY NATHAN: How did you first encounter trend forecasting?

EMILY SEGAL: After college, some friends and I were trying to make ends meet in New York City, post–financial crisis. Somebody found an official trend forecasting report on the server of the company they worked for and emailed it around. At that time, trend forecasting reports were highly produced, glossy PDFs that used a lot of beguiling neologisms and suggestive lifestyle photography to present a sort of pop-cultural theory of what it was like for young people living in urban centers. We found this format to be fascinating: very rich, very strange—and so, in the spirit of fan fiction, we decided to start exploring ways to make our own version. We made a PDF and distributed it on a series of very limited-edition custom USB drives. We also released it for free online, which was an important aspect of the project for us.

EN: Would you describe your engagement with the format as earnest or more ironic and satirical?

ES: At first, it wasn't a particularly critical gesture, but something more lighthearted—I'd call it essentially artistic. Coming out of school, we liked that these trend forecasts were so *not* academic, mixing commercial and pop-culture languages, but were trying to describe the same kinds of cultural

changes that might be explored in more serious academic cultural criticism. Learning how to strike a tone where you're writing about the future in a way that's credible and amusing, but also leaves open a lot of possibilities, was exciting for us to try to emulate.

EN: How do you begin making a trend forecasting report?

ES: The type of trend forecasting I like to do is really a way to connect the dots among various disciplines. I'd sort of scan the horizon and locate interesting pressure points: Here's something going on in the arts; here's something from fashion; here's something from finance, or the political world. And then I'd find some resonance or pattern among and between them and try to abstract that out into what this might mean looking forward. A lot of trend forecasting is kind of anthropological. It's about digging into the world around you, making artistic, textual and visual associations, and then using your own rhetorical powers to put them together into something significant.

EN: What does trend forecasting offer culture?

ES: I think that trend forecasting equips us with new ways of looking at the world. Outside of a commercial context, it really has to do with pattern recognition, and speculating on future possibilities, which I think frees up room to think about what might happen in fresh and innovative ways. At its best, trend forecasting can be a way of considering multiple futures—an engaging and engaged way of exploring the world we live in.

(1) *Mercury Retrograde* is an autofiction novel that follows the narrator, also named Emily Segal, as she accepts a job at an ambitious start-up in Brooklyn. Before long, both narrator and company start to break down in what *Harvard Review* called "an often hilarious portrait of life in the uber-modern workplace" in its review.

POWER TOOL

As Told To:
Emily Nathan

Icelandic artist LOJI HÖSKULDSSON on the tool that helped him find his medium.

It all started for me during a two-week program at Iceland University of the Arts in Reykjavík. It was 2010 and I was growing really tired of the conceptual art everybody seemed to be making. The rebel in me wanted to do something different. I'd had a conversation with my mother about wanting to try embroidery—she's a quilter by trade—and when she gave me a carpet needle, it just made sense. From the first stitch, I could tell that this was my medium. Everything about it felt right: the pace, the meditative aspect, the structure.

That first tool was a Danella, a semi-automatic rotary punch needle that was designed and manufactured in Denmark and is incredibly easy to use. Today, that needle isn't my favorite, but it has a special place in my heart as it was the gateway into embroidery.

I am very interested in abstract geometric paintings and straight lines. For the most part, I use burlap or jute for my background. What I like about the burlap in particular is that the warp and weft of the material create a horizontal and vertical grid. I find it meditative to count out the grid, and it's easier for me to create when I have the boundaries it offers. I'm currently making a piece that depicts dandelions, which of course don't grow in straight lines, but I really like putting them in like that. I'm always trying to put nature in straight lines in my work, but at the same time, I love breaking the rules. Most embroidery comes with instructions: You get this yarn, you do these stitches in this way to make a flower, and if you make a mistake, you need more yarn. What I like to do is pick random moments from life and use an interesting technique to freeze them in time.

I am always learning new stitches; sometimes they will stick and become part of my vocabulary, and sometimes an idea for a piece will come to me from a stitch, if it looks like a chain or a berry, for example. I've tried being more topical: Recently, plastic bags were a very hot topic here in Iceland, so I started incorporating them into my compositions, but I'm definitely not a political artist. I just want to make things that are beautiful—in a horrible world, there's always room for something beautiful.

Photo: Spessi

CREDITS

MUSTAFA COVER:	PHOTOGRAPHER	Luke Lovell
	STYLIST	Tana Grossberg
	TALENT	Mustafa Ahmed
	GROOMER	Ghost (Jessica) Pudelek
	PRODUCTION DESIGN	James Lear
	PRODUCTION COMPANY	CAMP Productions
	PRODUCER	Alicia Zumback
	STUDIO	Edge Studios

À LA MODE COVER:	PHOTOGRAPHER	Mar + Vin
	STYLIST	Maika Mano
	HAIR & MAKEUP	Piu Gontijo
	MODELS	Mahany Pery & Danyllo Pery
	EXECUTIVE PRODUCTION	Eduardo De Mauro, Daniel Palhares & Leandro Alves at Orizon Productions
	PHOTO ASSISTANTS	Franklin Almeida & Guto Cesar
	FASHION ASSISTANT	Gastão Luiz
	FASHION PRODUCER	Manoela Muniz
	SEAMSTRESS	Marisa Hiodo
	FASHION CREDITS	Mahany wears a dress by Walério Araújo, stockings by Calzedonia, shoes by Minha Avó Tinha and a headpiece designed by the stylist. Danyllo wears a headpiece by Penha Maia, sleeves and stockings by Calzedonia and vintage shoes by Prada.

SPECIAL THANKS:		Seongtaek Jang
		Francis Martin
		Anne Mette Müller-Krogstrup
		Chul-Joon Park

STOCKISTS:
A — Z

A	ACNE STUDIOS	acnestudios.com
	APRÈS SKI	apresski.es
B	BALENCIAGA	balenciaga.com
C	CALZEDONIA	calzedonia.com
	CASA JUISI	@casajuisi
	CAVIA	yourcavia.com
	COMME SI	commesi.com
E	EVAN KINORI	evankinori.com
G	GARBAGE CORE	garbage-core.com
	GUCCI	gucci.com
H	HERMÈS	hermes.com
	HOUSE OF FINN JUHL	finnjuhl.com
I	IITTALA	iittala.com
	ISSEY MIYAKE	isseymiyake.com
J	JACQUEMUS	jacquemus.com
	JIL SANDER	jilsander.com
	JUNTAE KIM	juntaekim.net
K	KARMUEL YOUNG	karmuelyoung.com
	KAWECO PEN	kaweco-pen.com
L	LALAZOO ARTELIER	@lalazooartelier
	LOUTRE	loutre.co
M	MAISON MARGIELA	maisonmargiela.com
	MARINA YEE	marinayee.be
	MARNI	marni.com
	MARSET	marset.com
	MINHA AVÓ TINHA	minhavotinha.com.br
N	NAMACHEKO	namacheko.com
	NUNA	nunababy.com
O	OLDER	olderstudio.com
	OMEGA	omegawatches.com
	OUR LEGACY	ourlegacy.com
P	PENHA MAIA	@penhamaia
	PRADA	prada.com
R	RICHARD MILLE	richardmille.com
S	STRING	stringfurniture.com
	SUPER YAYA	super-yaya.com
T	THE GLENTROTHES	theglenrothes.com
	TINA FREY	tf.design
W	WALÉRIO ARAÚJO	@walerioaraujo

Words:
Fiona Bae

PATRICK LEE, the director of Frieze Seoul, on a creative corner of the city.

It's 10 a.m. on a Saturday and I'm sitting at the bar of Hell Café Music in the Euljiro district of Seoul, just down a narrow alley from the iconic Woo Lae Oak bulgogi restaurant. In front of me is a turntable, an eclectic mix of vinyl—they have been playing Pharoah Sanders' *Love Will Find a Way* and Herbie Hancock's *Head Hunters*—and a large speaker system, though that might just be for show.

I regularly visit Euljiro. Within just the small cluster of alleys near here are a wealth of galleries championing emerging and student artists such as N/A, Cadalogs, Euljiro OF, Jungganjijeom, Hyeong, YPC Space and Interim, and it's only a short walk to the more established Doosan Gallery. While in the past small spaces like these came and went at a rapid clip, I hope they continue to exist for some time yet. *Focus Asia*, the showcase of emerging galleries at Frieze Seoul, is always a highlight, and I hope to see more artists who have shown at these small galleries at Frieze.

The area is centered around the Cheonggyecheon stream. Most people can remember a time when it was covered by a freeway, which was eventually removed in 2005. Nearby is the old Sewoon Electronics Building which now houses artist studios,

offices, cafés, small shops run by aspiring creatives and a nice rooftop. I remember visiting in my youth and buying bootleg music cassettes here. Alas, it is slated for demolition sometime in the near future.

The speed of change in Seoul over the past decade is palpable but the city still has a few pockets that have resisted complete gentrification. In the alleys of Euljiro there is a wonderful balance of the old and new, and it is teeming with talented curators, designers and creatives. This is despite the new high-rise buildings that have changed the skyline elsewhere in the city, though the cranes you can see in the neighborhood now seem to augur different times ahead here too.

I am always moved when I think of artist Kelvin Kyung Kun Park's *Cheonggyecheon Medley: A Dream of Iron*, a film that pays homage to the scrap metal workers of the area who helped drive Korea's recovery after the Japanese occupation, and who are now facing the threat of being forcibly relocated. But for now, at least, Euljiro retains its unique aura—a wonderful mix of the past and fast-moving present—and it is still one of the best places in the city to find the newest artistic talent.

Photo: Linda Nylind